European Decorative Arts
In The Art Institute of Chicago

European Decorative Arts
In The Art Institute of Chicago

Ian Wardropper

Lynn Springer Roberts

The Art Institute of Chicago

Executive Director of Publications,
The Art Institute of Chicago: Susan F. Rossen
Edited by Peter Junker, Assistant Editor
Production by Katherine Houck Fredrickson

Designed by Lynn Martin, Chicago
Typeset in Berkeley by Paul Baker Typography, Inc., Evanston, Illinois
10,000 copies were printed on 157 gsm. U-Lite by
Dai Nippon Printing Co. Ltd., Tokyo

All photographs by Robert Hashimoto, Department of Imaging and
Technical Services, The Art Institute of Chicago, except:
pp. 32, 69 by Thomas Cinoman; pp. 90, 95 by Alan Newman
and Terry Shank; p. 96 by Christopher Gallagher;
p. 108 by Kathleen Culbert-Aguilar; p. 117 by Terry Shank
Research assisted by Susan E. Perry,
Senior Library Assistant, Ryerson and Burnham Libraries,
The Art Institute of Chicago

Front cover: detail of figure from
"The Scarf Dance" centerpiece, hard-paste porcelain,
Sèvres porcelain factory, c. 1900 (p. 120–21)

Library of Congress Cataloging-in-Publication Data

Art Institute of Chicago.
 European decorative arts in the Art Institute of Chicago /
Ian Wardropper, Lynn Springer Roberts.
 p. cm.
 ISBN 0–8109-3253–9 (Abrams: hardcover). — ISBN 0–86559-090–7
(softcover)
 1. Decorative arts — Europe — Catalogs. 2. Decorative arts —
Illinois — Chicago — Catalogs. 3. Art Institute of Chicago — Catalogs.
 I. Wardropper, Ian. II. Roberts, Lynn Springer. III. Title.
NK925.A78 1991
745'.094'07477311 — dc20 90-86373
 CIP

CONTENTS

INTRODUCTION

This book celebrates the seventy-fifth anniversary of the Department of Decorative Arts. Following the incorporation of The Art Institute of Chicago in 1879, the museum began to collect glass, ceramics, metalwork, and furniture from many cultures, but without a formally established curatorial entity to guide this activity. In fact, the first object recorded in departmental files arrived completely by chance: an English nineteenth-century pewter goblet — once thought to be a Renaissance chalice — was discovered in excavations for the foundations of the museum's 1892 Allerton Building. Only in 1916 was a department of decorative arts listed in the annual report and a curator engaged. The growth of the collection to over 25,000 European objects certainly reflects the efforts of an increasingly specialized curatorial staff but, above all, demonstrates the taste and dedication of Chicago collectors.

The decisive factor in the museum's collecting of decorative arts was the formation of the Chicago Society of Decorative Art, later called the Antiquarian Society. Established in 1877, nine years before the museum, the society was an enthusiastic and informed audience for the decorative arts. Equally important was its financial generosity. The membership voted in 1891 to create a "fund to be applied to the purchase of articles pertaining to the Industrial Arts such as pottery, china, embroideries, laces, etc., to be presented to the Art Institute and marked in such a way that credit will be given to the Society for the gift." Its munificence has continued so steadily that, in 1977, a vast exhibition and thick catalogue were needed to display the numerous contributions the group had made in the past one hundred years. Only ten years later, *A Decade of Decorative Arts* was published, demonstrating that the pace of their gifts to the museum was, if anything, increasing. Through lecture programs and assistance with exhibitions, the Antiquarian Society continues to play a vital role in the museum and remains the department's most steadfast and important source of funding for acquisitions (see pp. 52, 93, 98, 99, 105, 112, 127).

Gifts by individuals were also vitally important to the initial growth of the collection. Some of the earliest gifts to the department were made by Martin A. Ryerson, Jr., a founder of the Art Institute. His benefactions over succeeding years, until his death in 1933 and subsequent bequest, constitute the single greatest donation of art to the museum. In the field of decorative arts, his contributions formed the nuclei of collections of earlier arts such as Italian maiolica, Limoges enamels (p. 22–23), and carved ivories (p. 15).

These early years saw a collecting pattern oriented toward a typological representation of applied arts influenced by the great specialized museums formed in the mid-nineteenth century in London (the South Kensington, later the Victoria and Albert Museum), Vienna (Museum für Angewandte Kunst), and Berlin (Kunstgewerbe Museum). Early collections ranged from Spanish wrought-iron gates to fine goldsmithery. A characteristic addition in this period was the enormous Blanxius Collection of English ceramics, formed with the intent to display "everyday" as well as finer examples and to represent as many factories and types of pottery as possible. When, in 1917, the museum expanded eastward to span the railroad tracks, a gallery in this bridge-building was endowed in the name of Frank Gunsaulus, divinity professor and founder and president of the Illinois Institute of Technology, for the display of "industrial arts." Here, the decorative arts were viewed in a wide context, from fine arts to the purely functional. The spirit of this intention remains today in the current display of arms and armor, tapestries and ecclesiastical vestments, and ceramics, glass, and metalwork from the Middle Ages to the early Baroque period. Gunsaulus also gave a large collection of Wedgwood pottery, which

augmented the department's important holdings in English ceramics.

In the 1920s, American museums became increasingly interested in what were considered the high moments of historical interior decoration, especially European and American. They created hybrid, furnished rooms in styles appropriate to particular epochs and assembled what period furniture and paneling or wall hangings as could be found, often of widely varying quality or probability of association. The Art Institute installed French Gothic, Rococo, Dutch, and Portuguese Rooms at this time. One reason these period rooms did not become as numerous in Chicago as they did in museums in New York and Philadelphia was because sixty-eight miniature European and American rooms, conceived and constructed under the supervision of Chicago socialite Mrs. James Ward Thorne, were assembled in the 1920s and 1930s and donated in 1940. Although the full-scale period rooms were disassembled several decades ago, because their arbitrary character ultimately was not true to the periods they attempted to represent, they nonetheless served to focus collecting patterns as well as leading to the establishment of funds to furnish the rooms that have been significant in the department's growth ever since. Most notable of these was the Lucy Maud Buckingham Fund, through which many important medieval and Renaissance objects entered the collection (see pp. 12, 13, 21, 25, 38).

The decades between 1920 and 1940 also witnessed a number of distinguished collections of objects accessioned into the department. Besides the Ryerson collection, in 1927, the museum received half of the Mühsam collection of northern and central European glass, dating from about 1500 to 1845. Formed in Berlin, this important collection was divided evenly between the Art Institute and The Metropolitan Museum of Art, New York;

through funds generously provided by Chicagoans Julius and Augusta Rosenwald, some 297 drinking vessels and other glassware found their way from Germany to Chicago (see pp. 28–30). Other collections in these years included Robert Allerton's extensive holdings of faience, as well as a vast range of European wallpaper, textiles, and furniture in his possession (see pp. 74–75).

Following World War II, significant collections continued to fill out departmental holdings. Mrs. William O. Goodman's collection of pewter was matched by collections of silver and other metalwork from Mrs. Stanley Keith, Russell Tyson, and Emily Crane Chadbourne (see p. 51). An enormous collection of primarily English decorative arts given by R. Thornton Wilson bolstered the department's already considerable strength in works from that country (see p. 81).

Recent acquisitions include the Arthur Rubloff collection of glass paperweights, one of the most extensive and finest of its kind (and the subject of a separate book). The enhancement of the collection continues through the dedication of many individuals, notably Mrs. Harold T. Martin, who has endowed a curatorship in the department and regularly supports the acquisition of important objects (see pp. 52, 60, 112, 117, 127), as well as through gifts and bequests of groups of objects from collectors such as Dr. Kenneth J. Maier (see p. 79), and numerous individual gifts, which are often aided by the extraordinary generosity of members of the departmental advisory committee. Curatorial purchases guided by such curators as Bessie Bennett and Hans Huth, using funds from the Antiquarian Society or other endowments, brought single objects of great aesthetic importance into the collection. The emphasis has increasingly been on the quality of ob-

jects, rather than on type, and on collecting objects that express mankind's highest aspirations, rather than on amassing variations.

As more specialists joined the staff, the focus of the collection shifted. In 1961, textiles' importance as a collection and unique properties as a medium were the reasons for the formation of a separate department. American decorative arts joined paintings and sculpture in 1975 to form a collection focusing on the arts of this country. The creation of the Department of Architecture in 1981 led to the transfer of post-1800 architectural fragments to augment the new department's importance as keeper of architects' drawings and plans from Daniel H. Burnham's legacy. In the process of redefining itself, the department often split like an amoeba only to reform later. For instance, European sculpture left to join paintings in 1980, only to return in 1985. This process has occured as well in other museums, a natural response to growth, shifting specialties, and curatorial interests. In recent years, the department has reversed the general trend of the 1970s and early 1980s to shrink and instead has extended its range, adding the classical art collection in 1989 and the Harding Collection of Arms and Armor in 1990. And the new installation of twentieth-century decorative arts has inspired the department to reaffirm its commitment to the art of our times (see the final two chapters of this volume).

In 1988, the department reinstalled virtually the entire range of its collections in new galleries in the Art Institute's Rice Building. Limited space required a careful review of all holdings to select only the best and most important objects, as well as to represent strengths of the collection. This book is a direct result of the evaluation process that shaped the reinstallation. Each of the objects illustrated here was chosen because it is an extraordinary work, notable for its successful design, its importance, beauty, or rarity. Each was selected as well to represent collections whose range can only be collectively measured in the galleries and the department's store rooms. As the first book-length survey of European decorative arts in the Art Institute, the illustrations and accompanying discussions offer both an introduction to the collection and a guide to the objects now on view in our galleries.

In organizing the book, we felt the need for more than a simple chronological presentation. A cue was again taken from our recent installations, where the philosophy of presentation is to cross boundaries of medium, geography, and time. Such an approach stresses connections rather than differences: how a silver sauceboat was adapted to porcelain, how chinoiserie spread like brush fire throughout eighteenth-century Europe, and how the radically simple structure of a nineteenth-century Thonet chair inspired Le Corbusier in the middle of the twentieth century. Some chapters focus on a particular period, such as the Renaissance, or on a particular type, such as English seat furniture. But many other issues are addressed: political influences (seventeenth-century England); religious values (eighteenth-century Bavaria); motifs (chinoiserie); factories (eighteenth-century porcelain production); and movements (Neoclassicism, Art Nouveau, nineteenth-century historicism). The choice is also a function of the tastes of two curators, their love and experience of a collection over a decade. But, ultimately, it reflects seventy-five years of departmental activity and over a century of interest in the decorative arts in Chicago.

Ian Wardropper
Eloise W. Martin Curator of
European Decorative Arts and
Sculpture, and Classical Art

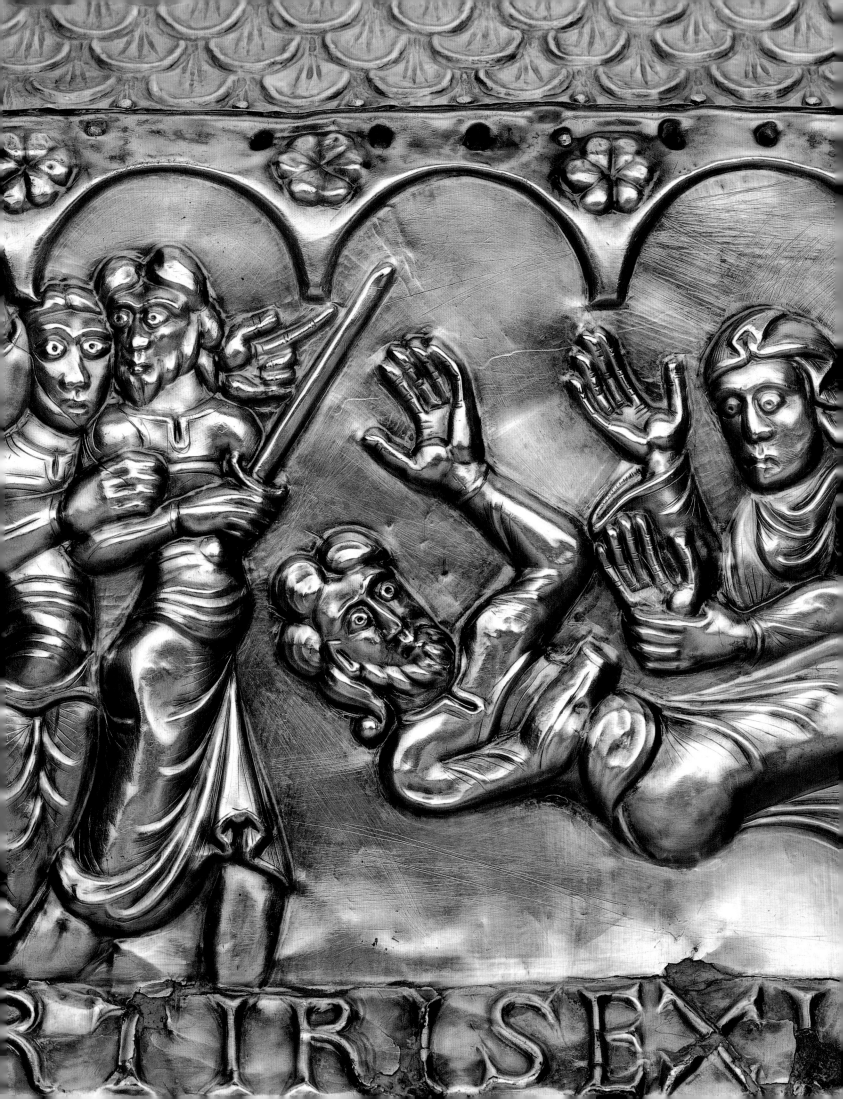

THE MIDDLE AGES

When Thomas Aquinas wrote of the "supreme beauty" that exists in the qualitative differences between things, the phrase he used was *summus decor,* which refers to not only things of God's making, but also to objects fashioned and decorated by skilled human hands. To Thomas, and to people throughout medieval Europe, elements of the visible world had spiritual significance, whether or not they served specifically religious functions. Today, the Gothic cathedral stands as the best-known and most exhilarating artistic expression of the time, but the achievements of artisans on a smaller scale, in metalwork, enamels, and ivory, were equally impressive, as the five works presented here attest.

Since the radiance of precious materials such as gold was believed to lead the mind, paradoxically, to heavenly and immaterial values, objects made for use in the Mass or sacraments were often the most lavish of the period. But the true treasures of the church were its relics, the sacred remains of holy men and women that attracted pilgrims by the thousands to sites across Europe. Along the busy pilgrimage routes that led to the most popular shrines developed a thriving commerce in reliquaries (containers for relics) and other devotional objects. Faith moved the arts, as cherished decorated objects were carried far from their points of origin. Production centers were often located near raw materials, as with the metalwork of the Mosan region, which bordered mining areas. But a concentration of wealthy patrons could also foster production, as it did in the Ile-de-France, where a tradition of ivory carving was sustained far from the sources of tusks in Africa and India.

The power of devotion can be seen in the chasse of Saint Adrian (p. 12). Like a miniature tomb, which indeed it was, this chest is topped by a fictive, tiled roof and supported by columns. Adrian was a Roman guard, in charge of the persecution of Christians, who converted to the faith he once abhorred. For this transgression, he was martyred. The story of Adrian's dismemberment and the recovery of his hand, which the chasse might have been made to contain, is unflinchingly told on the sides of the reliquary and reinforced by an inscription. The design was hammered out from behind on thin sheets of silver, through a technique known as repoussé. Convex bulges reduce the figures to simple forms, reflecting the severe and monumental style of Romanesque reliefs in the Spanish cities of Léon or Toledo, where the casket may have originated.

Performing a function similar to that of the chasse is a Mosan enamel plaque (p. 13). Its shape suggests that it may have formed the right half of an arch on a household shrine. The plaque depicts a bishop who holds in one hand a model of a Romanesque church and in his other a crosier, his staff of office. The sharp lines and colors of this plaque relate it to the art of manuscript illumination. Employing the technique of champlevé enamel, the artist gouged the design into a sheet of copper, then filled the sunken areas with powdered glass. During firing, the raised copper ridges kept the molten colors separate and formed a shiny counterpoint to the opaque enamels. The artist used this process with utmost precision to suggest light falling across the folds of the bishop's outer vestment, or dalmatic, and to keenly observe the man's features.

An object intended for private devotion is an ivory triptych (p. 15) that could have ornamented a private chapel or rested on a prie-dieu, a low desk with a ledge for kneeling in prayer; hinged to close, it was also portable. Despite its scale, the triptych

Chasse of Saint Adrian

1100/1135, Spanish
Repoussé silver on oak core

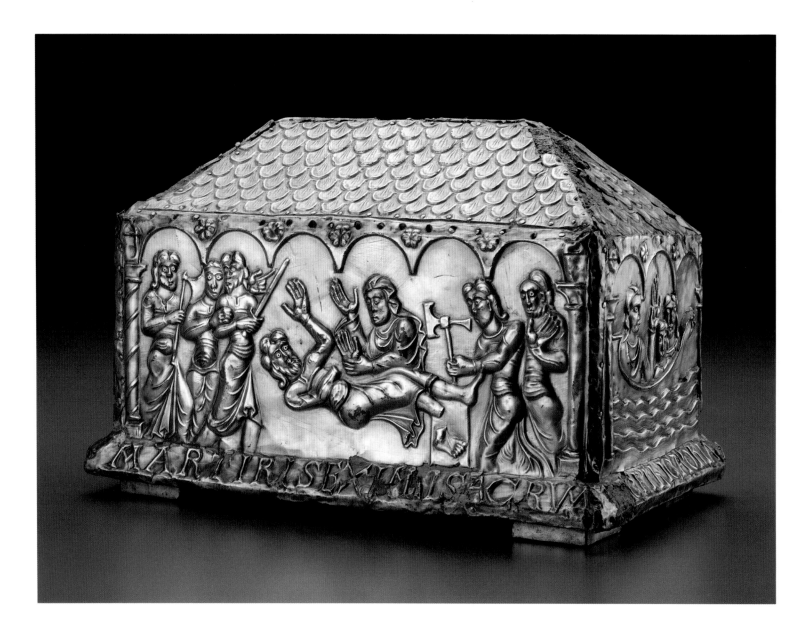

Plaque of a Bishop

1175/1225
German (Mosan region, probably Cologne)
Gilt copper and champlevé enamel

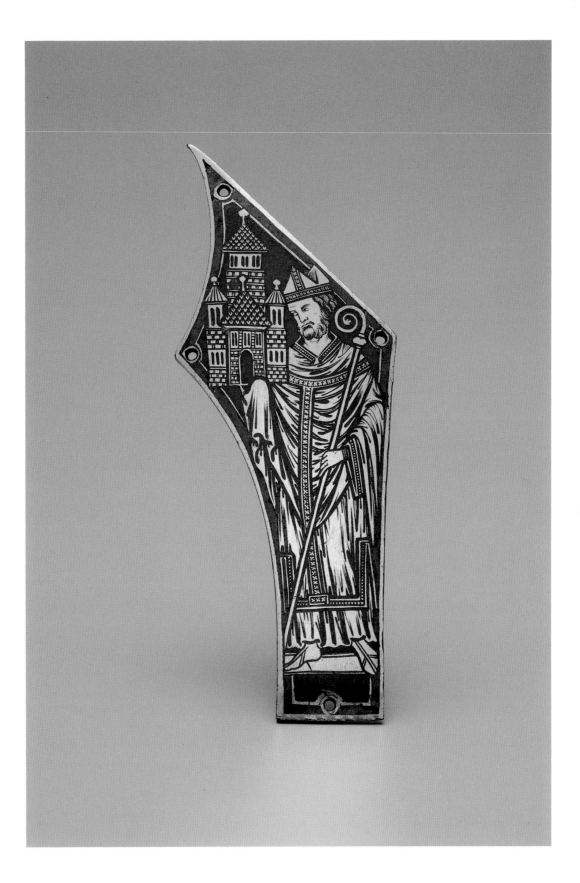

The Veltheim Cross

c. 1300, German
Gilt silver, enamel, and gems

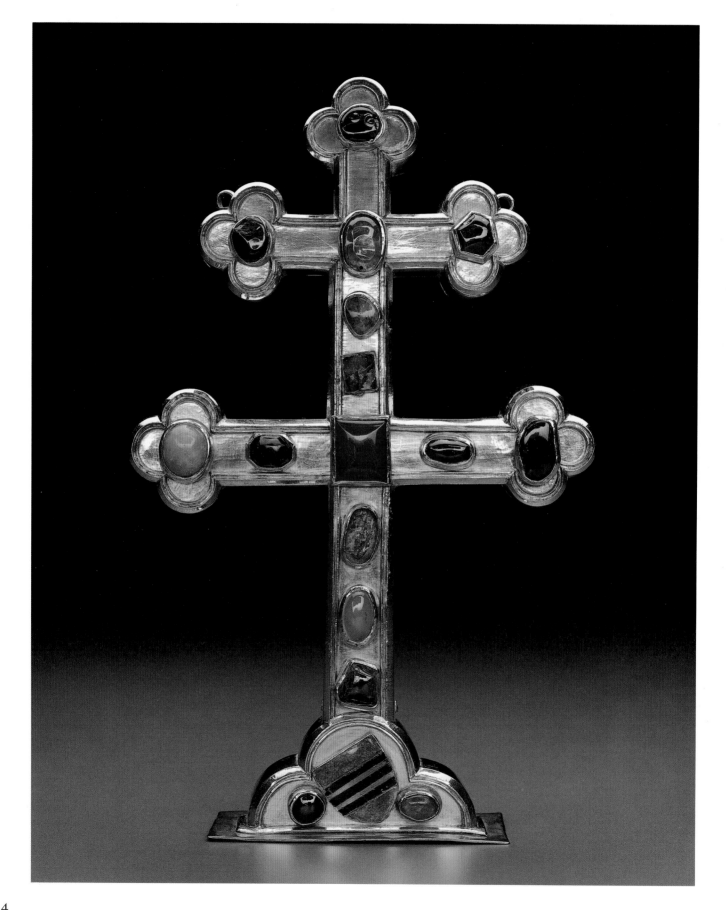

Triptych with Scenes from the Life of Christ

Fourteenth century, French (Paris)
Ivory

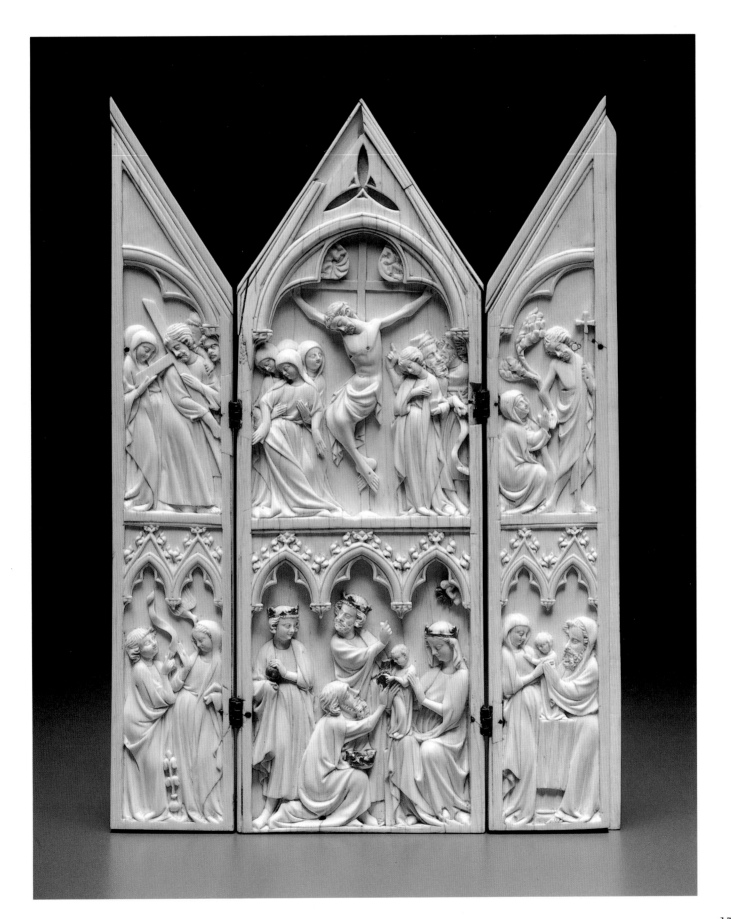

borrows from larger artistic forms, its wings and scenic areas echoing painted altarpieces, and its Gothic arches and decoration deriving from church architecture. It depicts scenes from the early life of Christ surmounted by events from the Passion. This combination was a common symbolic program in the arts of the thirteenth and fourteenth centuries. Ivory — in its whiteness — was associated with purity, but its surface was seldom left undecorated. Traces of gilding on the magi's crowns indicate that this example was partially painted.

The medieval affinity for surfaces rich with precious materials can also be seen in a patriarchal cross (p. 14) — a cross with a short arm above a longer one — which was decorated with sixteen unfaceted precious stones, or cabochons, two of which are missing. The remaining cabochons include blue sapphire, amethyst, and topaz. The cross may have been displayed in a number of ways. It has a cavity for fitting onto a processional staff as well as a hinged back for enclosing relics. An enameled coat of arms at the cross's foot reveals that it was originally donated to the church by a wealthy German family, the Veltheims. In the fifteenth century, it passed into the Guelph Treasure, a collection of 140 liturgical objects formed by a royal family at the Cathedral of Saint Blaise, Brunswick. Much of the treasure was dispersed in the 1930s, and The Art Institute of Chicago now preserves seven other fourteenth- and fifteenth-century works from this notable collection.

Not all medieval objects were religious. A covered goblet (p. 17), probably commissioned by a German guild as a ceremonial civic gift, is a brilliant example of the secular arts. Sharing a cup or proffering a drink to a guest were significant acts, especially in Germany. This silver drinking vessel unites a complex geometric form with the effects of a more modest and pliant decorative medium, basketry. A simulated hempen cord circles the stem, and a concoction of spliced and knotted forms creates a stylized flower at the crown. The goblet's most distinctive feature is its supporting wild men. These brutish and irrational counterparts of civilized men were thought to live in the remote wilderness. Costumed revelers frequently portrayed wild men in medieval festivals, in which they paralleled the bacchanalian role of the figures holding up this cup.

Covered Goblet

c. 1500, German
Parcel silver gilt with repoussé,
cast, and applied decoration

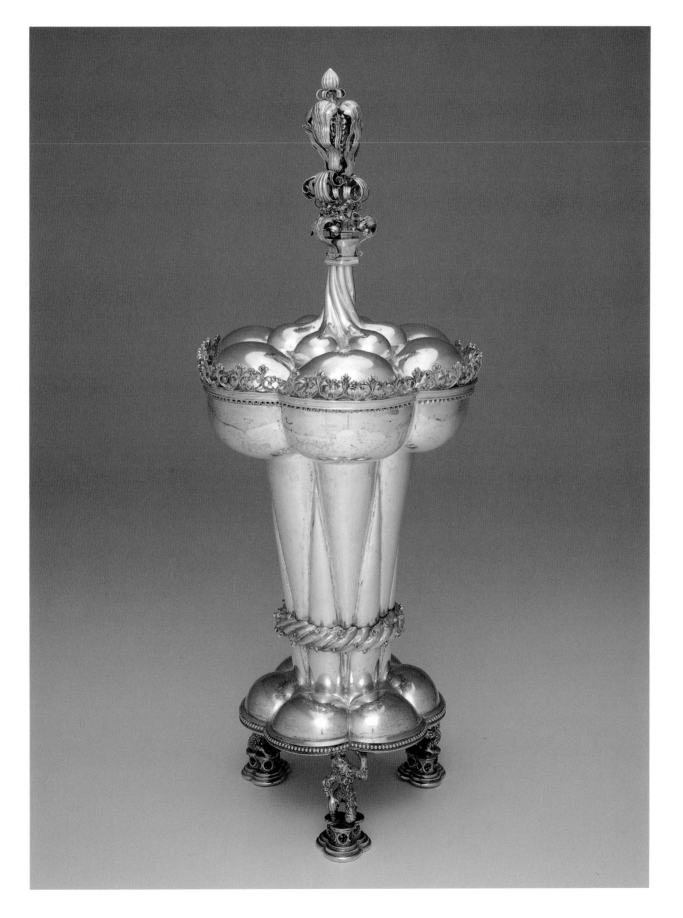

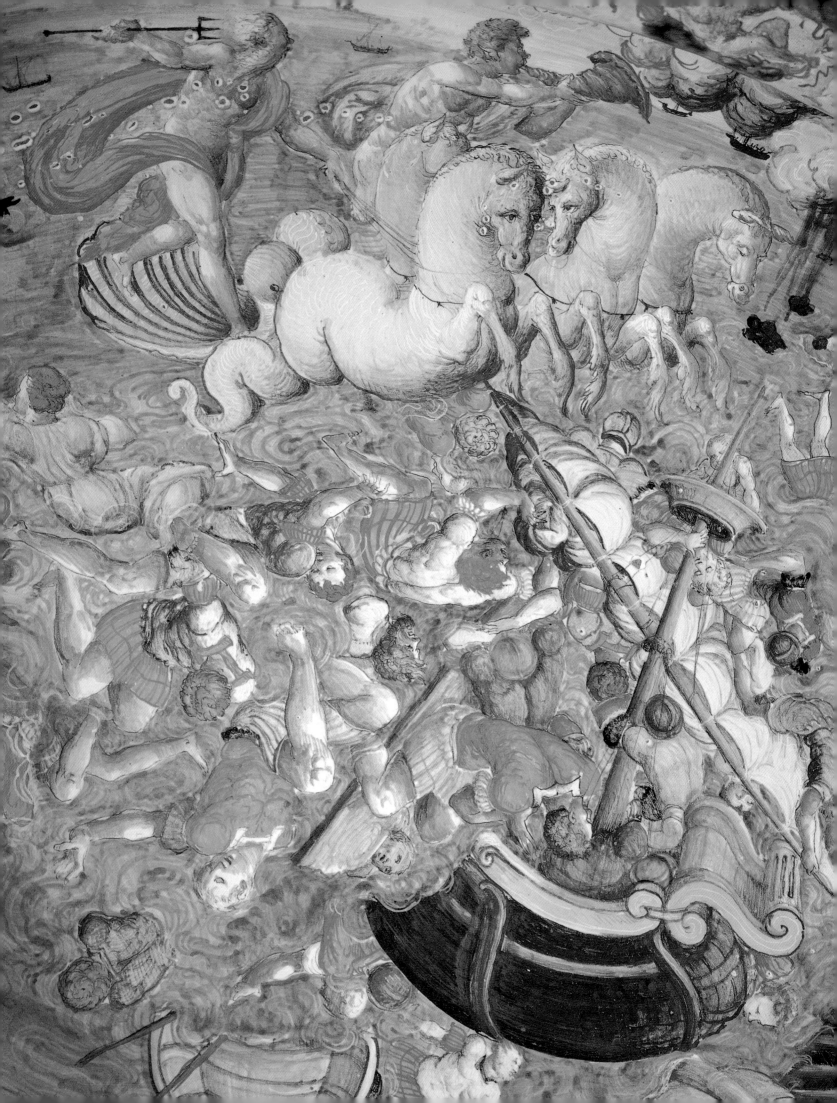

THE RENAISSANCE

The most spectacular objects made during the Renaissance embellished banquet tables rather than church altars, although liturgical implements continued to be commissioned. The four works presented here were used for entertainment. Nominally vessels for water or wine, these objects also displayed their owners' wealth, taste, and learning. Their decoration — including images of aquatic creatures and scenes both fantastic and historical — inventively illustrates their liquid-bearing function. Subjects were as often drawn from ancient poets as from biblical sources, and patterns were culled from wall paintings discovered in excavated Roman villas, reflecting the nobility's cultivated taste for pagan Antiquity. This interest in the classical past was part of a larger sense of discovery and celebration that marked the age.

New ideas and technologies, the growth of cities, and increased distribution of wealth brought changes in thought and fashion that naturally affected the decorative arts. As their exposure to the other arts broadened, craftsmen frequently borrowed the ornamental effects found in one medium and adapted them to another. The recent invention of printed books and engravings — which could reproduce famous paintings — provided craftsmen with designs and compositions to inspire their works. Some medieval centers of manufacture, such as Limoges, France — famous for enamels — survived and adapted to changing conditions. New production centers arose as well, such as those for tin-glazed pottery, called maiolica, which thrived in central Italian towns near riverbanks with plentiful supplies of clay. While local traditions rooted some decorative arts to particular sites, the practices of trade and craft guilds, such as the goldsmiths', instead encouraged artisans to move from city to city to learn their techniques, spreading styles internationally. The im-portation of silver and gold from the New World and the influence of the Renaissance and, later, Mannerism, led to more lavish and colorful decorative arts.

Even a modest-sized cup could provide an opportunity for exquisite workmanship and intricate design. The tazza, a shallow, ornamental bowl supported by a foot, was used for drinking or for holding candied delicacies. On a silver-gilt tazza (p. 21), three mermaids lock arms and entwine tails to form the foot that supports a shell-shaped cup. The interior, made from a separate sheet of silver, depicts a naval battle raging before a fortified harbor. The goddess Fama (Fame) trumpets from a floating chariot pulled by fabulous monsters. The locale may be Tunis, and the battle may represent that city's siege by Emperor Charles V in 1535. The tazza's commemorative nature and fine workmanship suggest that it was created for a noble client. Its style is so international that various countries have been claimed for its point of origin.

The tazza was a popular form that could be executed in various materials: cast in silver, blown in glass, carved in precious stone, or enameled on copper. This last technique was a specialty of enamelers working in Limoges. In the sixteenth century, enamel pigments were developed that could be painted directly on the metal surface rather than laid into channels (as in the champlevé method; see the Mosan plaque, p. 13) or separated by raised dams (as in the cloisonné method). With the new technique, enamelers could imitate the brushwork of an oil painting. A bright, varied palette prevailed in the early 1500s, but by mid-century, taste had tilted toward an effect called grisaille, which simulates relief sculpture by using shades of black, gray, and white.

The painted circles around the exterior rim of a Limoges tazza by the artist Jean de Court (p. 22)

Interior detail
of maiolica wine
cistern (p. 24)

simulate metalwork embossing, while the strapwork — the complex, linear ornamental motif popularized in high-relief wall patterns at the French court at Fontainebleau — evolved from designs in leather. Inside, the scene of Moses striking water from the rock for the thirsty Israelites is adapted from Bernard Salomon's Old Testament illustrations, a widely used source book first published in Lyons in 1553. Limoges enamel objects were frequently paired thematically, and the existence of tazzas by the same artist of Moses breaking the tablets of the Law in outrage at his people's idolatry indicates that we should view this scene as part of a moralizing biblical drama.

A generously sized maiolica wine cistern (p. 24) exhibits all the characteristics that made this ware popular: brilliant colors, lively painting, and storytelling images mixed with fanciful designs. The name maiolica, probably a corruption of Majorca, hints at its source, the port through which pottery from Moorish Spain was imported to Italy. While developing distinct regional styles, potters in towns such as Siena, Deruta, Faenza, and Urbino responded to the lustrous glazes of Hispano-Moresque pottery. The tin glaze perfectly preserves the joyous Renaissance colors; the nineteenth-century English critic John Ruskin's description of Giotto's frescos in Padua as "fresh as April" could equally be applied to maiolica. Like those of Giotto's frescoes, maiolica's colors were

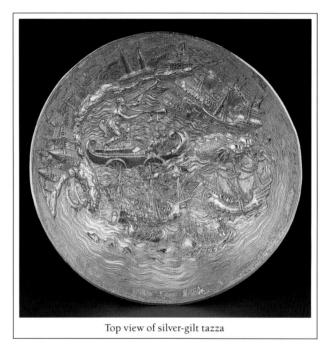

Top view of silver-gilt tazza

brushed into a wet slip, a process requiring speed and precision. Even the compositions on maiolica frequently derived from mural painting. Here, Giulio Romano's *Battle of Constantine,* a mural in the Vatican, was skillfully adapted to the curved exterior of the wine cistern by the Italian ceramic painter Francesco Durantino.

The cistern's purpose was to cool bottles of wine through the long hours of a summer banquet. Italian etiquette created a large demand for such specialized tableware, requiring a wide variety of types, from plates to large vessels. And, according to a 1618 tract by the scientist Ulisse Aldovrandi, food tasted better when eaten from ceramic plates rather than from the pewter commonly used in northern Europe. While the exterior of the cistern represents a land battle culminating in the conversion of the Roman emperor to Christianity, the interior depicts a legendary naval disaster, the sinking of Aeneas's ships. Around the interior edge, Juno is shown offering the wind god Aeolus "fourteen fair maidens" as a bribe to unleash violent winds on Aeneas's fleet. At the center, the ships disappear beneath the waves. This conceit must have been all the more effective when the cistern was filled with water, and the viewer with wine.

By the late sixteenth century, when silversmith Franz Dotte fashioned a sumptuous ewer-and-basin set (p. 25), such objects had become emblems rather

Tazza

1550/1600
Italian or Netherlandish
Silver gilt

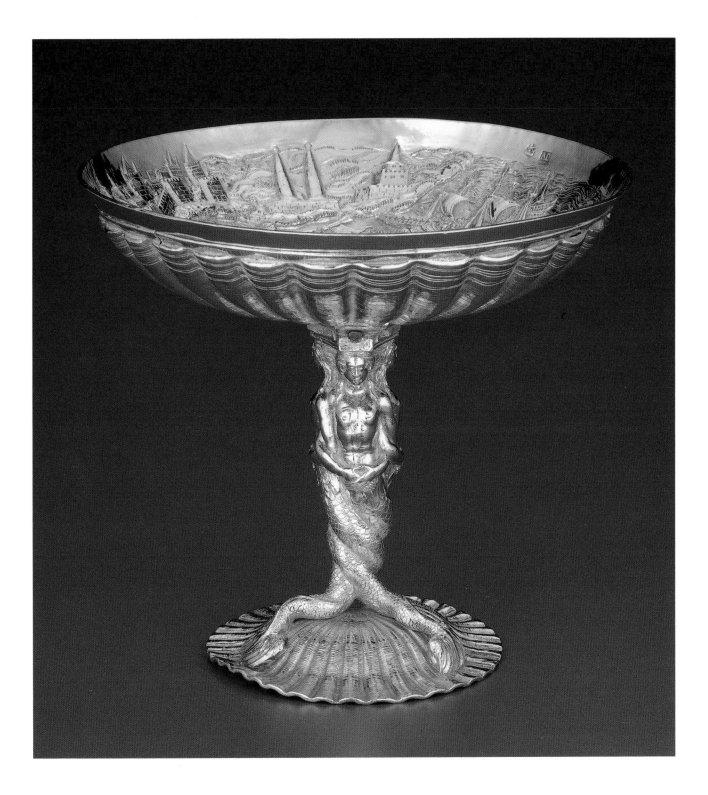

Tazza

Painted by Jean de Court
1553/75, French (Limoges)
Enamel on copper

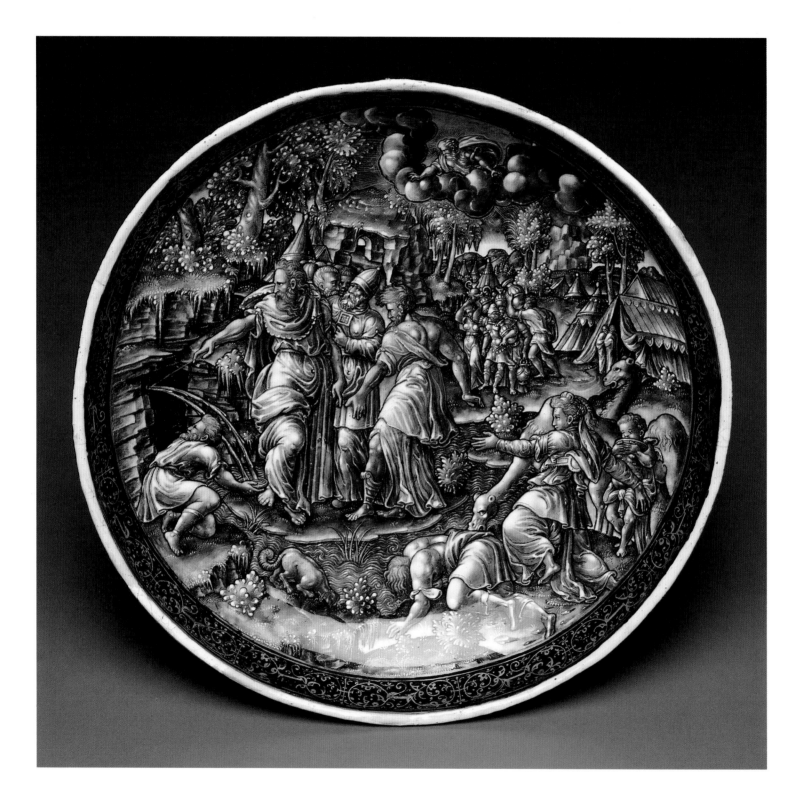

than necessities of courtly life. In an earlier age, when diners ate with their fingers, servants circulated to wash guests' hands with rosewater poured from a ewer into a basin. After the adoption of the fork, vessels like these more frequently adorned sideboards; freed from practical constraints, they began to display increasingly whimsical ornament.

Franz Dotte stamped his mark into this set about four years after he was made a master silversmith in Nuremberg in 1592, before his departure from that city in 1612. The basin and ewer exhibit the range of Dotte's skills, principally in repoussé work, in which the design is hammered and punched from the reverse, and also in the chasing that decorates the front.

Profile of enamel tazza

No silversmithing center surpassed Nuremberg in producing such elaborate silver work. The learning of this demanding craft was regulated by strict rules established by the guild: a silversmith began as an apprentice, then trained as a journeyman in another city, and was finally recognized as a master after the completion of a "masterpiece." Silver, shipped to Europe from South American mines, was worked principally in those cities with the richest clients. In periods of financial hardship, silver vessels were routinely melted down for conversion to bullion, making brilliant examples of workmanship from about 1600, such as this set, quite rare.

On the basin, sprites, tritons, and cupids splash in water; dolphins occupy cartouches on the sides of the ewer and the bottom of the basin. The ewer is further adorned by three faces, of an old man, an exotic "Indian," and a child, cast separately and hinged or fastened onto the surface. A convoluted, spinelike handle and sharp spout crown the whole. It has recently been suggested that parts of these elements were added by a skilled craftsman of the 1860s who enhanced several famous Renaissance masterworks. Nonetheless, the form and decorative conception of this set reflect the exuberance and grandeur that are implicit in the best late-Mannerist silver.

Wine Cistern

Painted by Francesco Durantino
1553, Italian (Castel Durante)
Tin-glazed earthenware (maiolica)

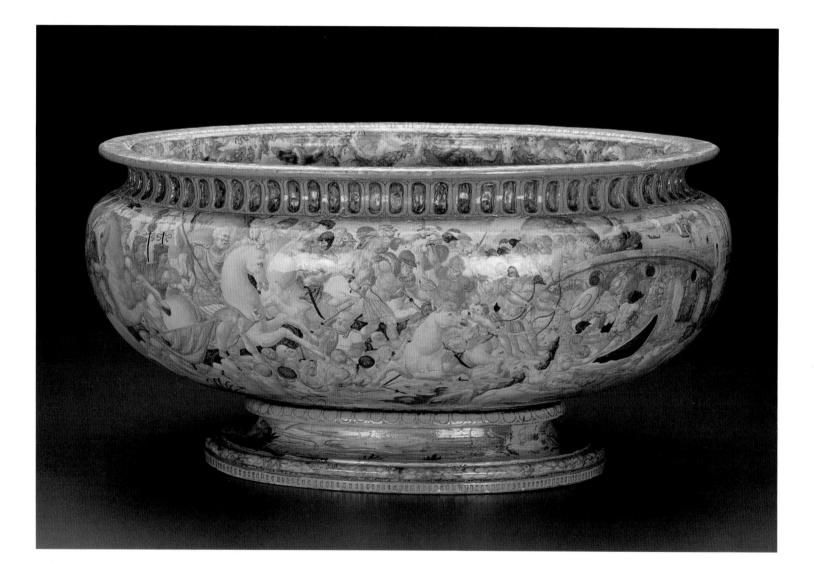

Rosewater Ewer and Basin

Franz Dotte
c. 1596, German (Nuremburg)
Silver gilt

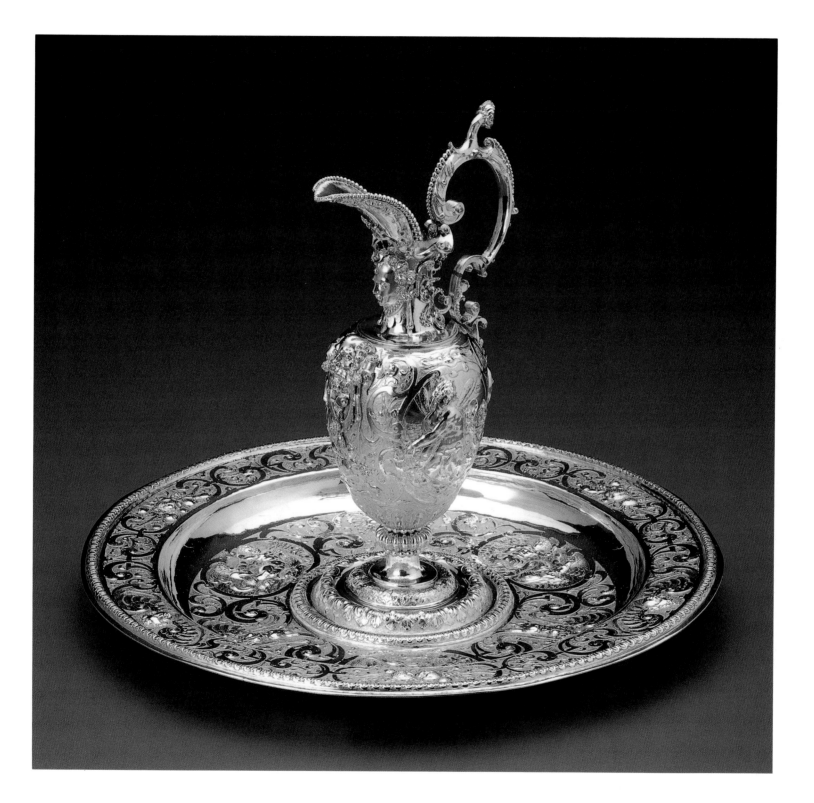

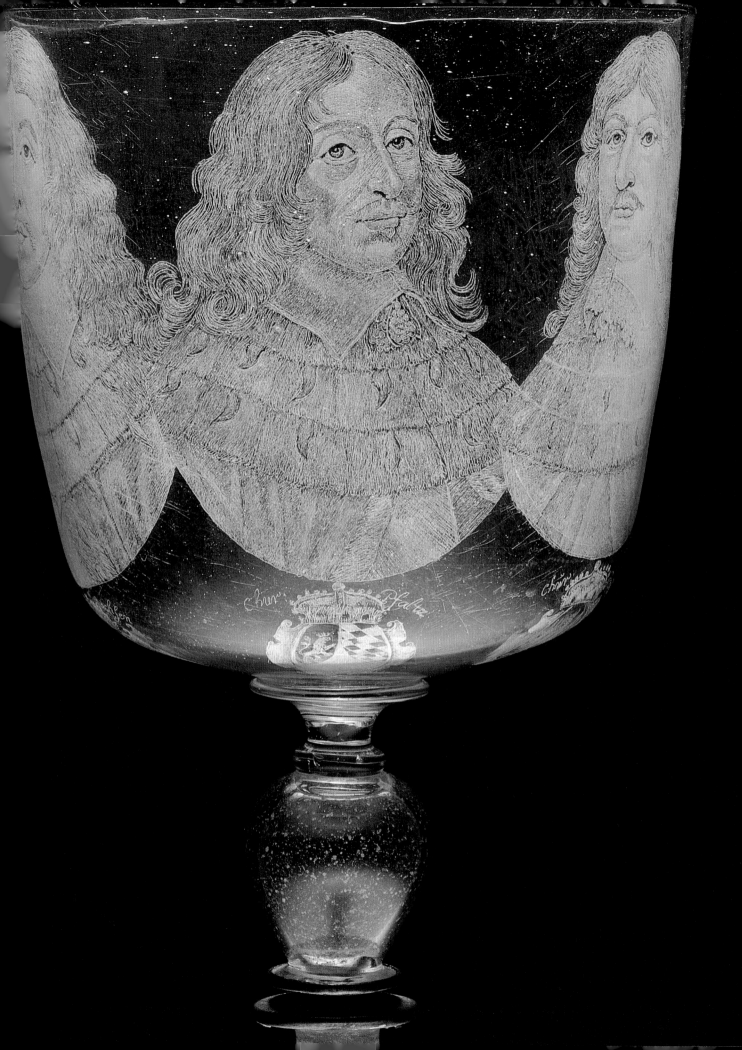

GLASS VESSELS OF THE SIXTEENTH AND SEVENTEENTH CENTURIES

After an English banquet in 1580, the German traveler Leopold von Wedel recorded: "They hailed me to a drinking orgy far in excess of what they are wont; they drank our healths in bumper glasses just to please us, for German drinking powers are a byword all over the world." The prodigious Teutonic drinking habits that so impressed von Wedel's hosts were celebrated in the forms of glass vessels. Often outsized by modern standards, many even incorporated drinking competitions into their structure, measuring by opaque bands the quantities each reveler was expected to quaff. Drinking was a socially significant act with numerous rules of propriety. Honored guests were greeted with *Willkommen,* sizable vessels from which the drinker was expected to down the entire contents. The most common *Willkommen* were of a type known as *Humpen:* tall, cylindrical beakers that were often ornamented with narrative or symbolic motifs (see p. 30). Despite the lighthearted nature of many German drinking glasses, sobering biblical tales or elaborate coats of arms frequently decorate their sides. As a glass was raised to the drinker's lips, such decorations admonished him to behave, or inspired his sense of civic duty.

From medieval times, glasshouses were located beside forested areas, because wood was needed to fuel the melting and blowing furnaces, as well as to yield potash, an essential ingredient of glass. In glass blowing, a mass of molten glass, known as the gather, is shaped by turning and blowing at the end of a hollow, metal tube. Impurities in the sand, which fuses with potash or soda to create glass, gave a characteristic green tint to the products of many Bavarian, Saxon, and Silesian centers. These greenish vessels are generally called *Waldglas,* German for "forest glass." Until the mid-sixteenth century, such glassware was usually undecorated except for the imprinted patterns made by molding the gather or by applying drops of molten glass to the exterior and rapidly pressing and cutting them. Such applications are called prunts, and they can be further embellished, as they are in the case of a *Waldglas* tumbler (p. 28), with dangling metal rings. Looking like a gnarled and knobby tree trunk, this rustic vessel was practical for drinking, since its protrusions provided a firm grip when the glass was wet.

Enameled glass, that is, glass decorated by painting and firing colored powders onto the surface, was common in German countries in the second half of the century. Family armorials and symbols of guild affiliations regularly appear in enamel decoration, and other popular images reveal contemporary preoccupations: biblical tales, folk wisdom, hunting, and politics. One favored theme, the ages of man, charts the ascent and decline of a lifetime. In contrast to Shakespeare's contemporary description of the "seven ages" allotted to man in *As You Like It,* this *Humpen* (p. 30) optimistically depicts a hundred-year span in ten stages. The hoop-playing child becomes the twenty-year-old dandy (p. 31), who in turn matures into the bellicose thirty-year-old. A symbolic animal accompanies each decade of life; so, a lion prowls beside the forty-year-old man in his prime. This amusing parody of life's cycle ends, as it must, with a frightening memento mori: skeletal Death drags the tottering hundred-year-old off the world stage. Tempering the hilarity of drink with a reminder of the impermanence of life, this decorative cycle typifies the contrast between the function and decoration of German glassware.

Tumbler

Sixteenth century
Probably Netherlandish
Blown glass with applied decoration, metal rings

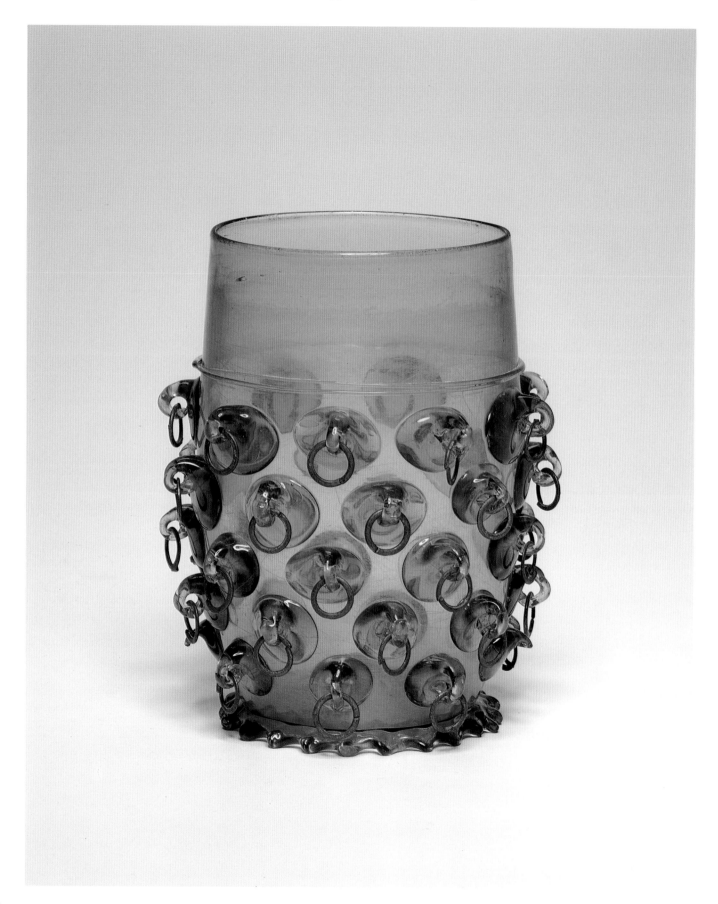

Goblet

Georg Schwanhardt the Elder (attr.)
c. 1660, German (Nuremburg)
Blown glass with diamond-point engraving

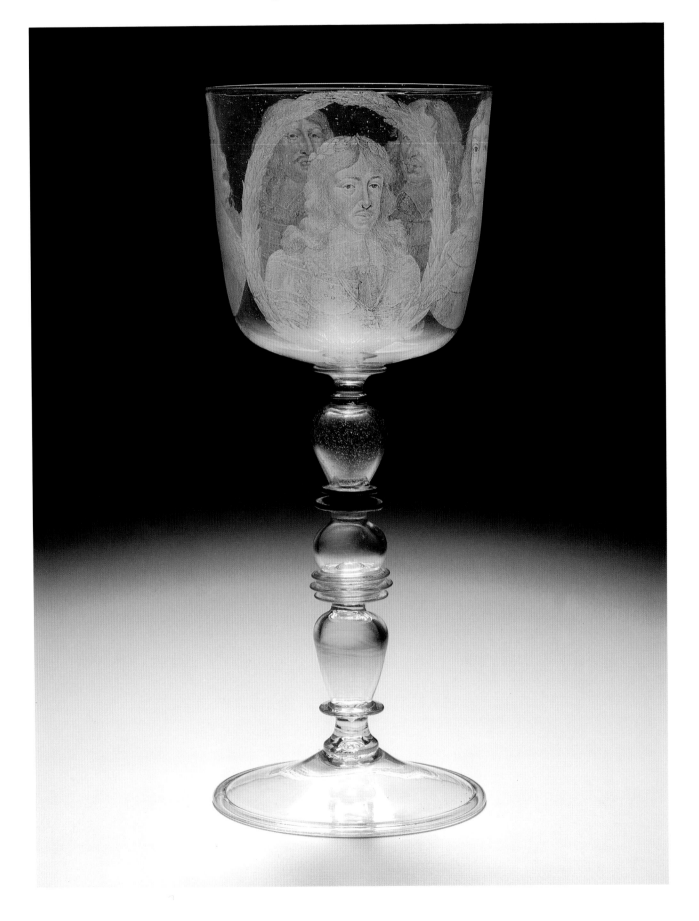

Tall Beaker (*Humpen*)

c. 1600, Czech (Bohemian)
Blown glass with polychrome enamel

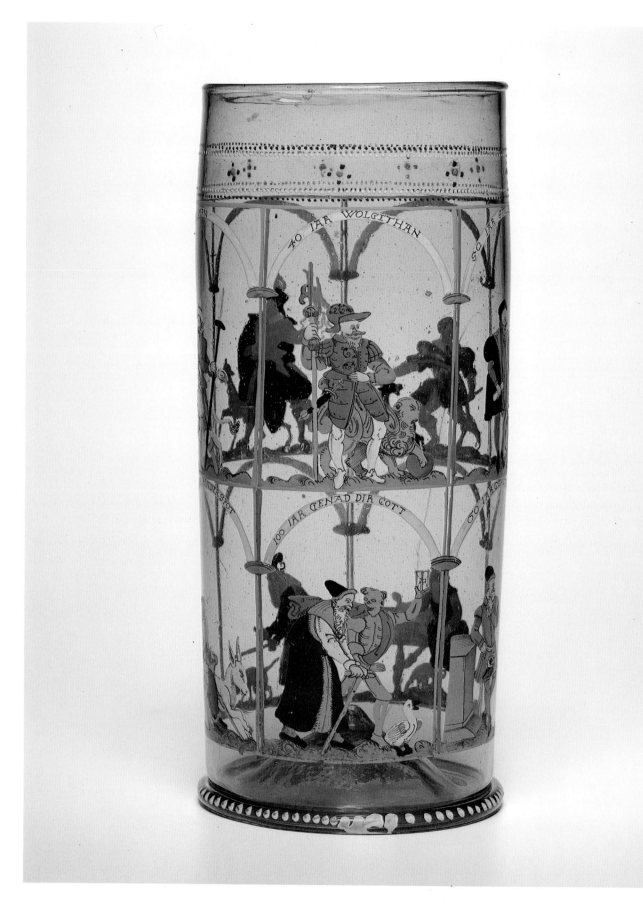

While enameling enjoyed wide popularity in the Renaissance, engraving was the most admired technique of glass decoration in the Baroque era. Since transparency enhanced the effects of subtly cut patterns, traditional German preference for green tint yielded to clear glass, rendered colorless by adding manganese to the mixture of ingredients. Northern European glasshouses also introduced a heavier, more brilliant glass, which stood up to the stress of copper-wheel or diamond-point engraving. These techniques were practiced in Bohemia, particularly in Prague, where the tastes of Emperor Rudolf II (1552–1612) encouraged gem-cutting and other intaglio decoration. One of Rudolf's artisans, Kaspar Lehman, trained a generation of glass engravers, among them Georg Schwanhardt the Elder, who spread Lehman's techniques to other cities. Glass engraved by diamond-point, a freer technique than copper-wheel engraving, required a surer hand and produced a looser effect. Although the Dutch mastered glass etching, the Germans practiced it experimentally. Some German masters must have learned the technique well, since it is known that Schwanhardt taught it to Emperor Leopold I (1658–1705).

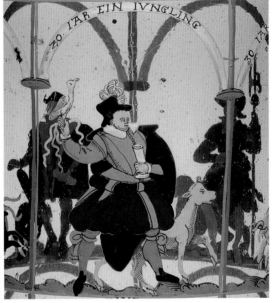
Enameling depicting twentieth year of "the ages of man"

A masterful diamond-point engraved glass attributed to Schwanhardt (p. 29) takes a form that was particular to the city of Nuremberg: a goblet on a tall stem with hollow knops separated by small disks called mereses. (The lower portion of the stem is a replacement, something not uncommon in older examples of glass.) As the glass is held up to the light or filled with colored liquid, etched portraits become visible, centering on Emperor Leopold, who is flanked by four electors of the Holy Roman Empire: Johann Georg II of Saxony, Carl Ludwig of the Palatinate, Friedrich Wilhelm of Brandenburg, and Ferdinand Maria of Bavaria. These were the empire's strongest secular rulers, in contrast to the spiritual electors, the archbishops of Trier, Cologne, and Mainz. National unification was a long-held dream in Germany, realized only in the nineteenth century. At the time this goblet was made, in the mid-seventeenth century, toasting the leaders pictured on it was a gesture of political solidarity.

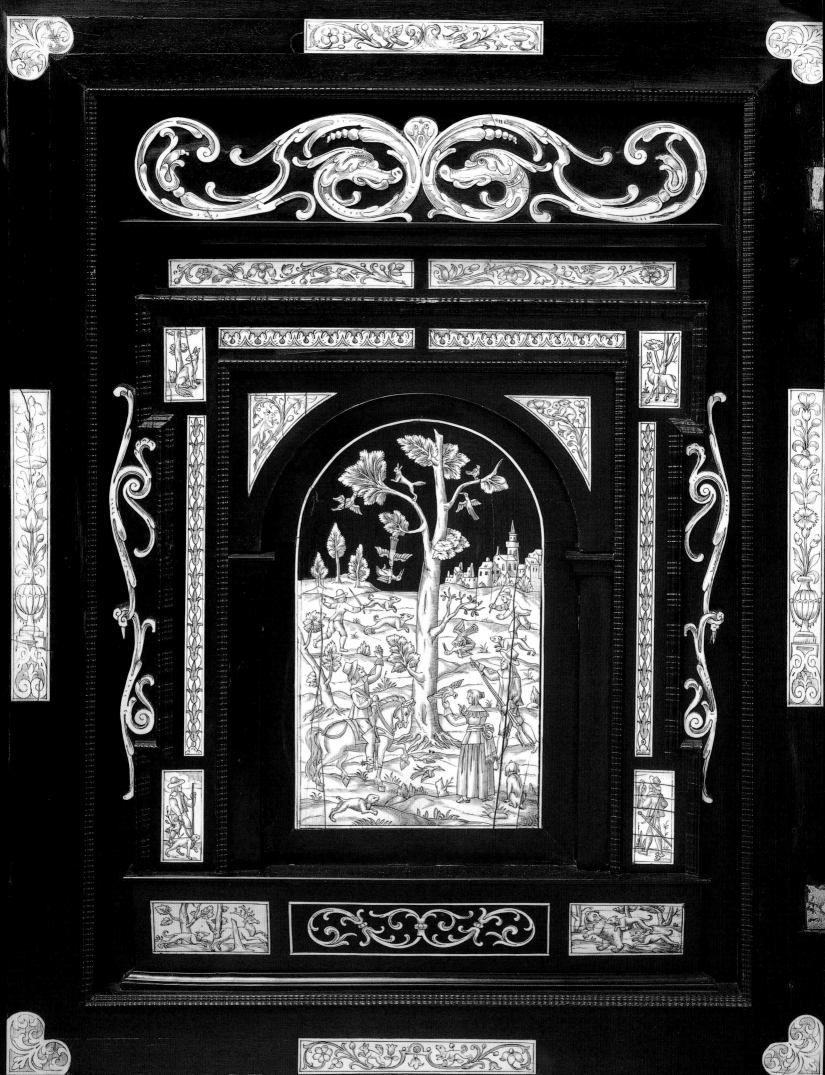

A MICROCOSM OF ART AND NATURE: THE AUGSBURG CABINET

The term cabinetmaker, meaning an artisan who makes fine furniture of all types, first came into currency in the seventeenth century, when intricate cabinets were the focus of woodworking activity. The design of these complex and elaborate chests of drawers required great skill, as they were often executed in a wide variety of decorative methods. An example in the collections (p. 34) includes carved ivory inlaid into ebony, applied bronze mounts, and Eger work, a technique invented in the Hungarian town of Eger, in which images are created from different woods that are stained and fitted together like jigsaw puzzles. The encyclopedic nature of these cabinets led to the inclusion of numerous other built-in features. The London-made timepiece that surmounts the cabinet dates from around 1715 and probably replaced an earlier clock. When drawers behind the clock are pulled out, a set of five cannisters for drugs and ointments is revealed. At least twenty-two other utensils—pharmaceutical implements, as well as hammers, scissors, and even an astronomical calculator—were made for this not-so-portable version of a Swiss Army knife. Thematically, too, the decoration ranges widely, from pure patterns to hunting scenes, and from specific mythological tales to the allegorical figure of the Christian virtue Charity, who stands on the cabinet's highest point.

The all-purpose nature of such cabinets stems from their varied functions. They evolved from a type of Spanish document chest, the *varqueño,* which features many narrow drawers for holding papers. While the drawers of *varqueños* are often hidden behind drop-fronts for writing, in German versions they are placed behind two doors, since the cabinet had shifted in function from document case to curio cabinet. Increasingly lavish exterior decoration complemented such interior contents as jewelry, gems, or rare minerals. These cabinets became microcosms of art and nature, covered by and containing precious materials from all over the world—in this case, ivory, but on other cabinets, tortoiseshell, mother-of-pearl, silver, or exotic woods—that were transformed through exquisite craftsmanship into examples of high artistry.

Repeated and varied throughout this work are sinuous ivory patterns, crisply contrasting the black sheen of ebony veneer, a feature that is typical of cabinets made in Augsburg, in southern Germany. Ordered rectangles confining these patterns define the facade of this architectural form and play against the swirling volutes at its crest and feet. The cabinet's appearance when closed is relatively modest. Opened, the doors reveal more lavish decor: carved figures on pedestals, called herms; bronze drawer pulls shaped like lion heads; and ivory pictures depicting scenes of falconry. In turn, the central panel opens to reveal yet another set of images. Here, activities of various professions are represented in Eger work. Hidden behind these are another rank of drawers. Such secret compartments were often included to guard special papers or treasures, since the cabinets served not only for display, but also as personal safe-deposit boxes.

Many of the most prized cabinets of the period featured coordinated surface ornamentation, with themes whose sources ranged from biblical stories to contemporary romances. In this cabinet, the

Augsburg Cabinet

c. 1640, German (Augsburg)
Ebony, carved and inlaid ivory,
stained and carved wood relief,
gilt bronze, iron implements

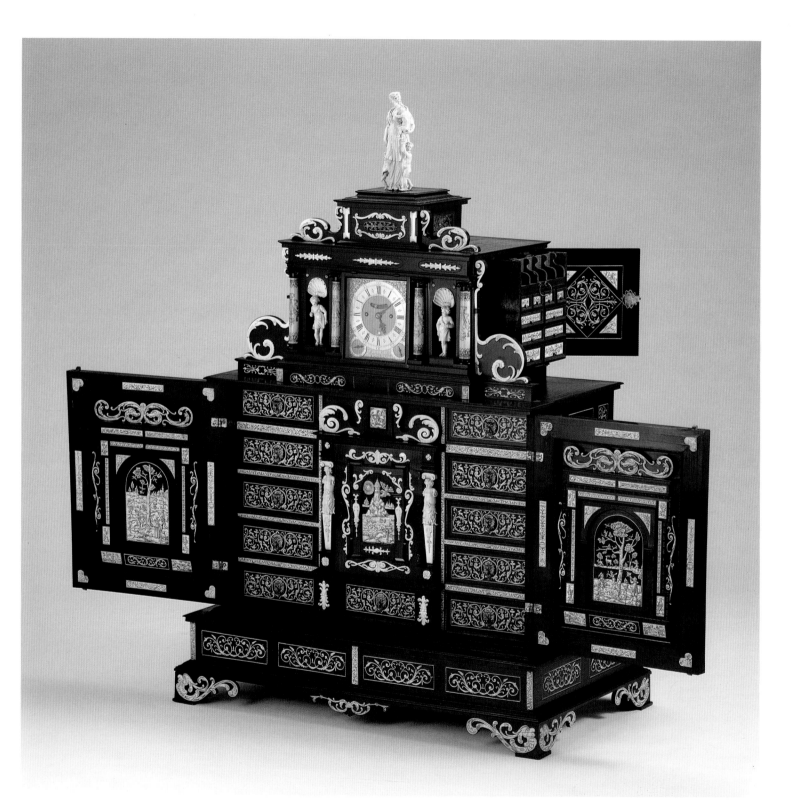

closed doors confronting the public are covered with arabesques, graceful abstractions of tendrils that recall the Moorish patterns found on Spanish *varqueños,* while the private interior centers on the theme of hunting, particularly falconry. On close examination, even the arabesques on the interior have images of hunting dogs chasing birds and rabbits tucked among the trailing foliage. Small ivory panels, locked behind the side door to the left of the clock and fixed across the interior of the main doors, feature hunters holding sporting guns or falcons; surrounding the hunters are various images of prey: boar, deer, foxes, bears, rabbits, and birds. The large, arched scenes inside the doors depict some of the dramatic aspects of bird hunting: falcons striking birds in mid-air, beaters and dogs flushing quail. The sport of hunting with falcons was at the height of fashion in the mid-seventeenth century, when this cabinet was made. King Louis XIII of France, for example, is known to have had no fewer than 140 birds of prey. Numerous treatises appeared on the subject, with such titles as *The Mirror of Falconry* or *Lecture to Falconers.*

Falconry may well have been a pastime of the cabinet's owner. But the theme of flight is extended beyond merely personal associations, into the mythological realm, and so is given a moral dimension. The central panel shows Icarus falling to his death in an attempt to fly to the sun, a story often seen as an allegory of the dangers of excessive ambition. Finally, the Eger panels in the innermost recess show another, more basic aspect of the falconer's role, this time in the context of other professions — cook, farmer, fisherman — whose everyday activities bring food to the table. From the aerial to the mundane, from aristocratic pursuits to ordinary occupations, this final series apparently brings the cycle of activity back to earth — or more simply, celebrates eating, the hunter's reward.

Brilliantly ornamented for display yet containing closely guarded secrets, ostentatiously luxurious yet mechanically practical, this cabinet is fittingly decorated, expressing its importance as well as its many applications.

View of closed cabinet

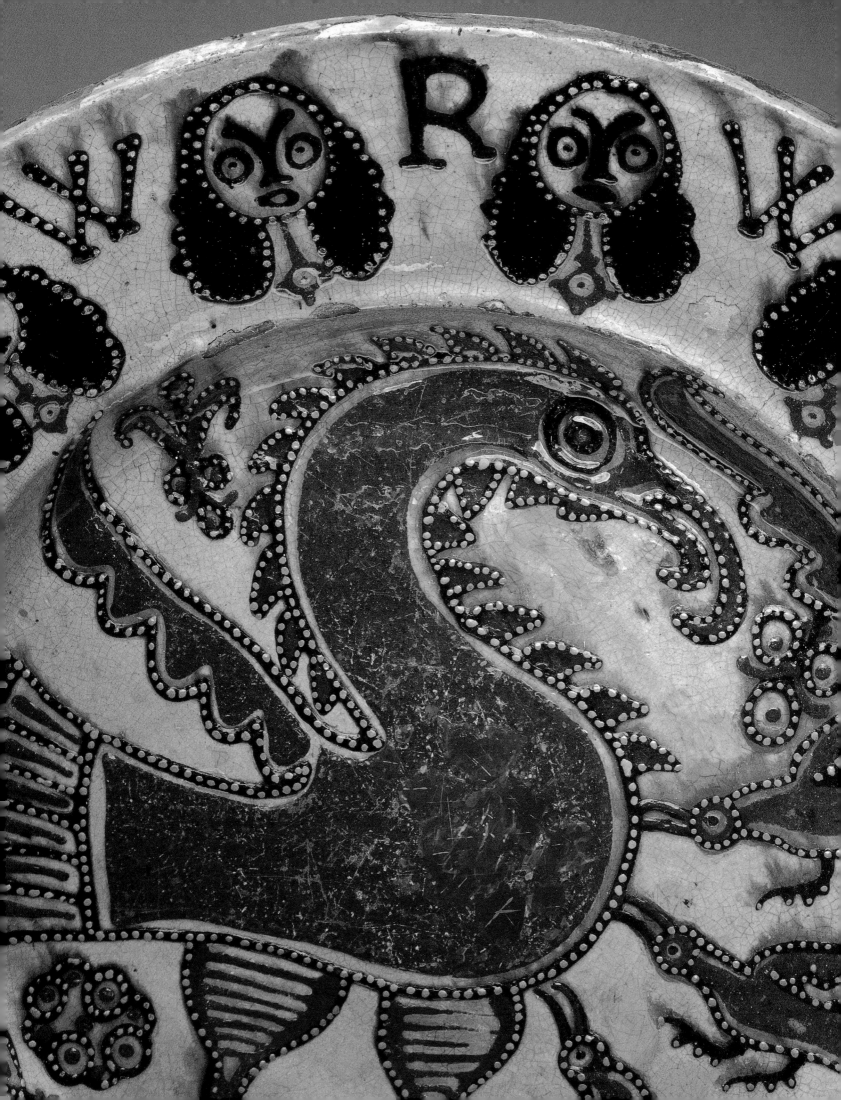

ENGLISH TASTE IN THE SEVENTEENTH CENTURY

The reign of James I of England (1603–25) began in a spirit of confidence and liberality. The king commissioned architect Inigo Jones to create palatial structures such as the Queen's House in Greenwich and the Banqueting Hall in London. These and other luxurious residences of the period were rationally planned and built on a grand scale, yet were often overpowered by intricate decorative patterns. The stone or wood facades of such homes were carved by Flemish and other immigrants who, as late as the 1600s, favored the complex ornamental styles of the Italian Renaissance. A combination of expansive scale and minutely executed decoration was characteristic of Jacobean architecture (after *Jacobus*, Latin for James) and distinguished the decorative arts of the time as well.

An inverted-bell-shaped standing cup (p. 40) is monumental in form, but is supported by a finicky, highly worked stem. Bold designs of sunflowers and roses encircle the cup, their shining, silver-gilt forms set off by a textured background punched into the metal. Stylized roses masquerade as simple decoration, but are in fact the political insignia of the Tudor monarchy. Nationalist symbols such as the English rose or Scottish thistle can be seen in the decorative arts, particularly embroidery, during this volatile age. Standing cups, wine cups, or steeple cups (cups covered with tall, finial-topped lids) were such highly prized household items in seventeenth-century England that they were often mentioned in wills. This cup belonged to an Englishman named Hugh Redyke, of Lincoln, and bears his coat of arms. Usually meant for display rather than for drinking, such silver objects were valued as much for the intrinsic value of their materials as for their craftsmanship.

The cup is, nonetheless, a product of a highly regimented and well-documented trade. From a series of hallmarks stamped into the rim, we can determine that this cup was probably made by Anthony Bates, in London, in 1607 or 1608. These marks were designed to ensure legal metallic content. The famous English sterling standard, set in 1300, called for 92.5 percent silver; the maker's imprint held him accountable for the degree of purity in his product. The mark was registered with a guild, in this case, that of the Worshipful Company of Goldsmiths, which regulated the profession of artisans who worked not just with gold, but with all precious metals. More than a trade union, the guild stipulated an arduous training program, limited the size of workshops, and attended to the religious needs and civic duties of its members.

Besides creating original vessels, goldsmiths were assigned the task of making mounts for the display or enhancement of natural rarities, such as coral or coconuts, or for works of artistry imported from exotic lands. These mounts could be as simple as a stand or frame for the treasured object, which would then be shown by a collector in an exhibit room or in a piece of display furniture such as an Augsburg cabinet (see p. 34). Frequently, the goldsmith's work adapted the object to another use. This is the case with a *kendi,* an Asian drinking vessel that was transformed into a ewer after its importation (p. 38). An eagle-headed spout was fashioned from silver, added to the bulbous mouth of the porcelain jug, and connected by a set of hinged straps to the waist and base of the vessel. A scroll handle links the waist to the lidded cover. These mounts form an armature to protect the fragile vase and to create a solid base that prevents it from tipping over. After Queen Eliz-

Ewer

Silver mounts: c. 1610, English
Vessel: Chinese, Ming Dynasty, Wan Li period (1573–1620)
Hard-paste porcelain with underglaze decoration, silver

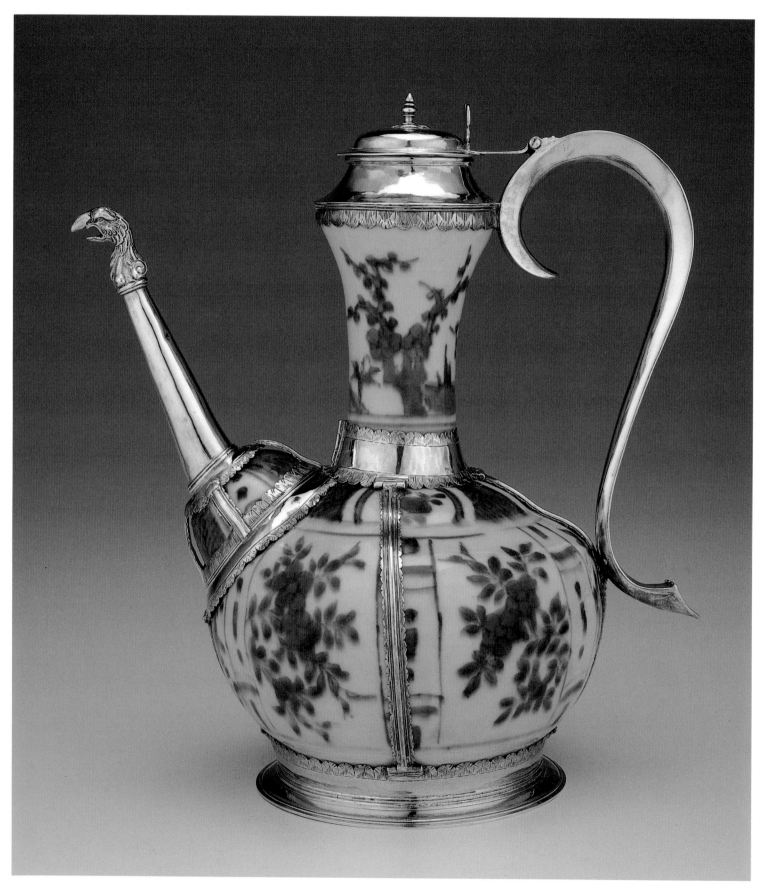

abeth incorporated the East India Company in 1600, porcelains, not yet manufactured in Europe, began to enter England in large numbers. In time, the Chinese tailored them to English taste and needs. But during the reign of Emperor Wan Li (1573–1620), when this *kendi* with under-glaze painting of flowers and plum branches was imported, it was still enough of a novelty to merit special mounting.

The red, white, and black images emblazoning the surface of an earthenware dish of about 1690 (p. 41) convey contemporary political and religious messages through an ancient technique called slipware. A slip is a creamy, watered-down clay, which can be applied to the surface of a vessel in dots and squiggles, like icing on a cake, or used to coat the surface of a vessel and then partially scraped away to reveal the undersurface. The directness and naïveté of this technique is well suited to objects of bold, rustic design. The manufacture of slipware was centered in Staffordshire after 1650, and one of its best known makers was Ralph Simpson, who made a number of versions of a design called "The Pelican in Her Piety." In the center of this dish, a pelican presents its breast to be pecked by her young. The misconception that the pelican feeds its offspring with its own flesh and blood was so common in the period the dish was made that it was used as a dramatic conceit by the playwright William Congreve, when he wrote: "What, wouldst thou have me turn pelican, and feed thee from my own vitals?" (*Love for Love,* 1695). The pelican became a symbol of charity, and, by extension, represented the concept of Christ's self-sacrifice.

Around the border of the dish, the monogram WR, for *William Rex* (King William), alternates with portrait heads of William of Orange. In 1689, this Protestant noble unseated his father-in-law, the Catholic James II, to be crowned William III of England. He jointly ruled with his wife, Mary, until her death in 1694. The tumultuous thirteen years of William's reign saw a lengthy war with France, the strengthening of the authority of Parliament, and a subsiding of the most divisive domestic religious conflicts. Combined with William's royal markings, the image of the pelican assumes a broader meaning, symbolizing a good monarch who seeks the welfare of his people. In the decoration of this simply produced dish was an unmistakable and timely statement about the loyalties of its owner.

Standing Cup

"A.B." (probably Anthony Bates)
1607/1608, English (London)
Silver gilt with repoussé, cast, applied,
and chased decoration

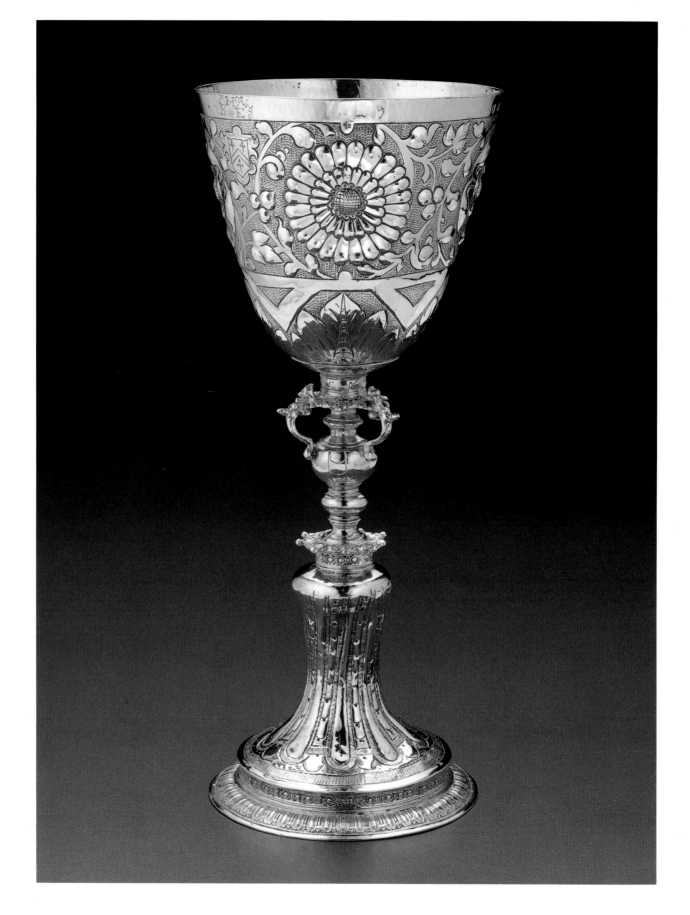

Dish

Probably made by Ralph Simpson
c. 1690, English (Staffordshire)
Lead-glazed earthenware with slip decoration

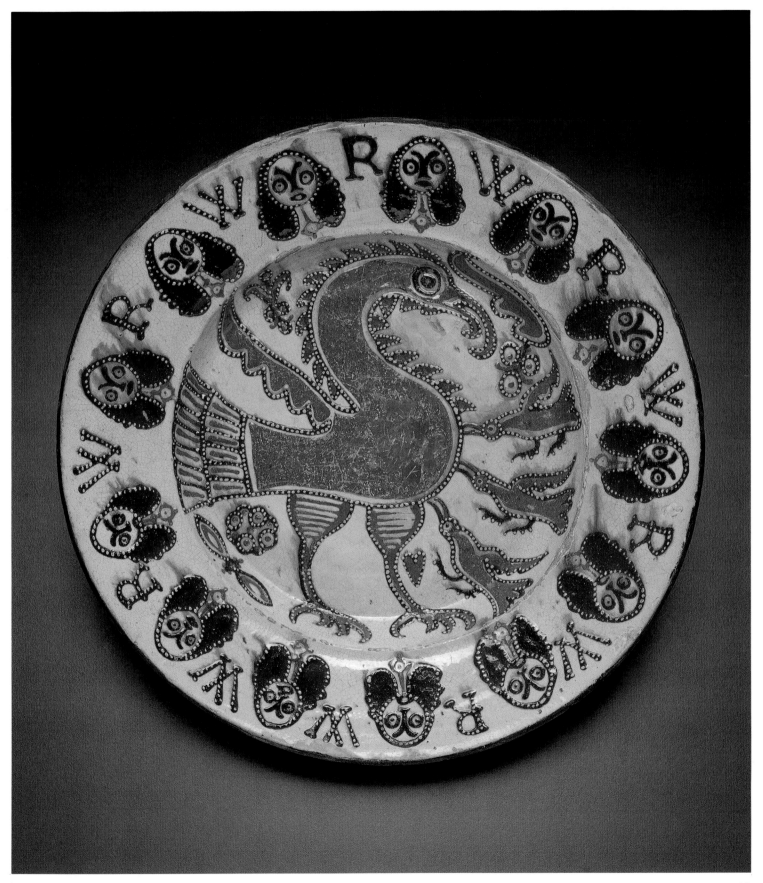

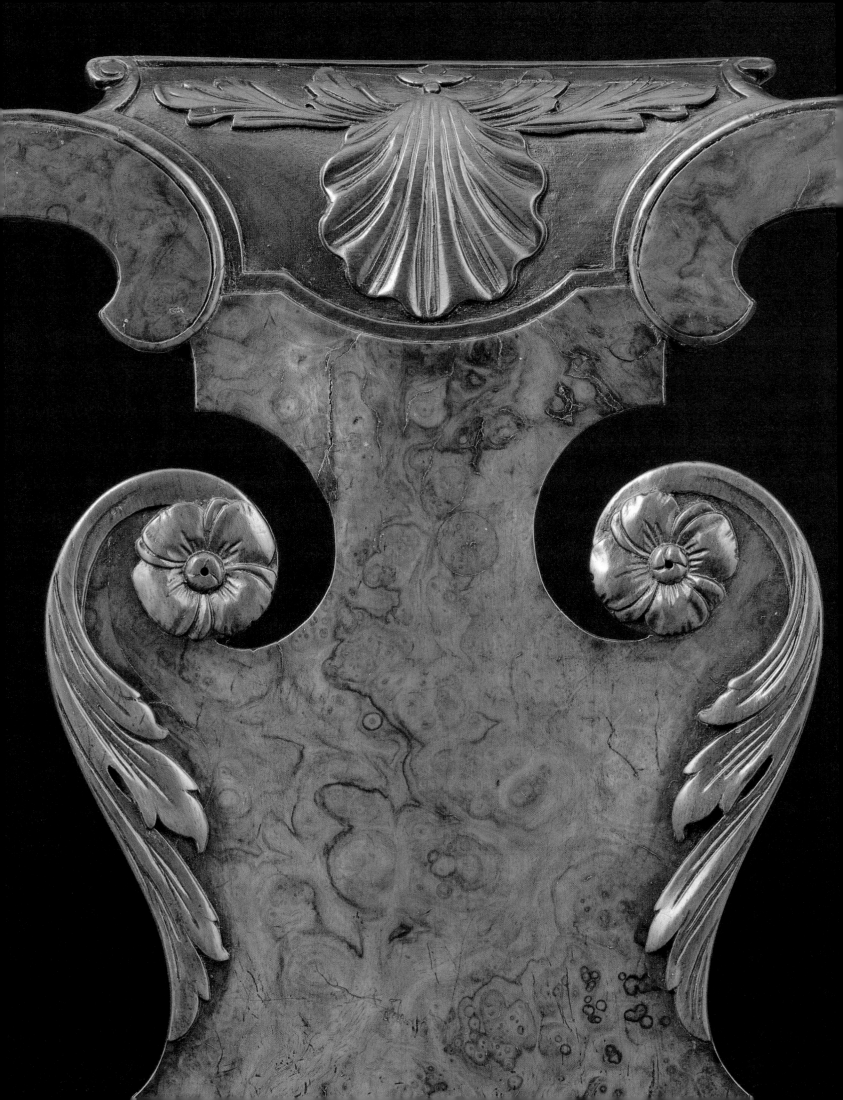

CONTINENTAL INFLUENCE ON ENGLISH FURNITURE

Created in England within a relatively short span of time — from the late seventeenth to the second quarter of the eighteenth century — the examples of furniture in this chapter illustrate how design traditions from abroad affected English taste, while, at the same time, the conservative styles that had prevailed through much of the seventeenth century continued to be a force. Alongside the grander and more showy French Baroque and classically inspired Italianate examples, the existence of relatively austere, more purely English pieces reflects the larger European context of the time, when various styles prevailed concurrently.

A pair of tall-backed side chairs (p. 44) reveal the French Baroque influence of the court of Louis XIV (r. 1643–1715). Their form is a sophisticated improvement over the heavy, turned-and-carved chairs that were traditional in Great Britain through the last half of the seventeenth century. New and modern in this pair were the introduction of curves throughout (softening the straight lines of the frames), the chairs' attenuated backs, and the emphasis on comfort implied in their upholstery. Velvet made in Genoa, Italy, quite possibly like the reproduction fabric now covering them, would have marked these chairs as opulent possessions, since the cost of the textile would have far exceeded that of the chair frames themselves. Another indication of the pair's luxurious nature is its gilding, which stands in dramatic contrast to the black-painted (or "japanned") beechwood frames.

The circuitous route that brought the style of the French court to England began with Louis XIV's revocation in 1685 of the Edict of Nantes, the proclamation that had allowed Protestants to live and worship in Catholic France. The subsequent exodus of Huguenots to Protestant Holland and England included a large number of artisans who brought to their adopted countries French style, forms, and techniques. Principal among these immigrant artists was the Paris-born architect and designer Daniel Marot. Marot worked at the court of the Dutch stadholder, William of Orange, who became William III of England in 1689. At the behest of William, Marot worked in England from 1694 to 1698. The pair of side chairs, and the rest of a larger, related suite of seat furniture now scattered in various collections, bears a close resemblance to designs Marot published in 1702. In Marot's engravings of his designs for the furnishings and textiles in the king's state bedroom, such tall-backed chairs formally line the perimeter of the room, underscoring the importance of state rooms in the public rituals of court life.

Although the Baroque style of the French court made a small but significant impact in England at the turn of the century, a more far-reaching influence, of Italian derivation, took place in the second quarter of the century. Grand, classically inspired building schemes were the passion of the third Earl of Burlington, Richard Boyle, who was the center of a circle that championed an English reinterpretation of the idiom exemplified in the works of the Italian Renaissance architect Andrea Palladio. While many of the Burlingtonians or Palladians, as they came to be known, practiced architecture as enlightened amateurs, architect-designers of stature, figures such as Colin Campbell and William Kent, were in the vanguard of the movement.

A gilded settee (p. 45), one of a pair in the collections that was, no doubt, part of a larger suite of seat furniture meant for a formal Palladian room, utilizes the vocabulary of carved classical decoration

Pair of Side Chairs

1690/1700, English (London)
Painted and gilded beechwood,
modern upholstery

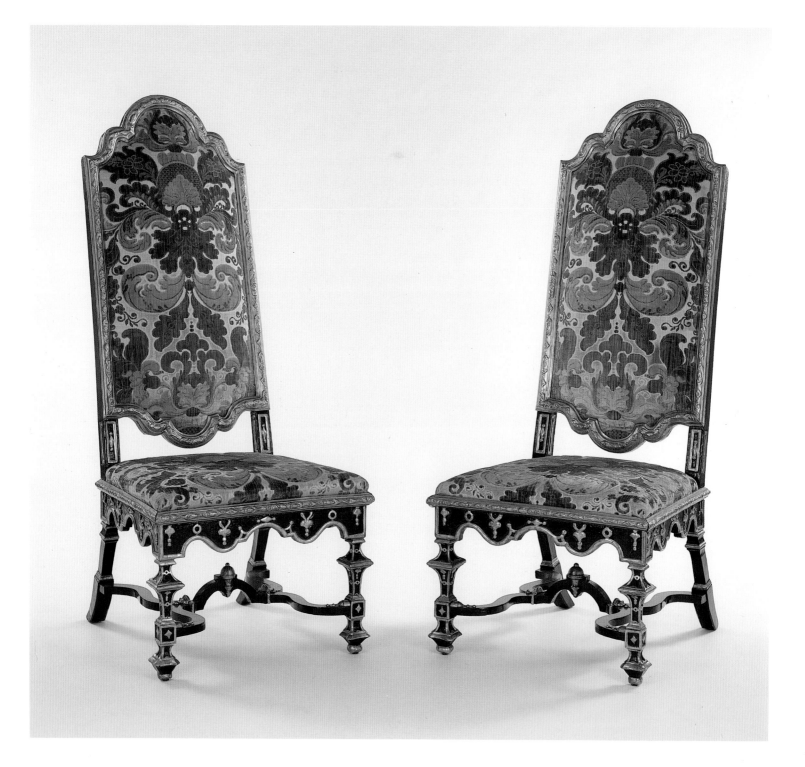

Settee

Possibly designed by William Kent
1725/35, English
Gessoed and gilded beechwood,
modern upholstery

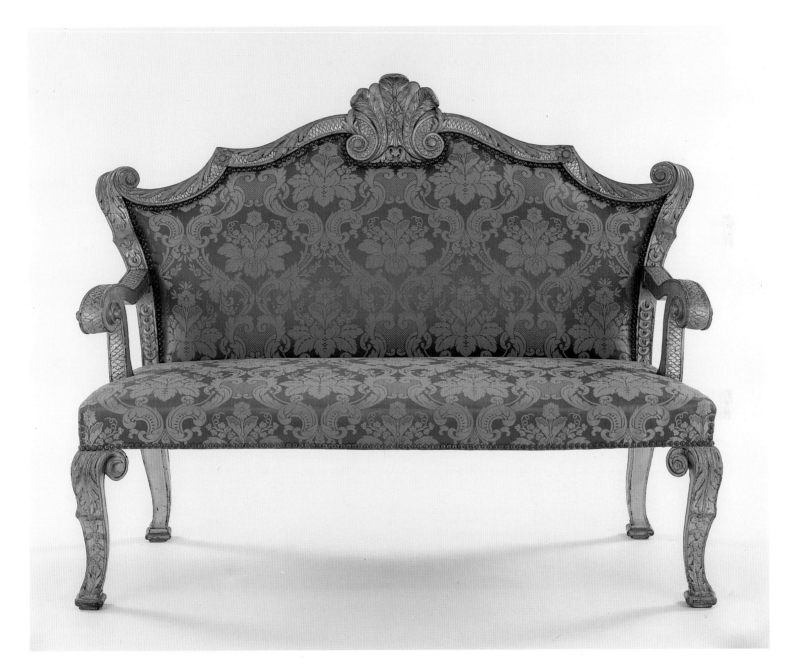

Side Chair

Firm of Giles Grendey
c. 1740, English (London)
Walnut and walnut veneers,
contemporary needlepoint

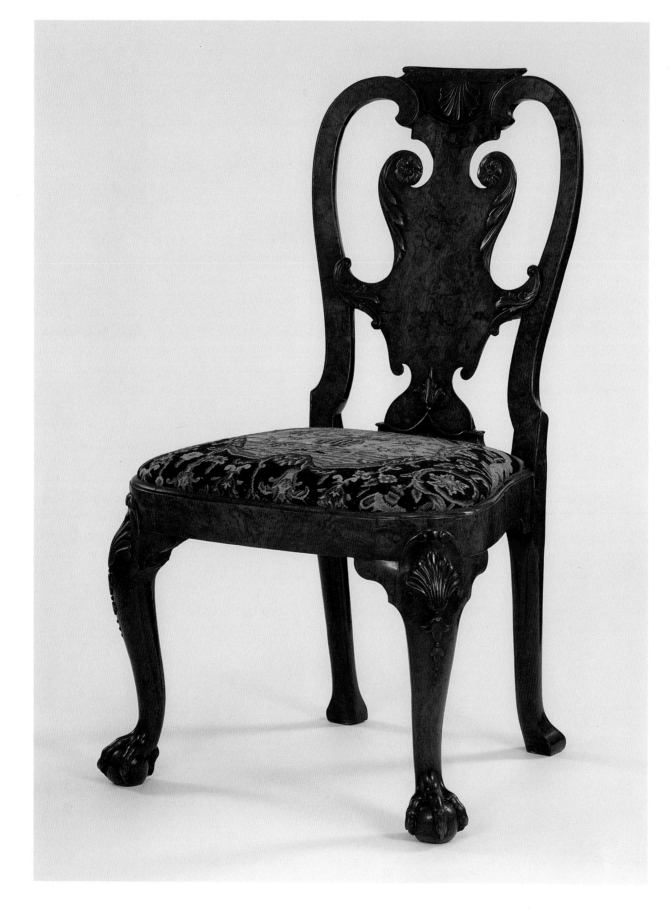

in the manner of designs by William Kent. Kent, who designed everything from buildings and their gardens to interior rooms, furnishings, and objects, was the first Englishman to create entire architectural and decorative schemes. Studies of existing Kent interiors show that the decorative motifs of the furniture were often keyed to motifs in the plasterwork, carvings, or mantel decorations. While the original site of this settee remains to be discovered, one can imagine the splendor of the whole from the richness of this single element.

Although a taste for new and stylish furnishings inspired by continental fashion played a prominent role in the evolution of design in Britain, there remained, in the first half of the century, a predilection for furniture of a less ostentatious sort. The increase of wealth among a broader range of aristocrats, as well as an ever-expanding, affluent middle class, created a time of great expansion in the furniture trade. As cabinetmakers' and guild documents from the period indicate, the refinements and amount of decoration on a piece of furniture were factors of cost — if a client were willing to pay, he could have the most elaborately decorated version of a given design.

On the other hand, the customer's own taste played a role as well, and firms of craftsmen in various media were formed to supply the differing needs of a broad range of clients.

One of the most extensive cabinetmaking firms in London was that operated by Giles Grendey from 1716 to 1766. The Grendey firm boasted not only a large domestic production, but a considerable export trade as well, sending furniture as far as Norway and Spain. The furniture Grendey produced ranged from simple but durable church furniture to stylish, finely carved pieces such as a side chair in the collections (p. 46). The graceful lines of the chair curve continuously, from crest and stiles to the horseshoe-shaped seat and cabriole legs. With its carved shells, pendant bellflowers and acanthus, and its urn-shaped splat, this side chair could have been a handsome part of a number of different rooms, used singly or in multiples to accommodate dining or other daily functions. Grendey's side chair might have been made for the home of a London merchant or physician, or for the private rooms of the grandest aristocratic country house.

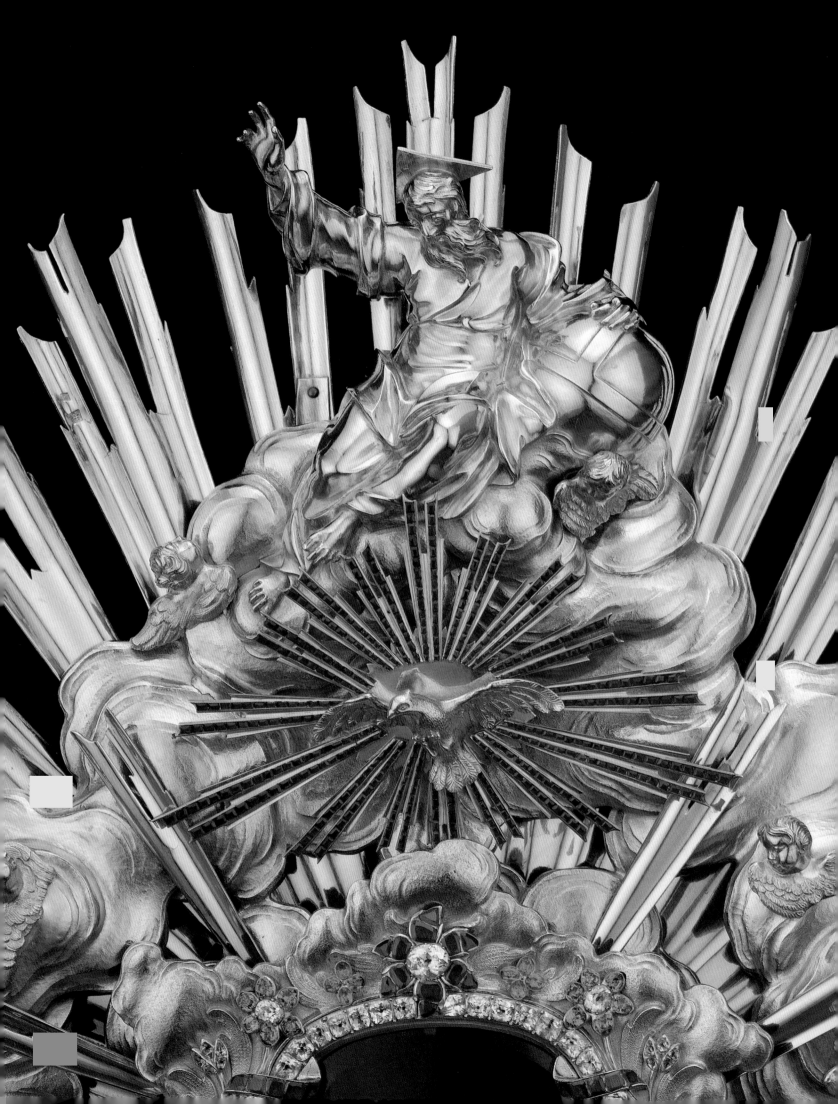

IMAGES OF FAITH
IN THE BAVARIAN ROCOCO

Devotional images made in Bavaria and Austria during the Rococo period command their audience like players on a stage. Like actors, painted and carved figures of saints adopt lively, rhetorical poses calculated to provoke emotional responses. These images usually take their places in carefully arranged environments, participating in a unity of sculpture, decorative arts, painting, and architecture known as *Gesammtkunstwerk,* which can create an intoxicating, fervently religious experience. The light, swirling forms of the Rococo style were highly fashionable in Germany during the second half of the eighteenth century and were manifest in the religious art of the time. Another major influence on devotional art had taken root two hundred years earlier, with the struggle between the Roman Catholic church and Protestant reformers, notably Martin Luther. Protestants, in varying degrees, rejected as unscriptural the representation of saints and of biblical subjects, which had long been employed by the Catholic church to instruct its faithful. Nevertheless, visual expressions of Catholic piety not only endured, but became increasingly exalted and sensuous, as the church used the arts to appeal to people in tangible and joyous forms. Walking through a light-filled, eighteenth-century Bavarian church, one is personally swept into the spiritual drama.

As might be expected in a time with such a dynamic and holistic approach to the arts, the decorative arts were intensely sculptural as well as theatrical. The period's greatest modeler of porcelain figurines, the Swiss Franz Anton Bustelli, is best known for his series of Italian Comedy actors, which he supervised in production at the Nymphenburg porcelain factory near Munich from 1755 until his death in 1766. His religious figures, such as the Mourning Madonna (p. 52), originally grouped with Saint John the Evangelist and Christ Crucified, seem to be played by tragedians. Mary, grieving, clasps her hands awkwardly and throws back her head to stare at her dying son. If the gestures seem histrionic by today's standards, the emotions are no less real, and suited to the mood of an operatic age. Flowing robes mirror her inner turmoil, fluttering off as in a wind. Bustelli's figures were often enlivened by touches of brilliant color, but here the pure, white porcelain lends a sober, almost ghostly quality to the figure; from the rear, the razor-sharp pleats of her gown create an abstract pattern like frozen rivulets of water. Bustelli's powerful compositions rival in miniature the life-size wooden images carved by such sculptors as his teacher Ignaz Gunther.

Another artist influenced by contemporary sculpture was the German sculptor and ivory carver Peter Hencke, who was the pupil of Paul Egell; Hencke's figure of Saint John of Nepomuk (p. 53) illustrates the similar concerns and style that link him to his teacher. Dense and difficult to master, ivory yielded only to precise and expert carving. In the hands of a sculptor like Hencke, technical difficulties seem to disappear: a gently swaying posture animates the figure, and textures of fur, lace, and hair are rendered with extraordinary mimetic facility. At the same time, the sculpture captures the ecstatic character of the saint, who adores a crucifix (now missing) in his right hand. The saint stamps on a hideous, snake-covered crone, representing heresy, while an innocent youth seeks his protection.

The subject of this ivory, John of Nepomuk, was a Bohemian vicar who was tortured by Emperor Wenceslaus IV and murdered by drowning in the Moldau river at Prague in 1393. As confessor to Princess Joan, wife of the emperor, John defended

the sacraments and the principle of ecclesiastical immunity by refusing to reveal to the jealous Wenceslaus the contents of his wife's confession. Following John's canonization in 1729, numerous images of him appeared throughout the Holy Roman Empire, but particularly in Bohemia, where he became the principal patron saint. This small statuette may have been the object of private devotion. It is supported by a carved, gilt-wood socle, a fantasy of curving volutes and leaves that is an archetypal expression of Rococo architectural form. The socle indicates the kind of architecture that once surrounded the statuette, as it probably was designed to match a decor, or even fit into a particular niche in a room.

Unity of the arts, the principle that so strongly marks Rococo art in southern Germanic lands, is keenly expressed in a silver-gilt monstrance made by Joseph Moser in Vienna (p. 51). Representations of God the Father, angels, cherubim, and the Holy Spirit float in heavenly clouds irradiated by streams of light; sparkling garnets and almandines surround a crystal chamber. The chamber was used to display a sanctified host during special eucharistic vigils, when the monstrance was placed behind or near the church altar. Its stem, depicting smoke that billows from a burning, sacrificial pyre, dissolves into the heavenly clouds. At the base, a vignette of an altar on flagstones is partially covered by a rich cloth; a bowl and knife, sheaves of wheat, and bunches of grapes composed of seed pearls are strewn about. All of these elements coalesce to create a seamless, dazzling *coup de théatre*. Ultimately, the composition depends on Gianlorenzo Bernini's *Cathedra Petri* (finished in 1666), the colossal sculptural and architectural vision that rewards pilgrims to Saint Peter's Basilica, Rome. The goldsmith Moser has translated this monumental auriole into a smaller, but in its own right no less effective, glory.

Moser enriched the monstrance in a way that transcends its glittering materials, imbuing it with layers of symbolism. The grapes and wheat produce wine and bread — the eucharistic signs of Christ's sacrifice, which is remembered in the Mass. The funeral pyre and knife allude to the Old Testament sacrifice by Abraham of a ram in place of his son Isaac; smoke from the pyre becomes the glory of heaven. On a deeper level, the imagery on the monstrance dramatically declares the belief that the Old Testament is redeemed by the New, as the sacrifice of a lamb prefigures that of Christ, "the bread of life," who was ritually embodied and celebrated in a host at the center of the dazzling frame.

Monstrance

Joseph Moser
1762, Austrian (Vienna)
Silver gilt with semiprecious stones, seed pearls

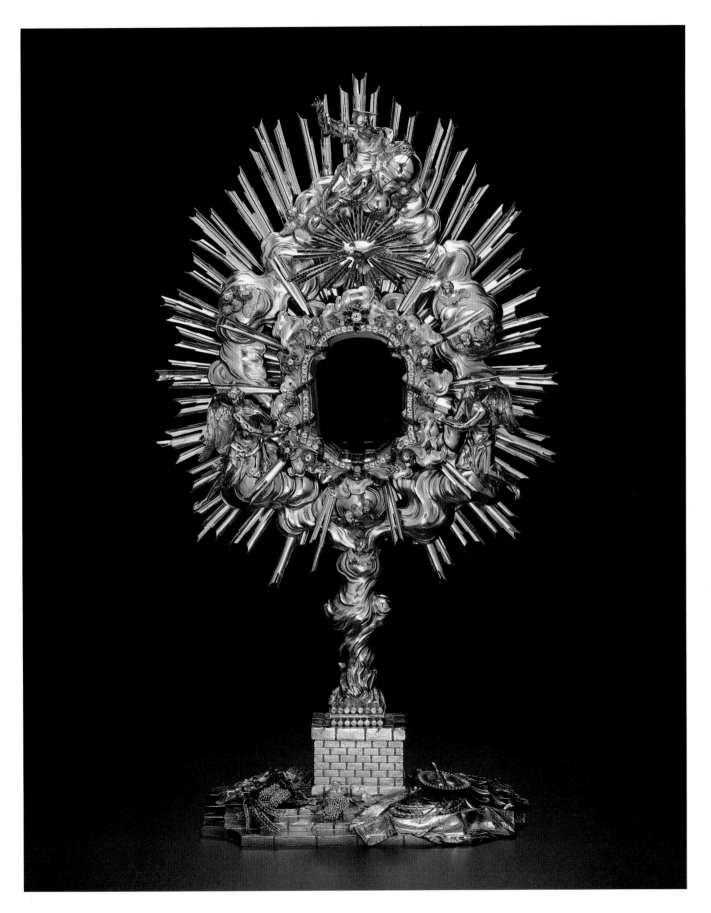

The Mourning Madonna

Modeled by Franz Anton Bustelli (Swiss)
1756/58, German (Nymphenburg)
Hard-paste porcelain

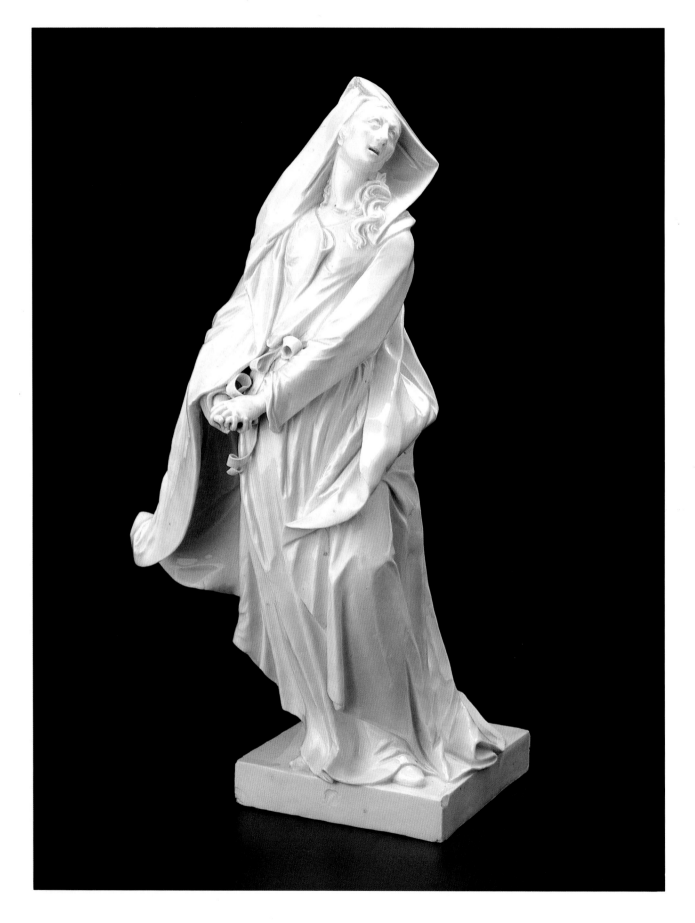

Saint John of Nepomuk

Peter Hencke
c. 1750, German
Ivory, gilt-wood socle

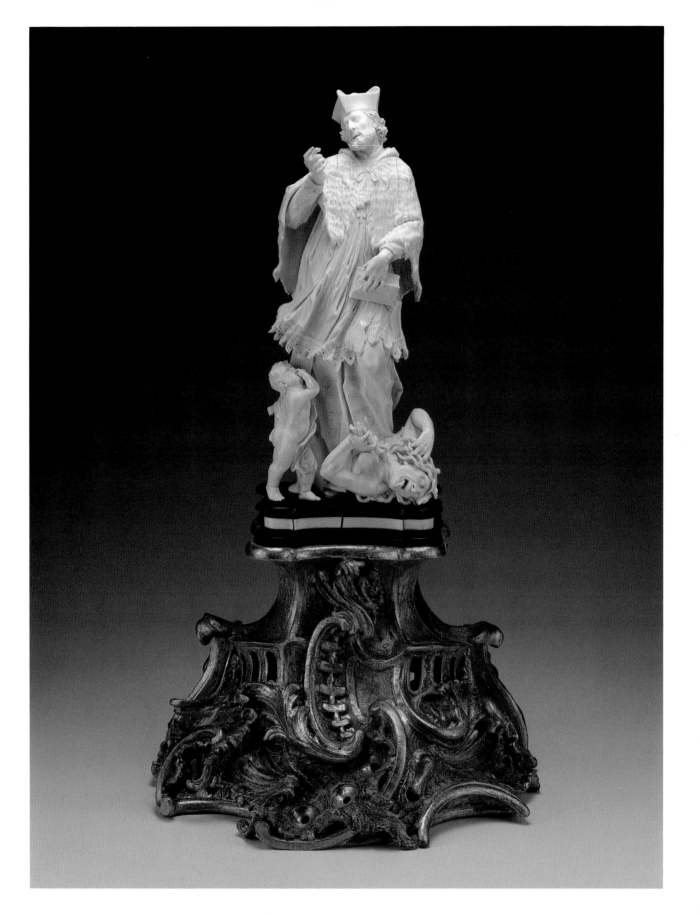

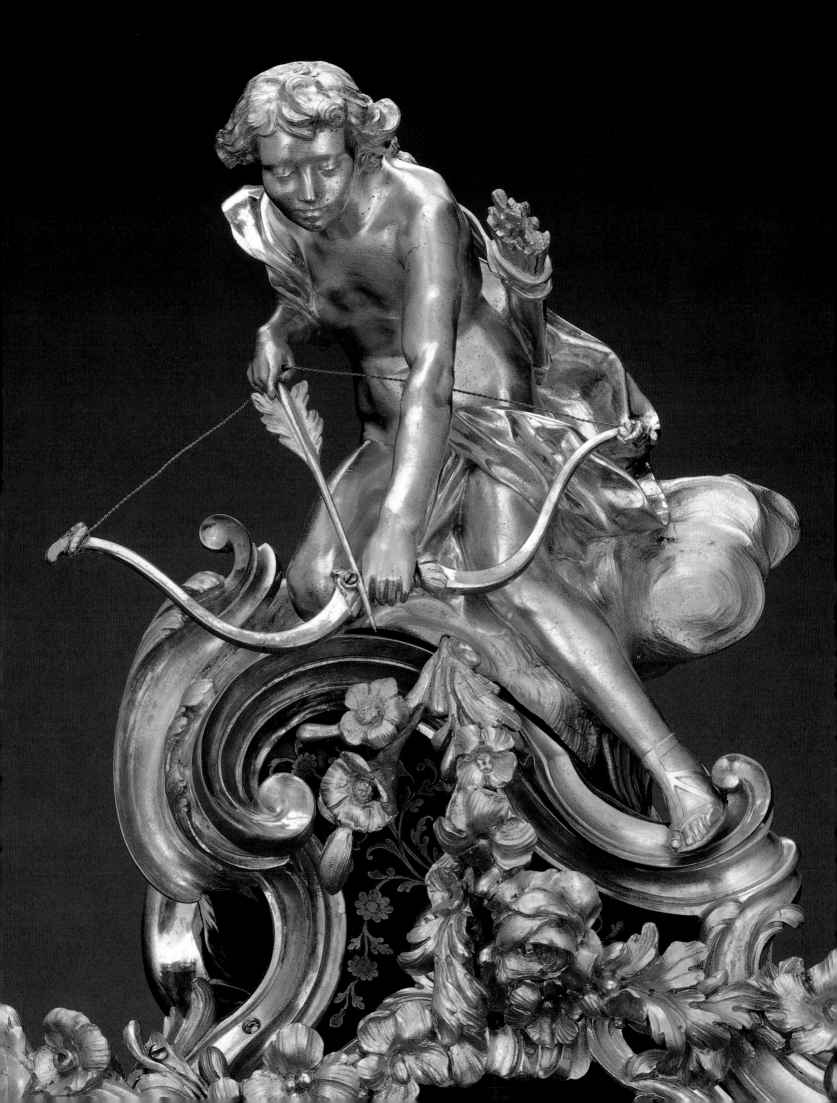

THE MARRIAGE OF ART AND TIME:
A FRENCH WALL CLOCK

Among the most complicated and costly objects produced for fashionable eighteenth-century interiors were sculptural, French clocks, most often the collaborations of numerous specialized branches of artisanry. In the manufacture of luxury timepieces, horology, the science of making clock movements, was wedded to the arts of cabinetmaking, bronze casting and chiseling, gilding, and other crafts. The most elaborate results of these collective labors did more than simply tell the time: they delighted the ear with music and dazzled the eye with dramatic episodes intended to provoke a heightened awareness of time passing. Shortly after the mid-seventeenth century, the accuracy of timekeeping had been greatly improved through advances developed in England and Holland, specifically, the adoption of the pendulum and the invention of the balance spring. Timepieces became central to the smooth running of court life and the complex daily affairs of both bureaucracy and society. Initially, the new clocks were homely instruments housed in boxlike cases. But as they became an ever greater focus of attention, especially in France, clock movements began to be housed in stylish cases that were designed to complement interior architectural decoration.

By the time of Louis XV (majority reign 1723–74), when the wall clock presented here (p. 57) was made, the spirit of the age called for an asymmetrical interplay of curves and countercurves that would appear to lighten an object's mass. Decorative elements were drawn from nature — leaves, flowers, rocks, shells, and water — and reassembled in a seemingly spontaneous, often fantastic manner. This aesthetic sensibility defines the Rococo, a word derived from *rocailles,* which originally referred to the elaborate, fantasy rock grottoes in the royal gardens at Versailles. An outstanding example of Rococo style, this wall clock is one of the most exuberant and lavish objects of its kind.

The clock's case, candelabra, and wall bracket are the work of one of the premier cabinetmakers in the era of Louis XV, the German-born Jean Pierre Latz, who emigrated from Cologne to Paris in 1719. By 1741, Latz had merited the honor of being appointed *ébéniste,* or furnituremaker, to the king. While he produced chests, corner cabinets, and other pieces of furniture requiring marquetry surfaces and gilt-bronze mounts, Latz was best known for the beauty of his clock cases. He also achieved notoriety in his day by surreptitiously modeling and casting his own gilt-bronze mounts, in defiance of Parisian guild regulations, which required *ébénistes* to limit themselves to the craft of furniture, while members of the guild of bronze founders produced the mounts. Latz defied the rules more than once, and inventory records of his shop confirm the presence of numerous bronze elements for use in clock cases. In this example, Latz's considerable talents as a cabinetmaker took a secondary role to his skills as a modeler-sculptor, illicit though they were.

A signature on the dial tells us that the movement of this eight-day clock was manufactured in the Flemish city of Ghent by Francis Bayley. Bayley may have been part of an extensive family of English clock- and watchmakers that for over two centuries worked in the environs of London. The Flemish connection to the London Bayleys could be explained by the regular traffic of artisans across the Channel between England and the Low Countries. The clock's movement not only measures hours and minutes, but, as revealed by the uppermost of three dials, also plays music. Six tunes are listed in the arch, some in inaccurate French. The other dials

allow both the striking mechanism and the selected tune to be turned off. Of the six melodies played by the clock, four are dances, while two must have been popular songs. One of them, *Dragons pour Boire,* suggests a pun, relating to the mythical creature depicted under the clock case and also to the members of the French mounted infantry, or *dragons,* perhaps a reference to the status of the clock's owner.

Latz created a witty allegorical scheme in which the case and the wall bracket on which it sits expand upon the function of the timepiece. The scene is that of Apollo, god of music and rationality, about to slay the serpent Python. The space between the clock and the wall bracket is cleverly used to suggest the cave of Mount Parnassus where the beast lived. The presence of another god, centrally placed near the bottom of the triangular base of the bracket, helps provide a key to the allegory. In the attention expended on this small mask — depicting a vigorous, majestic, and laurel-wreathed countenance — one sees more than merely commonplace decoration. The face is that of Zeus, father of Apollo and chief of the pantheon, god of the heavens and the upper reaches of earth. Born at midnight, Zeus is the deity most closely associated with concepts of time. Above Zeus, a smaller mask, of Hera, completes the hier-

archy. The sister of Zeus and ultimately his spouse, Hera is the goddess of marriage and a divinity of childbirth.

The presence of Hera and of two small coats of arms that rise above her, supported by lions, reveal another aspect of the allegory, as well as the purpose behind the work's creation. The armorials belonged to a Flemish couple — one each for husband and wife — whose marriage the wall clock was probably created to celebrate. They reflect the union of a woman of the family Le Clercq d'Olmen, Barons Poederlé of Brabant, with a man of the van den Meersche family. Given the Flemish citizenship of bride and groom, it is no accident that the clock commemorating their wedding incorporates a Flemish musical movement that plays dances and songs.

Along with this festive gift came an auspicious triumvirate of deities whose favors include time, song, marriage, and offspring, all boding well for the newly married couple. At the same time, when glimpsed in the stillness of a dimly lit salon as the minutes ticked by, with the flickering of its own candles revealing its shadowy details, the clock as easily could have conveyed a message of the evanescence of life.

Wall Clock

Jean Pierre Latz
1735/40, French (Paris)
Oak veneered with tortoiseshell and kingwood, brass inlay,
gilt bronze, glass; musical movement

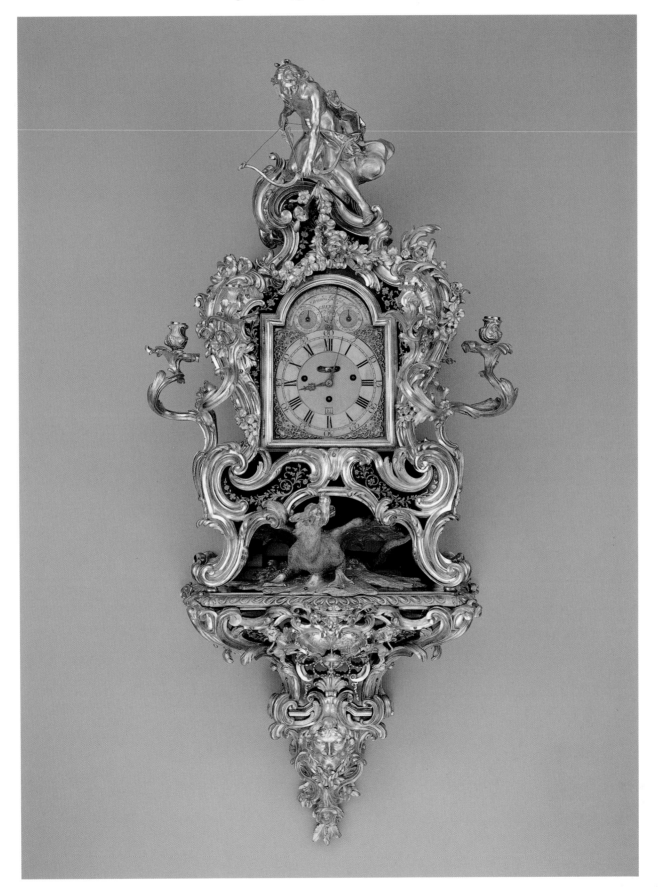

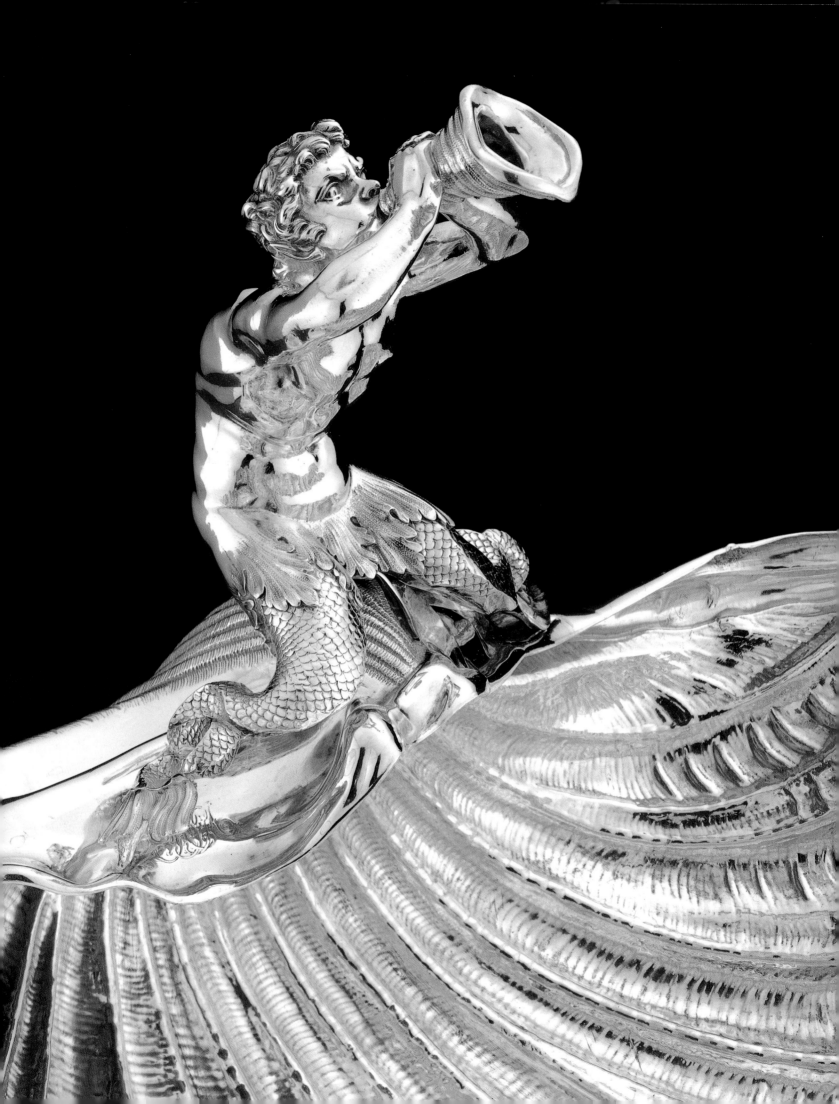

THE ENGLISH GOLDSMITHS' TRADITION

Objects of gold and silver, desirable for their intrinsic value as well as for their beauty or usefulness, have always been popular means of maintaining wealth. Plate can be easily melted down in periods of need and converted into currency — the metals' potential for liquidity being as literal as it is figurative. In prosperous, eighteenth-century England, the clientele of London goldsmiths grew beyond royalty and aristocracy to include merchants, gentry, and institutions that not only wanted the security of owning precious metal, but also sought to commemorate notable events or to validate their positions in society through the conspicuous display of their wealth. Prestigious objects were custom-made to suit the client. As the demands upon goldsmiths increased, they altered their traditional practices. Some goldsmiths continued to work individually or with a partner, but many developed large firms that employed associates, journeymen, apprentices, and laborers. Some firms began to specialize in a single kind of object, such as spoons, or to supply such elements as spouts or finials for larger works.

In 1685, an event in France had far-reaching consequences for English goldsmith work. That year, Louis XIV revoked the Edict of Nantes, which protected the rights of French Protestants, or Huguenots. Among the Huguenot artisans who fled for Britain and the Low Countries was a group of goldsmiths who settled in London, bringing with them a fresh vocabulary of design, different techniques, and new forms. Not surprisingly, their arrival provoked a good deal of antipathy from their native colleagues. But by the 1720s, the virtuosity of a second generation of Huguenot goldsmiths, who were more assimilated into their adopted culture, began to raise the standards of craftsmanship throughout the British guild system.

One of the most inspired of the second generation was Paul de Lamerie, who in 1716 was named goldsmith to the king. His early work is simple and severe, in the tradition of late Baroque classicism. However, by the 1730s, his silver showed the influence of the romanticized, asymmetrical designs of Juste Aurèle Meissonier, the principal promulgator of the French Rococo style, whose engravings were available in England soon after their publication in 1734. De Lamerie's facility with the imaginative new style is seen at its peak in the so-called Tredegar Cup (p. 60), named for an early owner. The intense realism of natural elements on the cup — festoons of daisies, petunias, and roses — easily accommodates the fanciful conceit of the panther-hatted, grimacing satyrs, their beards entwined with grape vines. De Lamerie's mastery of design and execution, here and in numerous other examples, explains his reputation as the most important goldsmith of the eighteenth century.

Presentation pieces such as the Tredegar Cup form an important category of objects in the history of goldsmithing. Their utility is chiefly symbolic, expressing gratitude or commemorating events. Goldsmiths Richard Gurney and Thomas Cooke II maintained their London shop on Foster Lane "at the sign of the Golden Cup." Perhaps when an agent of the Society of Merchant Adventurers of Bristol was seeking a goldsmith's firm in order to commission a presentation gift, the shop's sign caught his eye. For whatever reason, Gurney and Cooke were chosen to produce a solid gold, covered cup (p. 61) in honor of Sir John Lockhart-Ross, captain of His Majesty's ship *Tartar,* who in 1756 and 1757 captured a number of French mercenary vessels hired to prey on Britain's merchant fleet. Archives indicate that the Bristol merchants offered the gold cup, worth 100 pounds, "for his great vigilance in taking so many French privateers." The cup is inscribed "The Gift of the City of Bristol to Captn Lockhart of

The Tredegar Cup

Paul de Lamerie
1739/40, English (London)
Silver

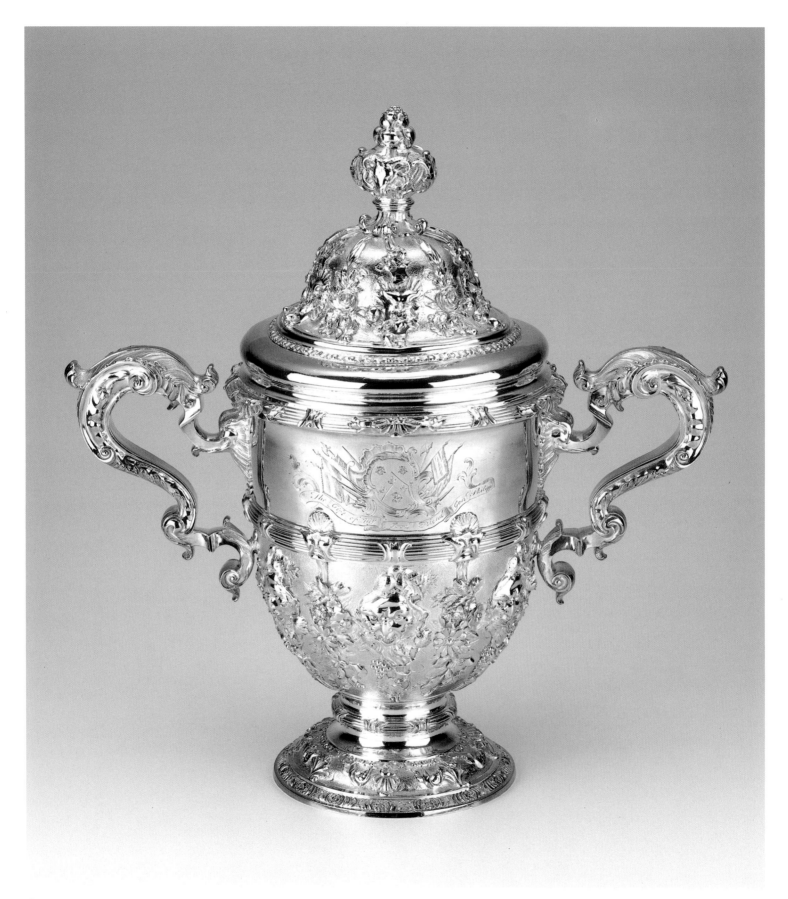

The Lockhart Cup

Richard Gurney and Thomas Cooke II
1757/58, English (London)
Gold

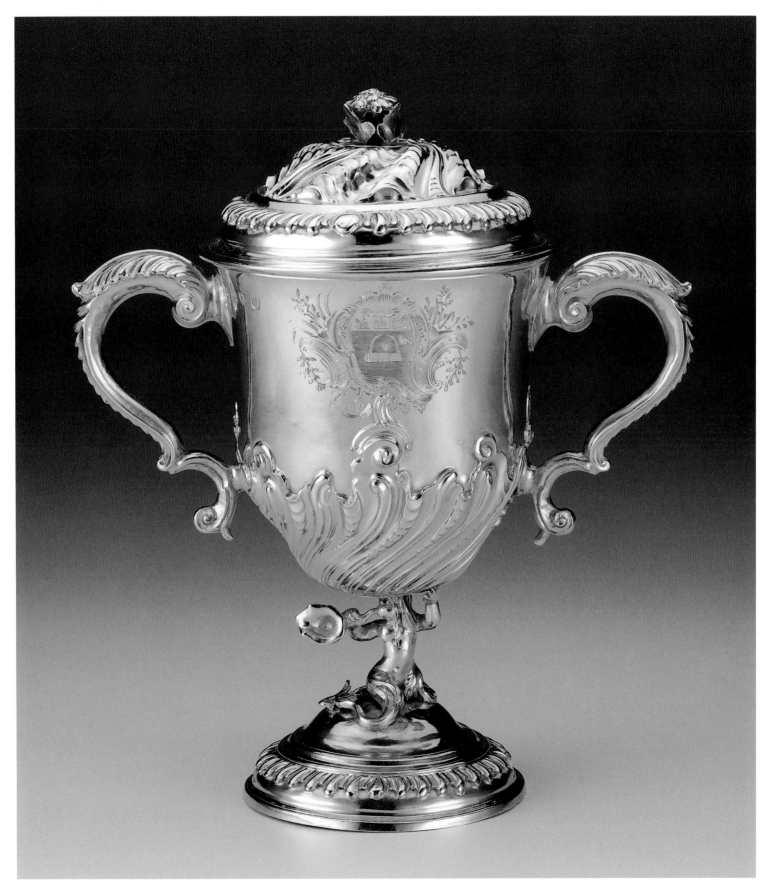

Tureen

John Bridge
1823/24, English (London)
Silver

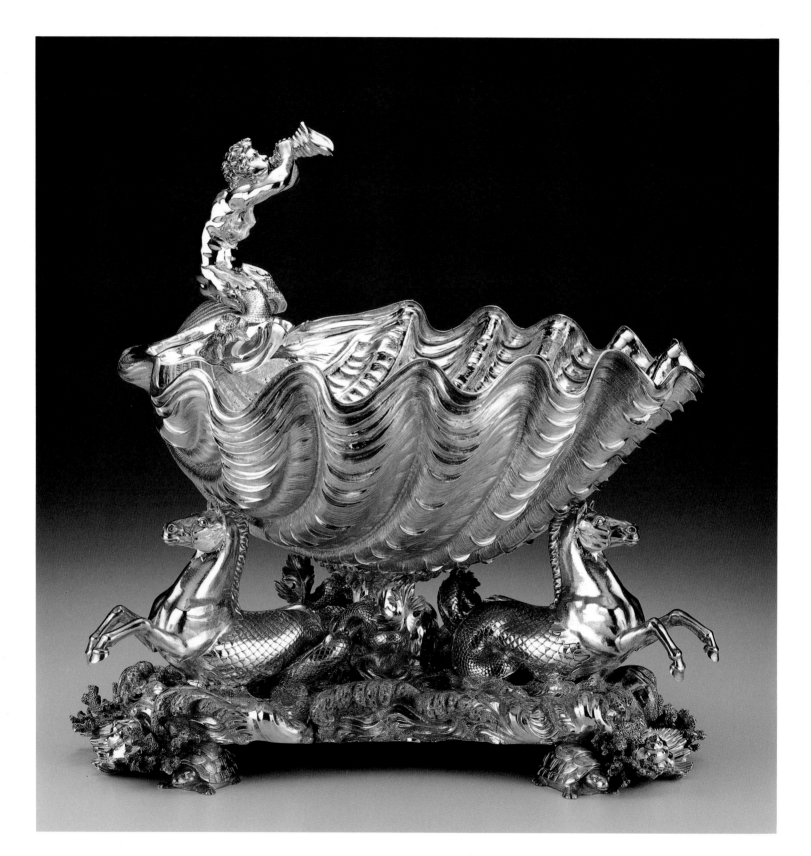

ye Tartar, 1758," and is engraved on one side with the arms of the Society and on the other with those of its heroic recipient.

That the Rococo was still in fashion twenty years after de Lamerie's Tredegar Cup is evident in the light, spiraling waves of embossing and the shell-like cover of the Lockhart Cup. Triton, son and trumpeter of Poseidon, sits blowing his conch-shell horn, supporting the cup. A rare example of the vessels entirely wrought in gold in its century, this diminutive object is proof that the material was reserved for the most important of memorials, and that, while the craftsmen who worked with all precious metals were known as goldsmiths, its costliness rarely allowed them to use it in large scale.

In 1823 or 1824, more than eight decades after the fashioning of the Tredegar Cup and six after that of the Lockhart Cup, a tureen in the Rococo spirit (p. 62) was produced in London by John Bridge, a partner in the firm of Rundell, Bridge and Rundell. The half century prior to the tureen's creation had been devoted to Neoclassicism, the restrained style that had superceded the Rococo. The revival of interest in the Rococo, and in French decorative arts of the previous century in general, was in large part due to the tastes of King George IV (r. 1820–30), whose appetite for the style was whetted by his acquisitions of royal objects being sold in post-Revolutionary France. The king had a penchant for silver and, for many years, had commissioned pieces to be used on state occasions with the silver already in the royal collection. He was not only the most illustrious client of Rundell, Bridge and Rundell, but its most acquisitive, as well.

The tureen, intentionally massive to suit the taste of the age, takes the shape of a giant clam shell surmounted by Triton; it is held aloft by hippocampi, mythical fish-tailed horses, which rear above the coral-filled sea; the whole composition is supported by turtles at the base. Within three years, Bridge's firm supplied the king with a matching group of four tureens, nearly identical to this example, but gilded and covered. While the design for all five tureens was provided by Britain's premier sculptor, John Flaxman, their inspiration was undoubtedly a centerpiece made in 1741 for Frederick, Prince of Wales, already part of the royal collection. The eighteenth-century centerpiece, acknowledged as one of England's most important contributions to Rococo silver, was probably wrought by Nicholas Sprimont; but it is most indebted to the designs of Juste Aurèle Meissonier. Thus, the spirit of Meissonier echoed nearly a century later in the five Bridge tureens. It must have been the king's intention to use the four matching pieces in conjunction with the earlier centerpiece as part of his grand service. It is tempting to speculate that the earlier version, illustrated here, in some way served in working out this ambitious royal commission.

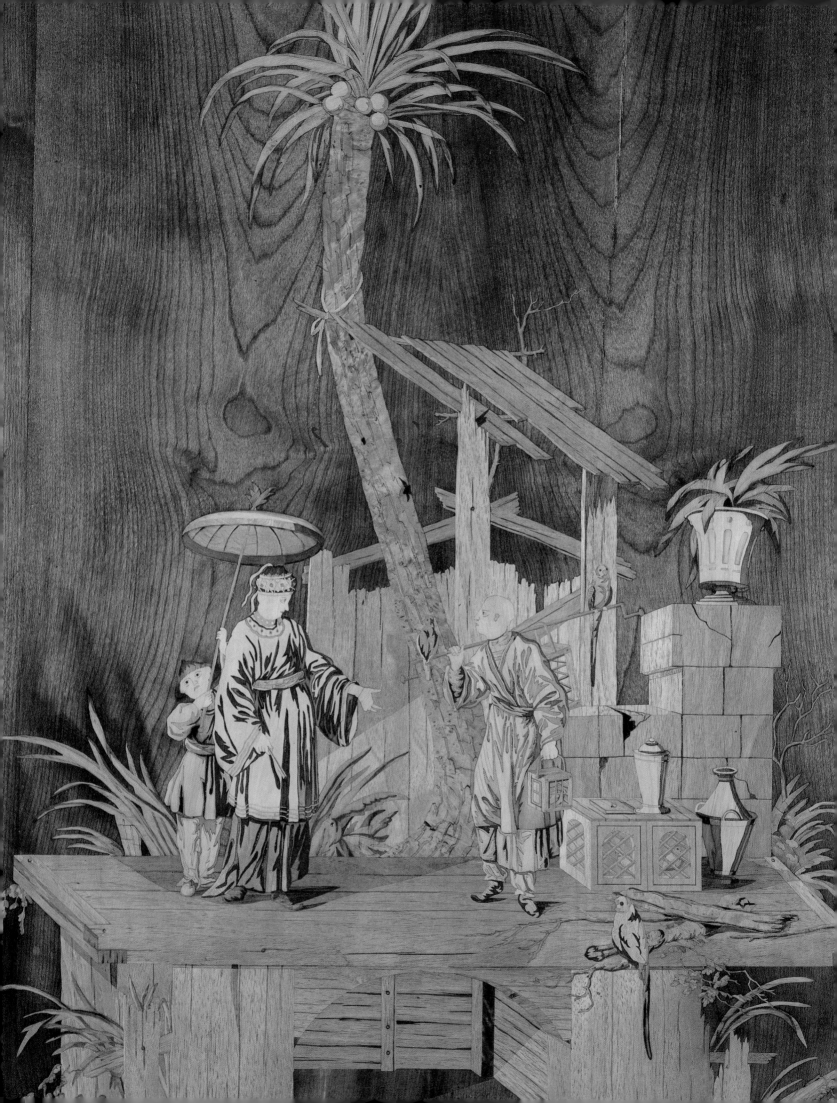

CHINOISERIE

The decorative arts have always charted sudden, short-lived phenomena, as well as profound and enduring trends. One of longest-lasting European obsessions was that for *le goût chinois,* or the taste for the art and imagery of China—a vague geographical designation that was understood to comprise much of the Far and Near East. This infatuation with the Orient became widespread after the formation of the English East India Company in 1600 and the competing Dutch East India Company in 1602. The unprecedented quantities of oriental goods imported by these enterprises had an enormous impact on European decorative arts. Chinese porcelain, a fine, white, transluscent material that Western technology had not yet perfected, so intrigued European consumers that potteries rushed to approximate the substance and copy its decorative patterns. Tea imported from China and India inspired a new afternoon ritual and sparked a demand for pots and cups to hold the beverage. By the eighteenth century, the production of chinoiserie had grown from instances of specific imitation into a diffuse, westernized style that varied from one country to another and was adapted to virtually all types of objects and all media.

First aroused by the accounts of Marco Polo's thirteenth-century voyage to China, the Italian vogue for chinoiserie was later reinforced by the Venetian Republic's extensive trade with the East. By the eighteenth century, Venetians were so infatuated with the Orient that they sailed Chinese junks in regattas and flocked to the premiere of Carlo Gozzi's chinoiserie play, *Turnadot.* Palaces on the Grand Canal had interiors painted in the Chinese manner. For instance, the Ca'Rezzonico, now a municipal museum of decorative arts, was lavishly decorated by the Rezzonico family after their purchase of the

palace in 1750. In addition to commissioning the painter Giovanni Battista Tiepolo to create frescoes for ceilings, the new owners followed contemporary fashion by decorating at least one room with orientalized motifs. A door from the palace (p. 69) depicts two scenes that provide glimpses into the imaginative perception of the broad and colorful East. In the upper panel of the door, the gallant encounter of a noble couple takes place before a palm tree; in the lower panel, a pipe-smoking potentate is being served tea. Both scenes are framed by bright sprays of flowers connected with flowing ribbons. The smooth, many-layered surface of the lemon-yellow door was achieved through lacquering, a technique borrowed from China but used here with an oil-based mixture rather than the resin-based one employed by Chinese craftsmen.

The most famous example of the adoption of Chinese customs is the English habituation to tea drinking, which continues to the present day. In the eighteenth century, another popular beverage in England was punch, which was made by adding imported spices to hot wine. Punch was often served in wide-mouthed bowls, but oversized teapots maintained its warmth longer and were also popular. A punch pot made in Staffordshire (p. 66) consists of a wheel-thrown body to which a spout and handle in the form of crab-apple branches have been added. The white stoneware of which it is made was produced by Staffordshire potters who were trying to refine earthenware in an attempt to rival Chinese porcelain. The surface of stoneware is harder and often glassier than that of earthenware, the result of flinty clay being fired at very high temperatures. After the punch pot was shaped and placed in the kiln for firing, salt was thrown into the fire, causing sodium to disperse and combine with elements in the

Punch Pot

1755/65
English (Staffordshire)
Salt-glazed stoneware with enameling

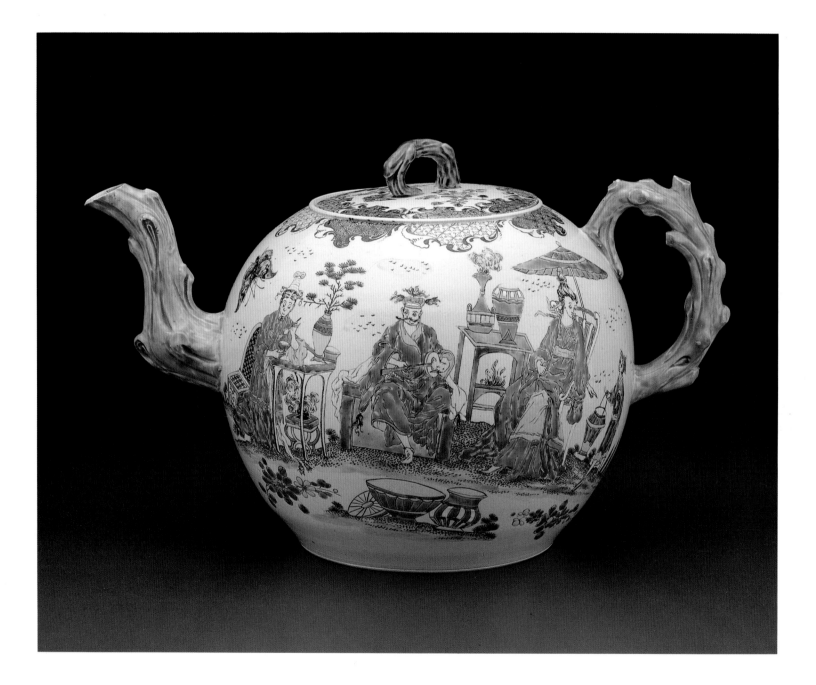

clay to form a glaze. The painted decoration was applied later, followed by another firing to fix the enamels. In scenes on the punch pot's sides, Chinese courtiers are shown luxuriating in a garden. These images were probably adapted from engravings of work by influential French designers such as Jean Baptiste Pillement, who specialized in blending Chinese motifs with Rococo ornament.

Chinoiserie decoration was also applied in wooden inlay to fine German furniture. Abraham and David Roentgen operated a father-and-son firm of cabinetmakers in the city of Neuwied, on the Rhine. The Roentgens supplied furniture to courts and great families throughout Germany, but many of their early pieces were conceived for English tastes. The designs of Thomas Chippendale, whose book *Gentleman and Cabinet-Makers Director* (1754, 1755, and 1762) helped to create fashion in English furniture, often featured Chinese Rococo motifs, such as pagoda crestings and fretwork.

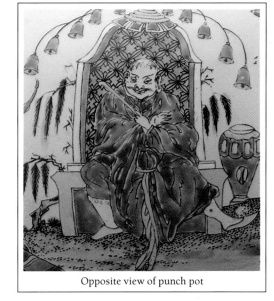

Opposite view of punch pot

Around 1775, David Roentgen adapted the design of an earlier Chippendale desk and bookcase, changing the the top to a broken scrolled pediment that was more compatible with the German Rococo style.

The walnut surface of Roentgen's secretary desk (p. 68) is covered with wood inlays, or marquetry, which conjure Chinese gentlemen standing upon edifices that look like dilapidated stage-sets. The depiction of these half-ruined structures became an occasion for the marquetry cutter to display his virtuosity. Details of birds and trees add to the brilliant, light-handed decoration and lend a convincing touch of reality to the scene.

Reality, however, had little to do with the intoxicating appeal of chinoiserie decoration. Chinoiserie teased the European imagination with scenes of an exotic culture far beyond the horizon, promising a carefree existence in a never-never land few could actually visit or know.

Secretary Desk

David Roentgen
c. 1775, German (Neuwied)
Walnut and other woods, bronze mounts

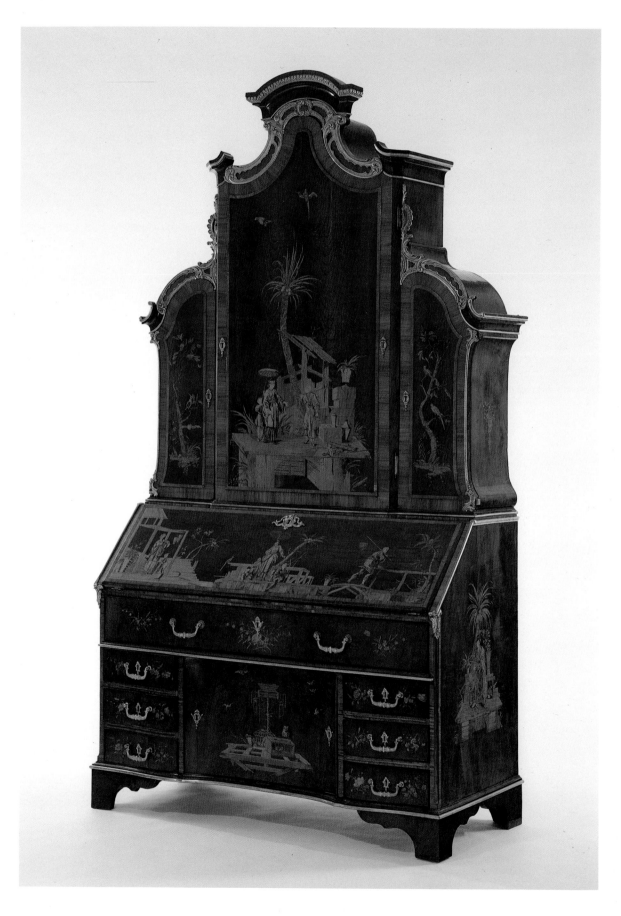

Door from the Ca'Rezzonico

c. 1750, Italian (Venice)
Lacquered and gilded wood

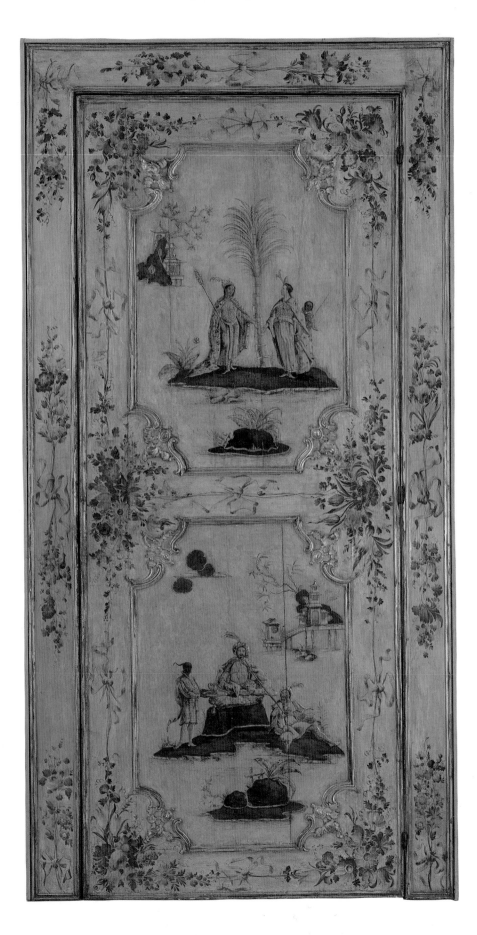

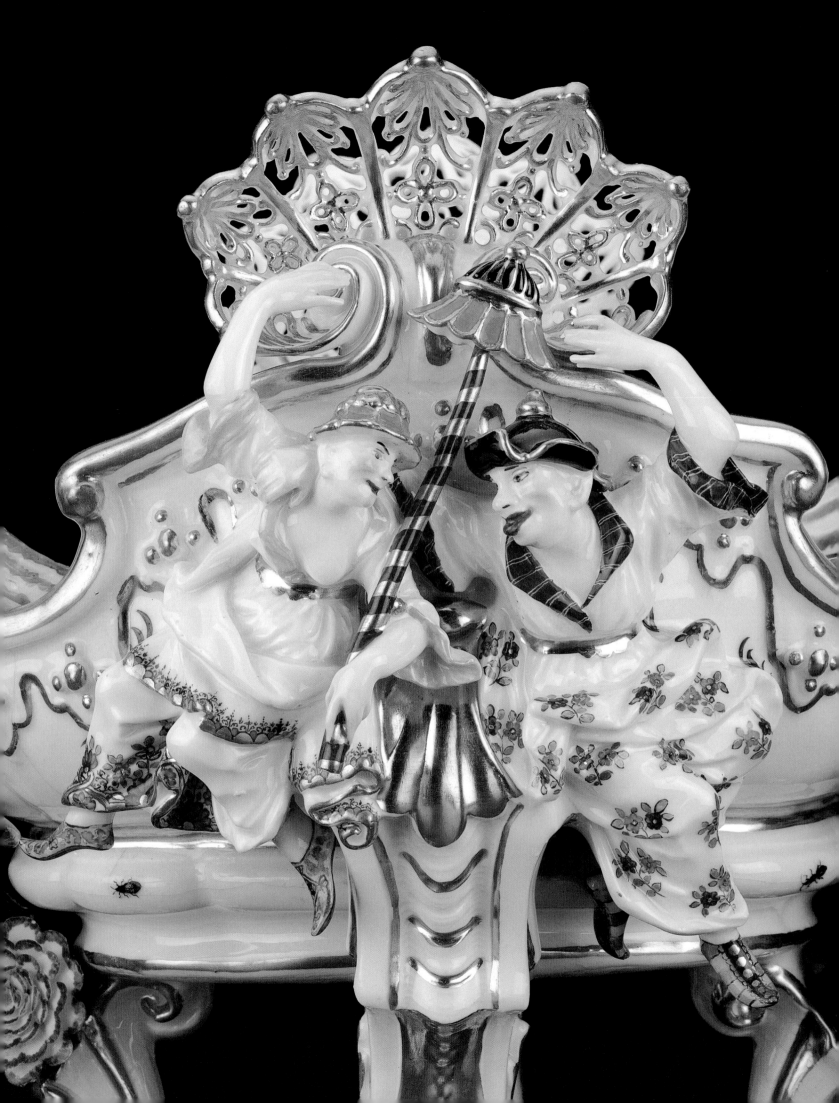

MEISSEN PORCELAINS FOR BANQUETING

Court banquets, long a feature of royal life, by the eighteenth century had become ceremonial events replete with pomp and theatricality and governed by rigid protocol. As early as the Renaissance, court sculptors had worked with confectioners to design dramatic table decorations made of spun sugar or wax. In the eighteenth century, these ephemeral creations were supplanted by figures made of porcelain. Porcelains, along with glass and silver, also graced tables in the form of elaborate dinner services. Contemporary sketches and accounts describe these artfully contrived table settings, as well as the specific placement of centerpieces, candelabra, platters, tureens with stands, plates of varying sizes, sauce boats, wine glasses, utensils, and even such extravagant touches as damask-linen napkins folded in intricate patterns.

The banqueters devoured their way through courses that included fish, fowl, game and meats, soup, stews, savoury pies, vegetables, and salads. Serving as the *finale* was the dessert, intended to be the most spectacular course of the evening. Astonishing assortments of fresh and preserved fruits, jellies, creams, large and small cakes, pastries, nuts, and various other sweetmeats were displayed on the dessert table amidst porcelain figures and centerpieces that were carefully chosen to evoke a mood and theme for the banquet.

Heinrich, Count von Brühl, in his dual role as administrator of the Royal Saxon Porcelain Manufactory at Meissen and Prime Minister to Frederick Augustus III (r. 1733–63), Elector of Saxony and King of Poland, had both occasion and means to stage banquets that were memorable in their extravagance. Writing after a banquet hosted by Count von Brühl in 1739, Sir Charles Hanbury-Williams, the British Minister in Dresden, recalled the moment when "the Des[s]ert was set on I thought it was the most wonderful thing I ever beheld. I fancyd

myself either in a Garden or at an Opera. But I could not imagine that I was at dinner."

The manufacture of porcelains that could help to sustain such pleasant illusions had begun to evolve in Dresden a generation earlier, when two men employed by the court of Augustus the Strong (father of Frederick Augustus III) worked to re-create the formula for hard-paste porcelain, which the Chinese had achieved by the late T'ang dynasty (618–906). The experiments of Ehrenfried Walther von Tchirnhaus and Johann Friedrich Böttger resulted in a fine red stoneware in 1708. Shortly after his collaborator's death, Böttger revealed that he had succeeded in making true porcelain. By 1710, Augustus the Strong had established the porcelain factory in the Albrectsburg palace in nearby Meissen. Eventually relocated, the Meissen factory continues to produce to this day. Under the Saxon monarch's patronage until his death in 1733, the factory turned out an extensive range of porcelains for both useful and decorative purposes.

Count von Brühl was appointed to oversee the factory after Frederick Augustus III ascended the throne. Under the von Brühl administration, and with the brilliantly sculpted models of Johann Joachim Kändler, the factory rose to even greater heights and dominated porcelain production in Europe until mid-century. By 1738, when von Brühl became prime minister, he had been given the perquisite of being able to place special orders at the factory for his personal use "without financial commitment or obligation." Consequently, Count von Brühl, the advisor to a king more interested in opera and hunting than in porcelain, was not only Meissen's director but its biggest client.

Manufactured in 1737 for Countess von Brühl, a magnificent table centerpiece (p. 73), incorporating a lemon basket and sugar caster, is remarkable for its large size and luxurious decoration. The com-

plete centerpiece, designed and modeled by Kändler, consisted of a large, flat plateau, made in sections and fitted together, supporting a tall, four-legged, open basket decorated with fanciful roosters and pairs of Chinese figures. Lemons, a novelty in eighteenth-century Germany, were artfully stacked within this gilded container. At either end of the plateau were sugar casters in the form of Chinese figures embracing under a canopy. Additional elements of the original ensemble assumed amusing shapes: a pair of vinegar and oil cruets took the form of roosters with Chinese riders; a pair of spice jars masqueraded as Chinese women astride mussel-shaped containers; and another pair of spice jars resembled double mussel shells, laid back to back. The idea of such a centerpiece with accouterments was present in early eighteenth-century silver pieces by Johann Melchior Dinglinger. What is extraordinary about the porcelain version is Kändler's imaginative chinoiserie decoration. The asymmetry and spirit of this ornamentation, with its gesturing and leering Chinese couples, add a note of Rococo playfulness that enlivens the Baroque sobriety of the massive form.

The same liveliness and fantasy pervade the

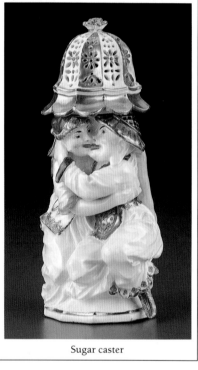

Sugar caster

group of twenty-one figures from the original Meissen "Monkey Band" (*Affenkapelle*). The idea for this group grew out of the taste for *singerie,* the fashion of depicting monkeys engaged in human activities. Dating to ancient times, this theme was reintroduced late in the seventeenth century by the French designer Jean Bérain and reached its zenith during the Rococo period with the published engravings of Christophe Huet. Early versions of the Meissen grouping were begun by Kändler in about 1747, and Madame de Pompadour, mistress of Louis XV, is known to have bought a set of nineteen on Christmas eve, 1753. Nearly fifteen years later, for reasons that are not entirely known, Kändler and his assistant Peter Reinicke reworked the molds and issued new versions, from which the fifteen figures in the Art Institute have come (pp. 74–75).

Porcelains for the banquet table were but one portion of the magnificence that characterized the Saxon court at Dresden. The fanciful figures and objects from the porcelain factory at Meissen introduced elements of wit and drama into one of the more festive rituals of court life, creating their own form of theater on an intimate scale.

Centerpiece and Stand

Modeled by Johann Joachim Kändler
1737, German (Meissen)
Hard-paste porcelain with enameling and gilding,
chased and engraved gilt-bronze mounts

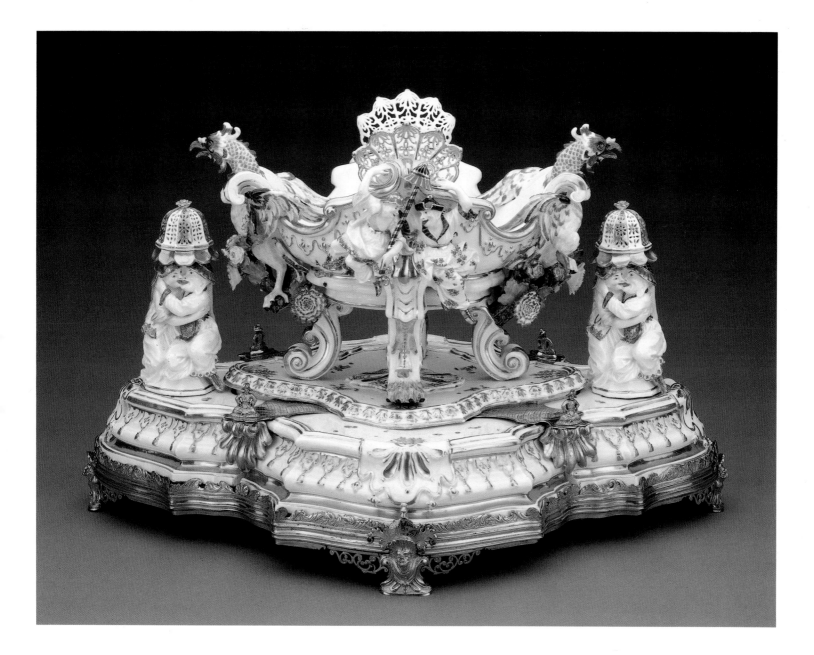

"Monkey Band"

Modeled by Johann Joachim Kändler and Peter Reinicke
1765/66, German (Meissen)
Hard-paste porcelain with enameling and gilding

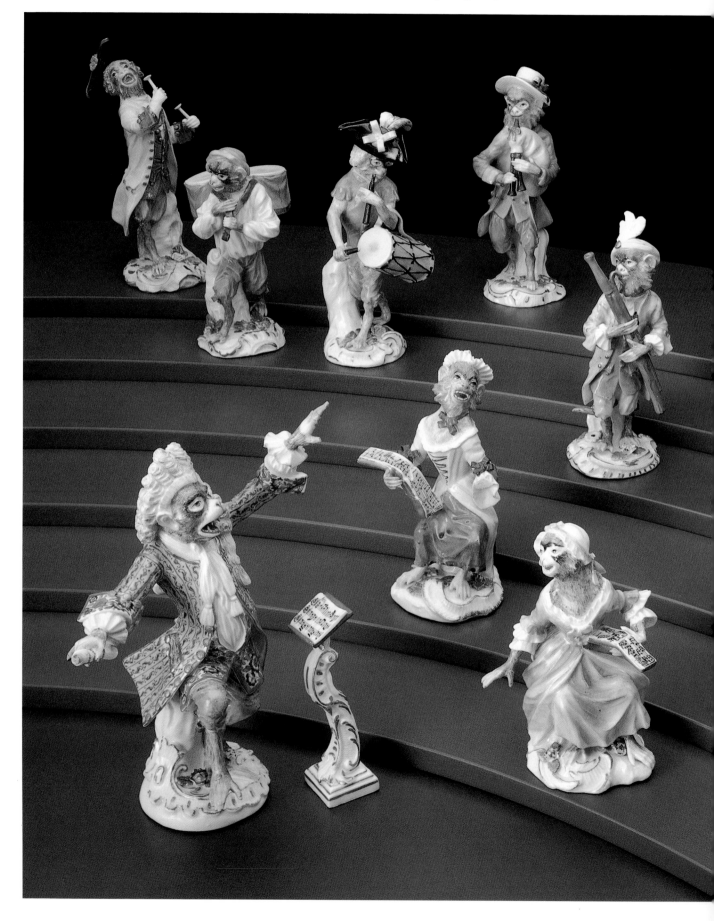

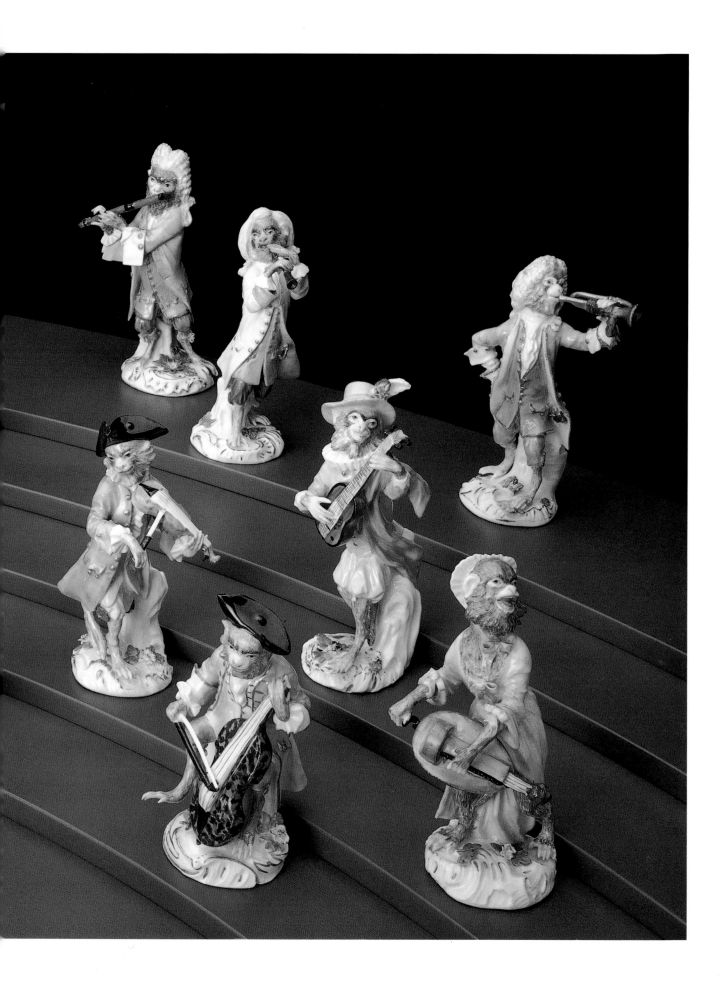

"BIZARRE AND FANTASTICAL" CERAMICS

The "elephant candelabrum" vase (p. 79), produced by the Manufacture Nationale de Sèvres, appealed to a clientele that valued refinement, caprice, and informality. French culture and society had changed considerably since the era of the Sun King, Louis XIV (r. 1643–1715), in whose court at Versailles grandiose schemes of architecture and decoration had served to convey a sense of formality and majesty, in order to exalt the monarch and, thus, France. In the years following the death of Louis, political and social changes in France, and throughout Europe, eventually altered patterns of living. Privacy, intimacy, and a less rigid decorum replaced the public displays of old. Along with these values came an appreciation for works in smaller scale that demonstrated qualities of refinement, novelty, and imagination. A new decorative style, which in later years came to be called Rococo, soon embraced all these ideals.

For the discerning eye, works in the Rococo style offered a number of cultivated qualities: asymmetry was usually emphasized; motifs were often extracted from nature but integrated in inventive and allusive ways; the mass and volume of objects were given a plastic, sculptural emphasis to suggest both lightness and flowing movement; and a light, lucid palette was employed in decorating objects and interiors. All media were affected as artists and craftsmen throughout Europe responded to the expressive potential of the Rococo. Porcelain was especially suitable to the demands of the new taste, as its properties of malleability and whiteness allowed it to assume a nearly boundless number of shapes and be painted in a great variety of colors and patterns. "As far as porcelain, above all, is concerned," wrote Hendrick van Hulst, painter at the porcelain factory at Vincennes, in 1751, "the most bizarre and fantas-

tical designs will often triumph over the most elegant and well thought out. If one eschews [both] the heavy and the trivial, and offers what is light, fine, novel and varied, success is assured."

Van Hulst's appraisal of contemporary taste is perfectly applicable to the masterful "elephant candelabrum" vase. The vase's form is attributed to sculptor Jean Claude Duplessis, designer of shapes at Sèvres, who probably took his cue from an earlier Chinese vase that incorporated the conceit of back-to-back elephant heads. Between 1756 and 1770, versions of the model were produced by Sèvres in three different sizes (the vase pictured here is the largest size), each edition almost always differently decorated. Displayed in sets of two or three on mantel shelves or commodes, with or without candles in the elephants' trunks and flowers in the vases, these exuberant forms would magnify the sensory effects of interior ensembles that included carved wood paneling, furniture decorated with parquetry and gilt bronze, patterned silk fabrics, and glimmering ormolu or silver accessories. The bizarre presence of elephants is rendered appealing by the undecorated surfaces of soft-paste porcelain, which, both luminous and tactile, seem to invite touch. Through brilliant artifice, the spiraling rose and gilt arches, twisting pendant flowers, and torquing white reserves dematerialize the bulging mass of the vase's baluster shape.

The ewer and basin (p. 81) made at the royal porcelain factory at Capodimonte, Naples, is another compelling group, and has strong affinities with the Sèvres vase. Its white, soft-paste porcelain surfaces — some of the most beautiful ever fashioned — conjure up the textures and luminescence of sea-washed shells and natural mother-of-pearl. The ewer, which incorporates a great deal of porcelain, appears less

weighty through the play of swirling lines and irregular surfaces. A *trompe l'oeil* coral handle contributes to the ewer's sense of lightness and completes the illusion of being encrusted with marine forms. As with Duplessis's elephant vase, this witty invention is the product of a sculptor's sensibilities. Giuseppi Gricci was the master modeler at Capodimonte, the factory established by Charles Bourbon, King of Naples (and, later, of Spain), a great grandson of the Sun King.

Sculptural qualities are also clearly demonstrated in a tureen with stand and cover made about 1750 at the Pont-aux-Choux factory in Paris (p. 80). The overall form of this massive earthenware vessel was inspired by the great Baroque silver tureens of the late seventeenth century. It owes its decoration, however, to the eighteenth-century designs of Juste Aurèle Meissonier, one of the greatest designers of the later Rococo style, whose published engravings inspired artisans in all materials throughout Europe.

The Pont-aux-Choux tureen seems to float above its stand like a boat on a sea of swirling curves and countercurves. The undulating forms and broken surfaces, along with the sheen of pale, cream-white earthenware, serve to reduce the visual mass in much the same way that the reflective surfaces of contemporaneous silver vessels do. It is those magnificent silver objects that the Pont-aux-Choux factory replicated in its newly developed, English-inspired cream-colored earthenware with a clear lead glaze. As a part of the royal sumptuary taxes levied to finance the Seven Years' War, Louis XV collected gold and silver objects from princely families, aristocrats, and the clergy throughout France. Even the monarch himself parted with some of his treasures. The ceramic vessels subsequently produced at Pont-aux-Choux were, in a sense, memorials to specific works of the greatest French goldsmiths of the age. In addition to being objects of great beauty in their own right, earthenware vessels in the Rococo taste give us a sense of the splendor of those works of precious metal, few of which survived. Ironically, since earthenware, unlike its more durable counterpart, porcelain, is somewhat fragile, relatively few large-scale groups — vessel, cover, and stand — have survived.

"Elephant Candelabrum" Vase

Modeled by Jean Claude Duplessis the elder (attr.)
Painted by Vincent Taillandier (attr.)
1775, French (Sèvres)
Soft-paste porcelain with enameling and gilding

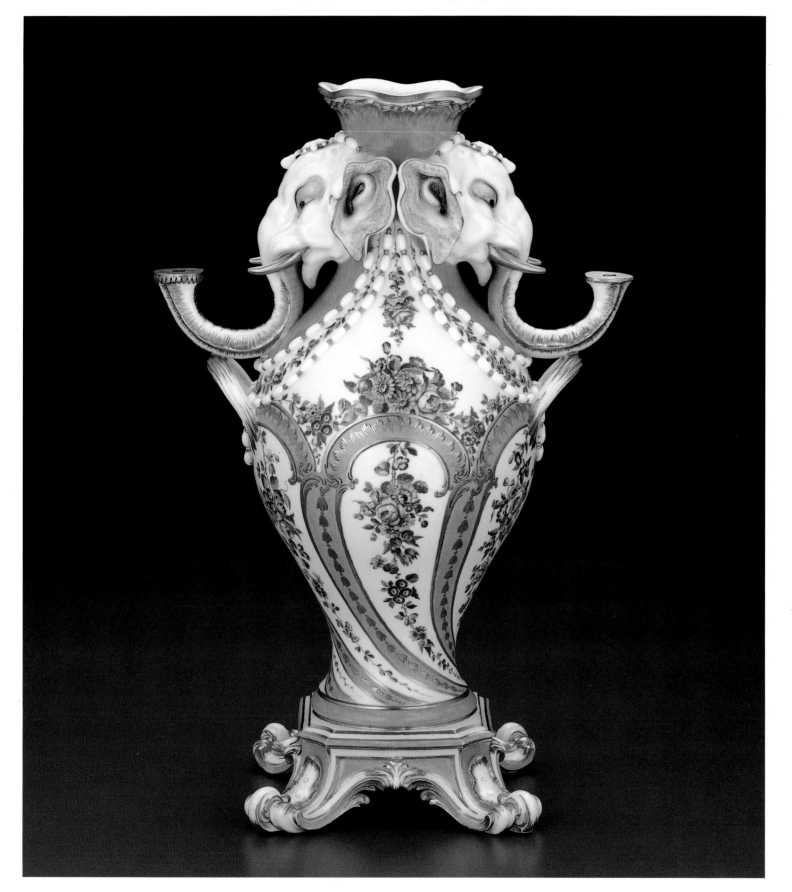

Tureen with Cover and Stand

Pont-aux-Choux factory
c. 1750, French (Paris)
Lead-glazed earthenware

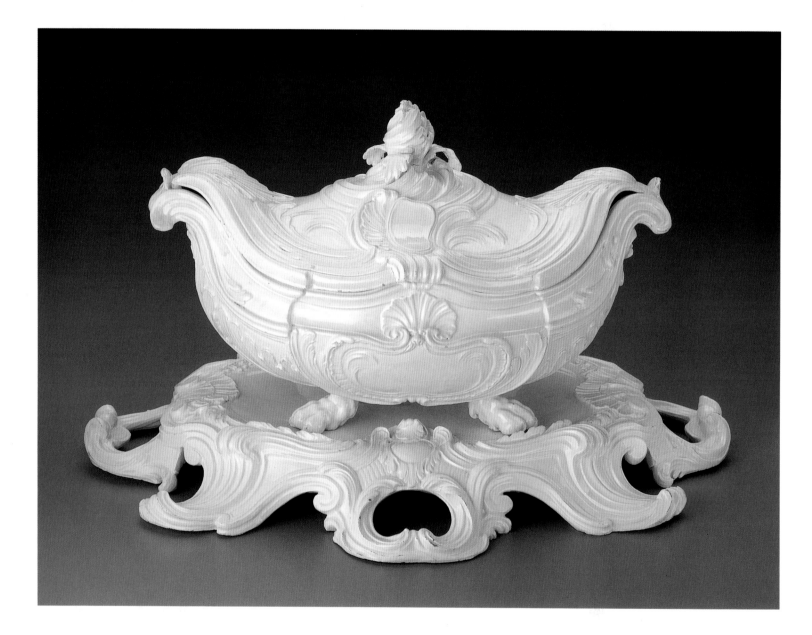

Ewer and Basin

Capodimonte factory
Modeled by Giuseppe Gricci (attr.)
c. 1745, Italian (Naples)
Soft-paste porcelain with enameling and gilding

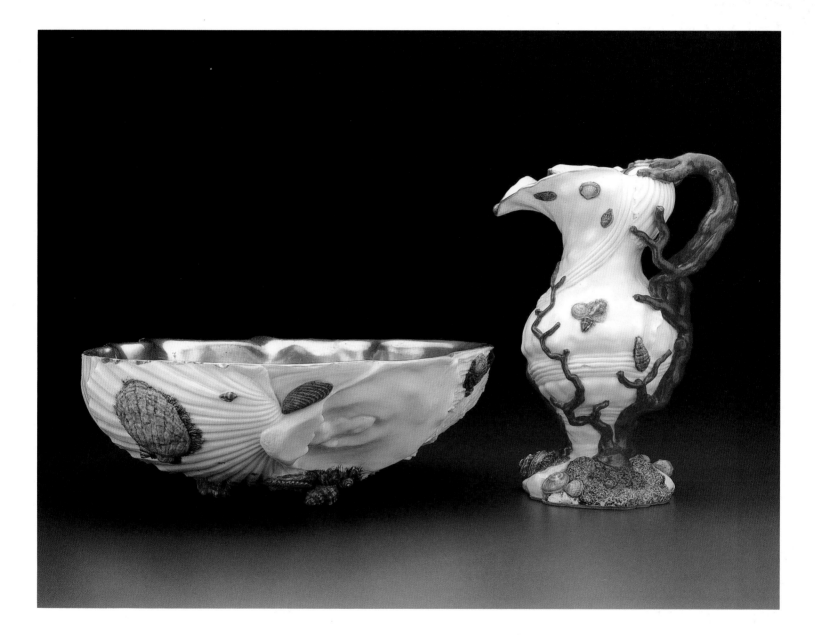

NEOCLASSICISM

One tries in vain to find forms better than those we have inherited from Antiquity." So wrote the influential French architects Charles Percier and Pierre Léonard Fontaine in their book *Receuil de décoration intérieure* (1801–12). In the encyclopedic spirit that infused the thought of the late eighteenth century, the lessons of ancient statuary and architecture, ever discernible in the history of Western art, were formally and comprehensively applied to contemporary art. Published engravings of classical furnishings excavated at Herculaneum and Pompeii influenced new designs in the decorative arts, and the pure forms and sober designs of Neoclassicism began to upstage the swirling shapes and joie de vivre that had characterized the Rococo period in many countries throughout Europe.

The education of the French sculptor Clodion exemplifies the attention artists paid to Antiquity. After arriving in Rome in 1765 to study at the French Academy, he and his colleagues tirelessly drew and modeled statues in the Forum and on the Capitoline Hill. A marble vase, one of Clodion's earliest works (p. 84), reveals the extent of his debt to ancient art. Its shape is clearly based on an amphora, a type of ancient Greek vase, though the handles—which take the form of turning horns sprouting from the heads of furry, goblinlike creatures—are a contemporary whimsy. Carved in low relief around the sides are vestals, the virginal priestesses of Hera, whose forms Clodion adapted from copies of Roman reliefs. These figures have the purity and power of ancient sculpture, yet are rendered with a degree of grace and subtlety that is suggestive of drawing.

Sculptors often provided the models for Neoclassical decorative arts. Clodion's vase follows one of a pair of terracotta models made by the artist, now in the Musée des arts décoratifs in Paris, indicating that he intended the marble as part of a set, an embellishment to a mantel or cabinet. A generation before Clodion, Etienne Maurice Falconet divided his career between carving exquisite marble statues and supplying models for figures and other decorations to be produced by the porcelain factory at Sèvres. A superb example of Falconet's ability is a set of andirons (p. 86) for which he modeled the goddess Venus and her husband, Vulcan.

In the carefully appointed interiors of the eighteenth century, no furnishing was left unconsidered; even the fireplace was a major component of the decoration. Venus and Vulcan, as symbols of air and of fire, were appropriate adornments for andirons. Floating on clouds and holding the (now missing) reins of her doves, Venus faces the crippled armorer Vulcan, who sits on an anvil, surrounded by examples of his craft. Like Clodion's vestals, Falconet's gods are based on classical examples but rendered with the principles of naturalism and informality inherited from the Rococo. Produced by a *bronzier*—a specialist in casting and chasing bronze furnishings and furniture mounts—the andirons exhibit the level of craftsmanship achieved in this period, which is unsurpassed in the quality of its decorative metalwork. The *bronzier,* believed to be Quentin Claude Pitoin, incorporated Falconet's figures into his design and produced the andirons for a wealthy clientele. Solidly architectural, with fluted columns and other motifs culled from Antiquity, Pitoin's work undoubtedly was consistent with the furnishings that surrounded it. The andirons' double-gilt coating would have gleamed and sparkled in the firelight.

Furniture was the highest expression of eighteenth-century decorative arts, and Jean Henri Riesener is justly cited as the greatest maker of French furniture in the thirty years before the French Revolution. As the official cabinetmaker to

Vase

Clodion (Claude Michel)
1766, French
Marble

Candelabrum

Firm of Matthew Boulton and John Fothergill
1771/72, English (Birmingham)
Gilt bronze, Derbyshire fluorspar (blue john),
wood with tortoiseshell veneer

Pair of Andirons

Modeled by Etienne Maurice Falconet
Cast by Quentin Claude Pitoin (attr.)
c. 1769, French (Paris)
Double-gilt bronze

Chest of Drawers (*Commode*)

Jean Henri Riesener (German)
1770/80, French (Paris)
Oak, mahogany, kingwood, purple heart,
unidentified exotic woods, gilt bronze, marble

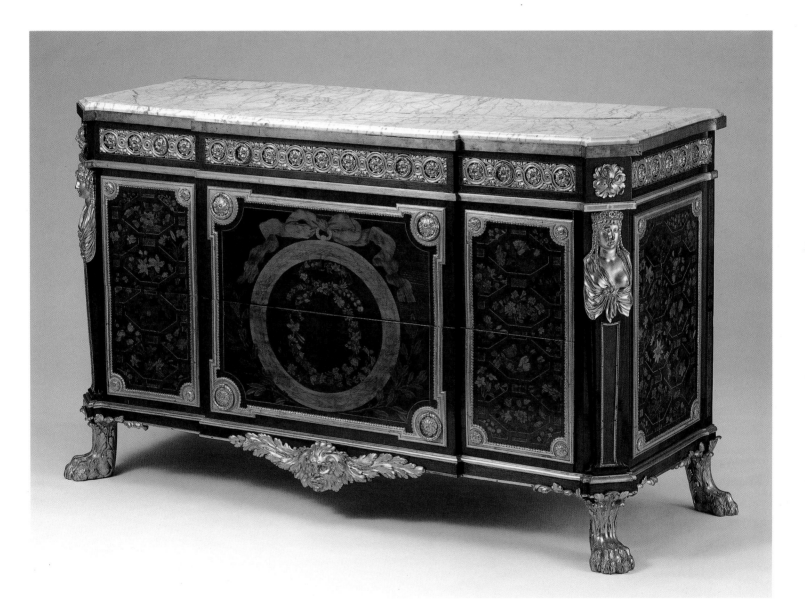

"The Portland Vase"

Wedgwood Pottery
c. 1790, English (Burslem, Staffordshire)
Black jasper ware with white jasper cameo decoration

the king, the German-born Riesener supplied major pieces of furniture to Louis XVI and his courtiers. A commode made by Riesener (p. 87) combines various crafts; most notable are its classically inspired ormolu terminal figures on the canted forecorners, and its inlaid wood, or marquetry. Here, Riesener, a genius at marquetry, fitted together a rich veneer of exotic woods to create the delicate flower bouquets and swags that grace the bold and simple form of the two-drawer chest. The powerful shapes of Riesener's furniture set it apart from the swirling silhouette and decoration of the Rococo examples that preceded it.

While the reputation of the French decorative arts in this period was deservedly high, there was strong competition from Great Britain, where the best-known proponent of Neoclassicism was the Scotsman Robert Adam. Adam's architectural and interior designs had a profound effect on the acceptance of Neoclassical designs in Europe and America. Among the many firms that produced designs by Adam was that of Matthew Boulton, who was one of the most versatile craftsmen and entrepreneurs in Georgian England. Besides running a metalworking business that made buttons and other small objects, Boulton was an inventor who collaborated with James Watt to refine the steam engine. In partnership with James Fothergill, Boulton ran a Soho manufactory that began to issue a limited number of highly refined ormolu wares. The partners' most successful decorations were *garnitures de cheminée,* coordinated groups consisting of a clock, candlesticks, and vases, intended to stand on a mantel. The firm supplied two garniture vases to King George III in 1771. The "king's vase" candelabrum (p. 85) is a variation on the form of this royal commission. Boulton devised a new technique of cutting fluorspar, a beautifully variegated but highly brittle mineral (nicknamed "blue john") that was quarried in Derbyshire, and he used this striking material as the core of the candelabrum.

Another English artisan who combined craftsmanship of the highest quality with innovative manufacturing was Josiah Wedgwood. To showcase the work of his Staffordshire pottery, Wedgwood undertook to reproduce in ceramic a celebrated glass vase, probably made in Alexandria about 50 A.D. Relief on the vase may depict scenes from the myth of King Peleus and the goddess Thetis, whose marriage breached the ordained division of mortal and deity. Excavated for Pope Urban VIII in the seventeenth century, the vase was widely known through its illustration in Bernard de Montfaucon's *Antiquité expliquée* (1719) before it entered the collection of the Duchess of Portland. (It is now in the British Museum, London.) Wedgwood's potters studied the vase in 1786, and, after three years of experiment, produced a small edition of reproductions for subscribers (see p. 88). The applied relief is a faithful restatement of the sharply cut original. Although Wedgwood sold Neoclassical-style ceramics in large volume, it may be the few examples of "the Portland Vase" that best express the intense desire in his time to emulate and understand the ancient past.

THE TASTE OF THE NAPOLEONIC EMPIRE

During the period known as the Directorate (1795–99), stability returned to France after the trauma of the Revolution. With Napoleon Bonaparte as First Consul, the period of the Consulate (1799–1804) inspired even greater confidence and saw a resurgence of businesses involved in the production of goods and furnishings. Much of this was fostered by the grand plan of Napoleon to refurnish the substantial number of former royal palaces and residences in a fashion consistent with the tastes and ideals of the new government. Working together, the architects Charles Percier and Pierre François Léonard Fontaine helped advance this vision, restoring and refurnishing the Elysée Palace and the Tuileries, as well as Compiègne, Saint-Cloud, Rambouillet, Fontainebleau, and, for Josephine Bonaparte, Malmaison.

In contrast to most furnishings in the earlier phases of Neoclassicism, which evoked the ancient world without following specific antecedents, the severe, bold forms in the designs of Percier and Fontaine were often adapted directly from classical furniture and accouterments, particularly as depicted in Greek vase painting. The authority and power that these furnishings gave to interiors were compatible with French aspirations, and the Greco-Roman style was perceived to be consistent with the republican government inspired by ancient Rome.

Percier's and Fontaine's *Receuil de décoration intérieure* was published in 1801–12 with numerous illustrations of objects and interiors. This virtual handbook for the new decorative style in France was eventually disseminated in Britain, the Continent, and America. Thus it was that, before the empire was formally established in France with Napoleon's coronation (a pageant staged in 1804 by Percier and Fontaine), this late phase of the Neoclassical style, which came to be called the Empire style, was already in place.

One of the Art Institute's most sumptuous late-Neoclassical objects is the Londonderry Vase (p. 95), an enormous gilded and enameled porcelain vase begun some time after 1805 and completed in 1813 at the Manufacture Nationale de Sèvres. The Sèvres factory was a chief beneficiary of Napoleon's policy of resuscitating former royal factories. The First Consul and his advisors believed that porcelains could serve the new regime much as they had served the old: as luxury items for the grand refurnishing plan and as state gifts to monarchs, aristocrats, and ambassadors. Lucien Bonaparte, Minister of the Interior, appointed Alexandre Brongniart to guide the regeneration of the old factory. Brongniart's innovations included new designers, porcelain-paste formulations, and enamel colors, and more efficient techniques of production. Shapes for some objects were taken from designs in the *Receuil*, such as Percier's *vase étrusque à rouleaux* — the so-called Etruscan scroll-handled vase that imitates a form now identified as Greek — the source for the Londonderry Vase.

The vase is so thoroughly documented in the Sèvres archives that nearly every aspect of its production is known, including the names of the architect who designed its decoration, the two principal decorators who separately painted flowers and birds, and the chief gilder. After a manufacturing cost of 11,311 francs, the vase was valued for sale at 22,000 francs, an enormous differential, indicating that it was considered to be of exceptional merit.

Ironically, this massive object, which so well expresses the adopted style of the empire, was used as a state gift not by Napoleon, who was deposed in 1814, but by his successor, the monarch Louis XVIII (r. 1814–24). The vase was released to the government on July 2, 1814, through the auspices of foreign minister Charles Maurice de Talleyrand. In August, it was presented to Viscount Castlereagh,

the English Secretary for Foreign Affairs who later was made Marquis of Londonderry, in whose family it remained until recently. Talleyrand was seeking an assurance from the English diplomat that France would not be excluded from the upcoming negotiations at the Congress of Vienna, the decisive meeting of the major powers to set terms of defeat for France after the collapse of the empire. Louis XVIII's timely gift of the great Sèvres vase was undoubtedly intended as a token of the king's pledge to cooperate with the convened powers. The Londonderry Vase thus cemented a relationship emblematic of Napoleon's defeat.

In England, one of the strongest advocates of a purified and accurately archeological form of Classicism was the dilettante and collector Thomas Hope. For his personal collection of antiquities, Hope designed appropriate settings and furnishings in his London townhouse, which were completed by 1804.

View of closed secretary desk

Three years later, much in the spirit of Percier and Fontaine, he published *Household Furniture and Interior Decoration,* which included the design for a "round monopodium or table in mahogany, inlaid in ebony and silver." This is the source for a circular pedestal table in the collections (p. 94). The table has a central inlay pattern not included in Hope's original design, and may have been produced, along with a few others of nearly identical design, by the same cabinetmaker commissioned by Hope.

While books of Empire-style designs were studied by craftsmen throughout Europe, by no means were they slavishly imitated. An innovation developed by Viennese cabinetmakers is reflected in a secretary of 1810/12 (p. 93). Made with materials and techniques typical of local workshops, the form of this secretary has no direct source in Antiquity, but its lyre shape and abundant decorative details — griffons, cornucopiae, paw feet, and interior caryatid figures — are familiar classical motifs. Variants of this desk type were produced as far away as Romania until the 1840s, indicating the status of Vienna as a major design center in central Europe.

Vienna, however, was itself absorbing influences from Paris, which, no longer the capital of a political empire, nonetheless continued as the preeminent European style center. The Empire style itself survived the imperial pretensions that fostered it, enduring for decades in both Europe and America as a valid source for less elaborate designs.

Secretary Desk

1810/12, Austrian (Vienna)
Various woods, carved, gilded, and painted,
with gilt-bronze mounts;
interior copper, brass, and maple marquetry

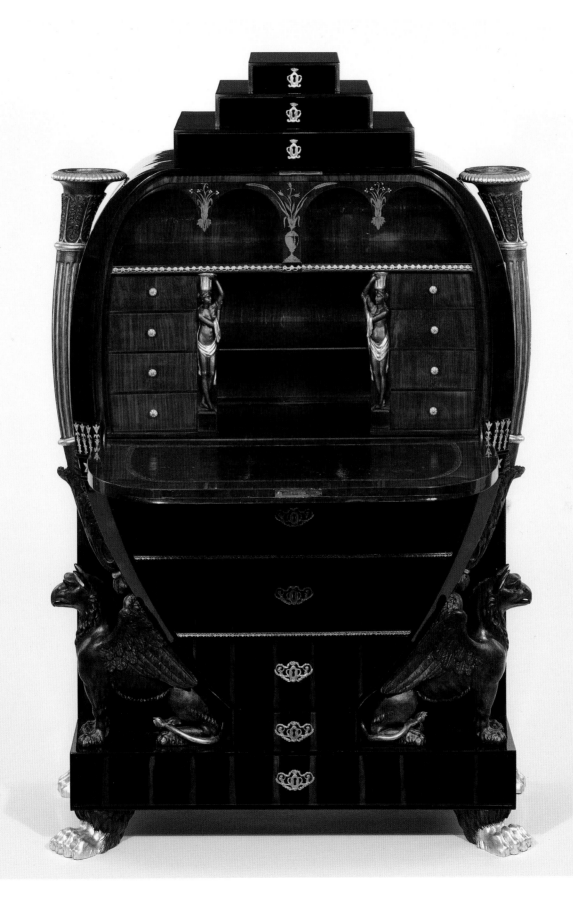

Pedestal Table

Designed by Thomas Hope
c. 1810, English
Mahogany with ebony and metal inlays,
gilt-bronze mounts, gilding

The Londonderry Vase

Designed by Charles Percier
Decoration designed by Alexandre Théodore Brongniart
1813, French (Sèvres)
Hard-paste porcelain, polychrome enamel, gilding, gilt bronze

BIEDERMEIER

The Congress of Vienna, in 1814, restored a number of European monarchies and aristocracies, but could not erase memories of unrest or fears of revolution. Austria's canny chancellor, Prince Klemens von Metternich, implemented formidable state controls and censorship to prevent the people from having a meaningful role in public discourse, lest the egalitarian lessons of the French Revolution filter into the Austrian middle classes. It was thought that the citizen's principal duty was to live a quiet life. Not surprisingly, the home became a sanctuary where domestic values and family-centered activities were elevated and cherished. Contemporary virtues were exemplified in the popular press by a fictional, comic character whose name, Biedermeier, eventually came to identify the period and its style.

Myriad Austrian and German watercolors and paintings of the 1820s, 1830s, and 1840s record in fond detail the domestic interiors of the Biedermeier period. These images reveal something fundamentally new in the arrangement of furnishings: absent is the traditional, symmetrical placement of objects that reinforced the public formality of the previous era; gone from the principal living or reception rooms of aristocrats or burghers are the large-scale, pretentious case pieces intended to create a sense of grandeur. Instead, groupings of furnishings are arranged around the perimeters of rooms and organized to suit various activities — whether writing at a desk or doing needlework while seated in chairs upon small, raised window platforms. The features of these Biedermeier rooms emphasize utility, flexibility, and the accumulation of material possessions. Taken together, they exude a sense of humane warmth and comfort. The walls display horizontal rows of two-dimensional works of art dear to the family, while tables, chests, desks, and shelves of cabinets exhibit heirlooms and other valued possessions. Bound volumes fill shelves or are stacked on tables, telling of a literate and educated culture. Chairs appear to be everywhere: beside sofas, around center tables, next to desks, in window niches, and flanking bookcases.

The Art Institute's armchair (p. 99) and side chair (p. 98), each made of native walnut in Vienna, could well have been used in the same room, whether in the home of an archduke or of a local factory owner. Elements of each chair vaguely recall the shapes and decorations of the French Empire style, but the forms are simplified, almost abstracted. The armchair, with its fluted, burl-walnut columns, takes the Empire motifs of classical columns and scrolls a step further, merging form and decoration into an innovatively articulated whole. Its front legs are both arm supports and decoration, and its decorative scrolls are conceived as part of the overall structure. While the stately form of the armchair suggests strength and dignity, its substantial upholstery insures comfort. The side chair, "design no. 89" in the archives of Vienna's most famous and prolific furniture factory of the Biedermeier era — that of Joseph Danhauser — is an exercise in spare, flattened, curvilinear shapes. Inspired by an earlier English chair with carved plumes for a back splat, Danhauser abstracted and simplified the decoration. Comfortable, durable, and easily portable, the chair is handily adaptable: it may, as required, seat a cellist in a family musicale, a reader by the bookcase, a seamstress on the window dais, or a guest supping at the sofa table.

Inextricably bound with the cultural focus on domesticity was an economic thrust to produce the material goods with which to feather the nests of the Austrian nation. Years of strife during the Napo-

Side Chair

Factory of Joseph Danhauser
1815/20, Austrian (Vienna)
Walnut and walnut veneer, modern upholstery

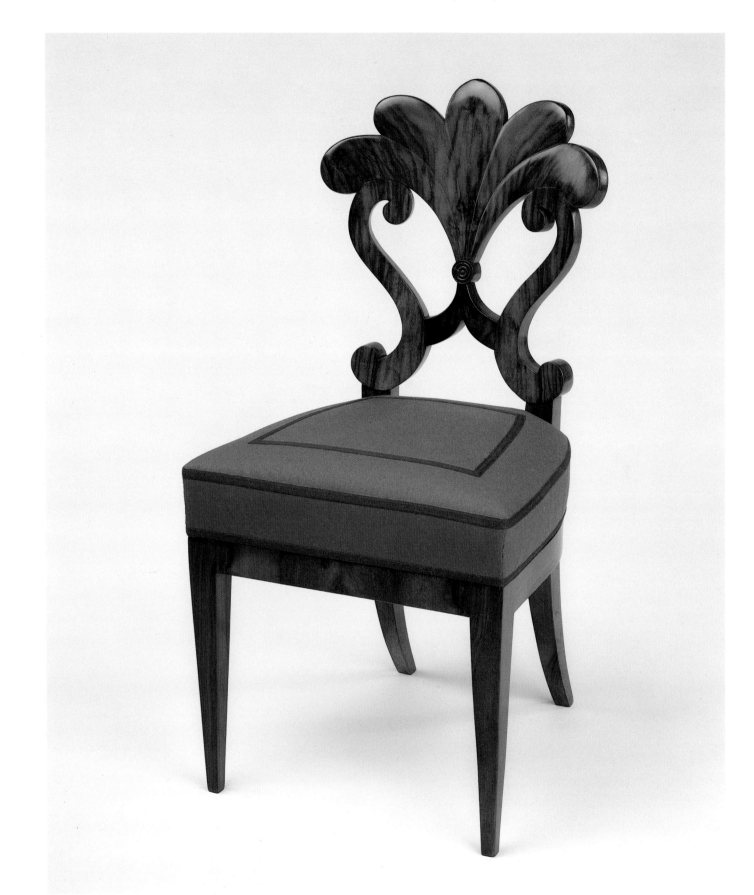

Armchair

1820/25, Austrian (Vienna)
Walnut and walnut veneer, poplar;
modern upholstery

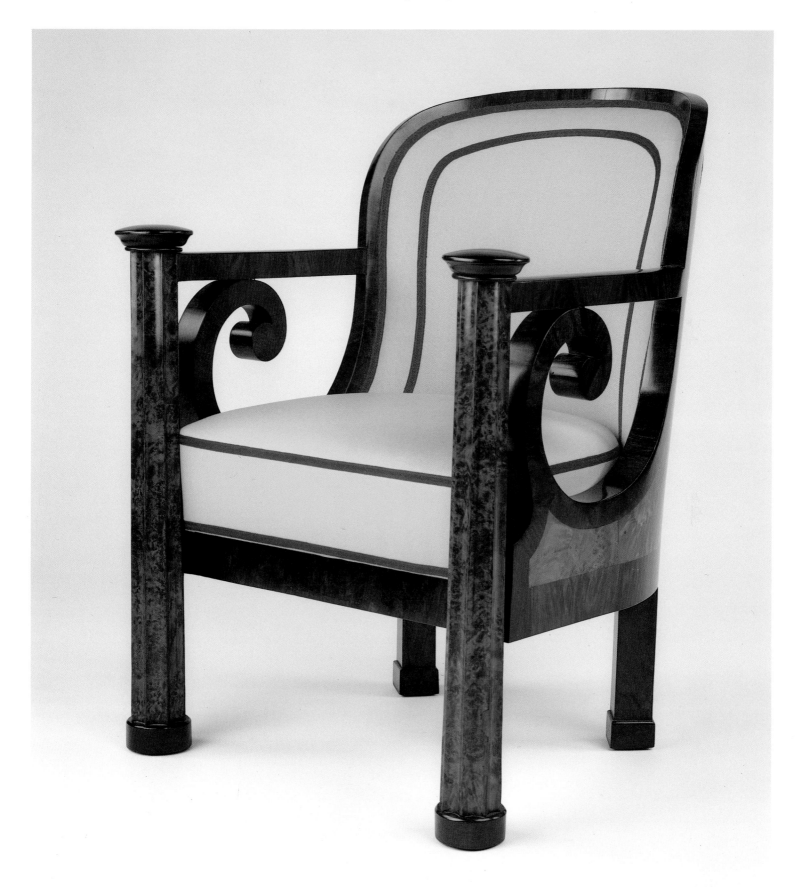

Tumbler

Factory of Friedrich Egermann
1830/40; Czech (Bohemian)
Lithyalian glass and gilding

leonic era had exhausted the people and sapped the treasury, making it necessary to create a competitive environment and steady markets that could support a viable economy. Industry and the applied arts were officially encouraged, and scientific, technological, and commercial innovations were emphasized. Manufacturers offered a range of merchandise through which customers could express themselves by making choices about which materials, colors, patterns, or degree of decoration they preferred. But to be competitive, manufacturers also had to produce their wares economically, calculating the reduction of costs all along the process.

A customer desiring a side chair from Danhauser's factory had a choice of 153 different versions. The consumer not only achieved satisfaction in being able to exercise personal choice, but also received for his money an attractive, durable, and utilitarian object. The spare beauty of his new purchase, and of many Biedermeier designs, was as much a function of the middle-class distaste for aristocratic excess as it was of the manufacturer's need to produce efficiently and economically.

The tendency of the era to pare down forms to their essentials, merging the useful with the beautiful, can be seen in everyday objects of glass, ceramics, metalwork, textiles, and other materials. Porcelains and glasses embellished with subjects drawn from nature, often bought as souvenirs of visits to local spas, were functional items as well as accessories for display. The curvaceous glass of a tumbler (p. 100) invites the grasp of the hand with its flared rim and pinched waist. The shape, substance, and decoration of the tumbler are one: stylized classical flutings made of visually compelling Lithyalian glass. Patented by the Bohemian glass factory of Friedrich Egermann, Lithyalian glass offered appealing and affordable surrogates to the carved jasper, agate, and semiprecious vessels that once caught the fancy of Hapsburg monarchs but were beyond the means of the average person. Bohemia, a center of glass making since the fourteenth century, was home to many factories which, like Egermann's, updated their designs and increased production during the Biedermeier years, exporting glass to all parts of Europe.

REVIVAL STYLES OF
THE NINETEENTH CENTURY

Eclecticism, the selective use of styles and ornament from the past, characterizes much of nineteenth-century decorative arts, having been rooted in the eighteenth-century re-examination of historical styles, most notably, Classicism. As the new century approached, there were numerous retrospective glances at Gothicism as well, ranging from architectural endeavors to a host of designs for furnishings in the Gothic mode by Thomas Chippendale and his contemporaries. Eclectic interiors were common enough in Britain by the 1820s and 1830s to be suitable targets for satire. In her tale *Our Village* (1824–32), writer M. R. Mitford recounts a visit to a fashionable English cottage:

Every room is in masquerade: the saloon Chinese, full of jars and mandarins and pagodas; the library Egyptian, all covered with hieroglyphics and swarming with furniture crocodiles and sphinxes. Only think of a crocodile couch and a sphinx sofa! They sleep in Turkish tents and dine in a Gothic chapel.

Underlying Mitford's caricature is an insight with relevance beyond her own time: the nature of fashion is such that it advances the limits of current taste. Novelty and innovation count for everything, and, surprisingly, are often sought in the past.

Throughout Europe, the expansion of an affluent middle class fed the growth of nearly all trades associated with the creation of furnishings. The new consumers were apprised of goods in the latest fashions by such comprehensive publications as Rudolph Ackermann's *Repository of Arts, Literature, Commerce, Manufactures, Fashions and Politics* (1809–28). Publications were, then as now, powerful propagators of taste, transmitting styles and designs over national boundaries and reaching both craftsmen and consumers. The promotion of new styles based on those of the past created a boundless succession of style revivals. The nineteenth century commenced amid the broad stream of Neoclassi-

cism, which soon led to more archeologically based revivals of Greek style, including the Empire style, which was in full swing when the Gothic revival began taking root; before mid-century, fashion directed its course to revivals of Rococo, Renaissance, Louis XVI, and Egyptian styles, not to mention the even greater historical specificity of revivals such as the Elizabethan, Tudor, and Louis XIV. To complicate matters, earlier styles were often intermingled or simply confused. For the most part, revivalists were not concerned with making accurate copies of period pieces; they were engaged in applying decoration from the past to objects of current manufacture.

Representative of the curious mixtures of styles that could be found is an octagonal, revolving library table (p. 105). One of a small group of nearly identical pieces made for different clients, the table probably stood in the center of a private library. Its expansive, leather-covered top facilitated writing and could be rotated, a technical innovation that allowed the reader to work with several large volumes at once. The form was probably derived from a late-Regency design by Richard Bridgens, first published in 1825/26. The table's form exhibits spare, solid, late-Classical characteristics, but its decoration is of another sort. Wood inlays embellished with ivory, brass, and mother-of-pearl decorate the top, apron, and legs. Foliage and cartouches with exotic figures (see p. 104) echo the Rococo style of the second quarter of the eighteenth century. The group of tables was probably made for Edward Holmes Baldock, a London dealer in French antiques who also altered existing pieces and arranged to have new items made.

Augustus Welby Northmore Pugin, a contemporary of Bridgens and friend of Baldock, was one of the most important early nineteenth-century designers of Gothic-style architecture, furniture, and

decoration, having trained under his French émigré father, the architect A. C. Pugin, an authority on medieval buildings. A devout convert to Roman Catholicism in an Anglican country, the younger Pugin proselytized through the architecture and fittings of his extraordinary churches and houses. To re-establish the Gothic order was Pugin's self-appointed Christian and artistic duty. He clarified his thoughts in a series of publications between 1835 and 1843, inveighing against the "bad architecture of the present time" and remonstrating himself for the early designs he "perpetrated" by merely applying Gothic decoration to existing forms, rather than deriving decoration from the purpose, materials, and means of construction. The conviction and eloquence of his published ideas — if not their specific prescriptions — were to make Pugin a respected elder within the art-reform movement that would coalesce in the second half of the century.

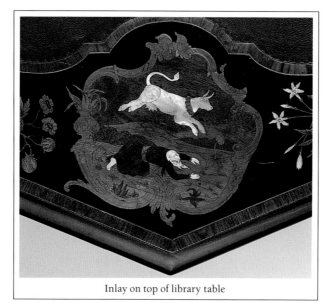

Inlay on top of library table

A chalice designed by Pugin (p. 107) was produced by the workshop of John Hardman and Company, a firm retained by the architect to make metal implements and fittings for his commissions. The inscription "Model" on its underside suggests that the vessel served as a sample to be shown to potential clients. As they would have been in the Middle Ages, final versions of the chalice were handcrafted by goldsmiths in precious metals and gemstones rather than die-struck in Sheffield plate, the silver-plated copper that was commonly used for less expensive metalwork.

Revivalism is a force that survives even to this day. One of the great reinforcements to its existence was the continuing forum provided by expositions in European and American cities from the middle of the nineteenth century on. The vast assortment of goods in each exposition was seen by thousands, and was broadcast to an international audience through commemorative publications. Reputations could be made and sustained by such celebrity, as was that of the Florentine neo-Renaissance sculptor and furniture maker Luigi Frullini. After exhibiting works and winning two prizes in Florence in 1861, he participated in expositions in London, Dublin, Paris, Vienna, Philadelphia, and Turin. From 1870 to 1890 his workshop expanded to accommodate commissions from both sides of the Atlantic. A massive armchair (p. 106), with an infant-sized putto on each arm, bears Frullini's signature and the date 1876. While the master most likely carved only the figures of the cherubs, the rest of the chair's decoration testifies to the consistency and skill of his studio carvers. Frullini's chair could not easily be confused with an object made during the fifteenth or sixteenth centuries. But its virtuosic form and carving of Renaissance-inspired ornament would have appealed to affluent patrons wishing to emulate the nobility and opulence of an earlier age.

Revolving Library Table

Designed by Richard Bridgens (attr.)
c. 1840, English (London)
Various woods, ebony veneer, brass,
ivory, mother-of-pearl, leather

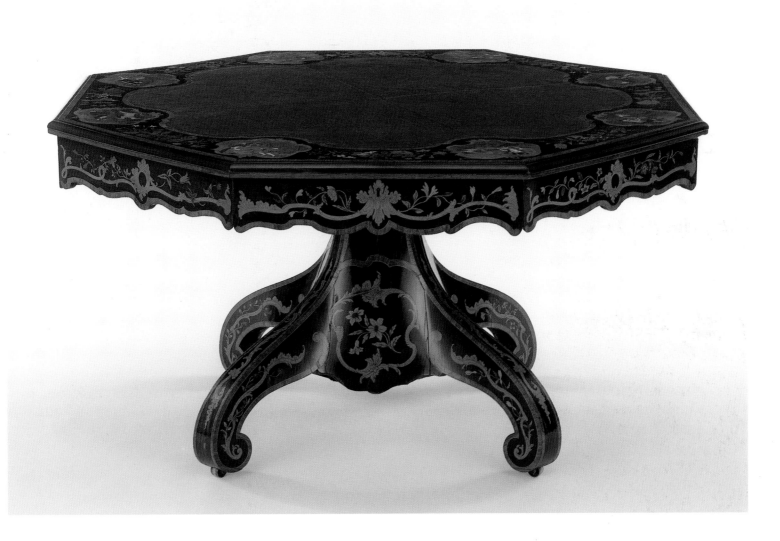

Armchair

Workshop of Luigi Frullini
1876, Italian (Florence)
Walnut, cut-silk velvet upholstery

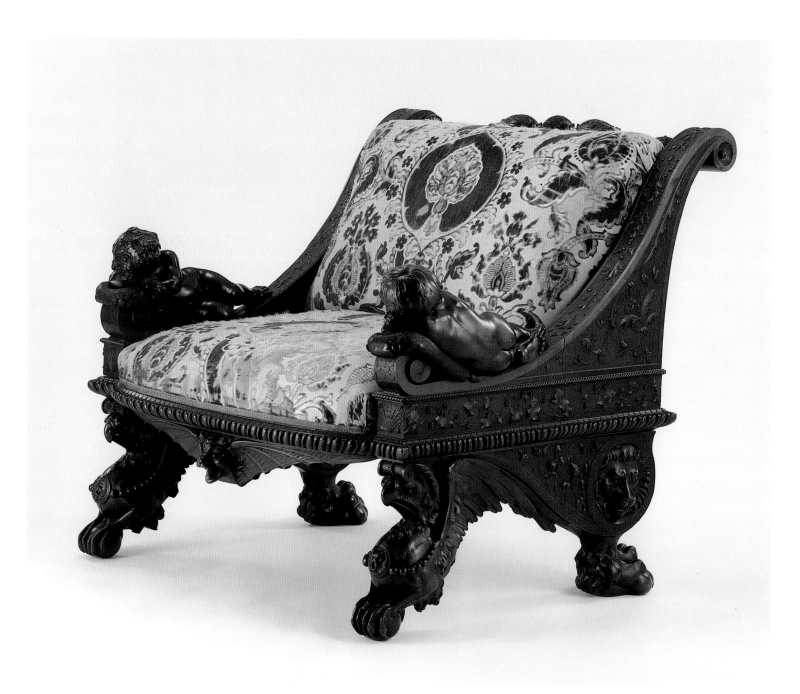

Model Chalice

Designed by A. W. N. Pugin
1846/49, English (Birmingham)
Gilt base metal, enamels, semiprecious stones

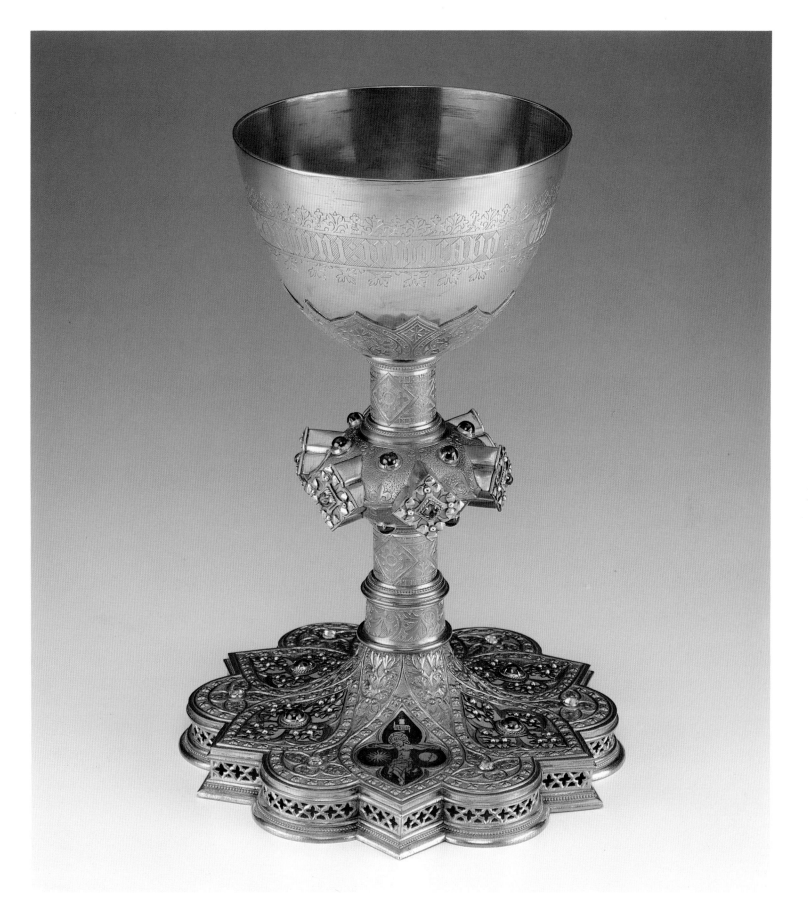

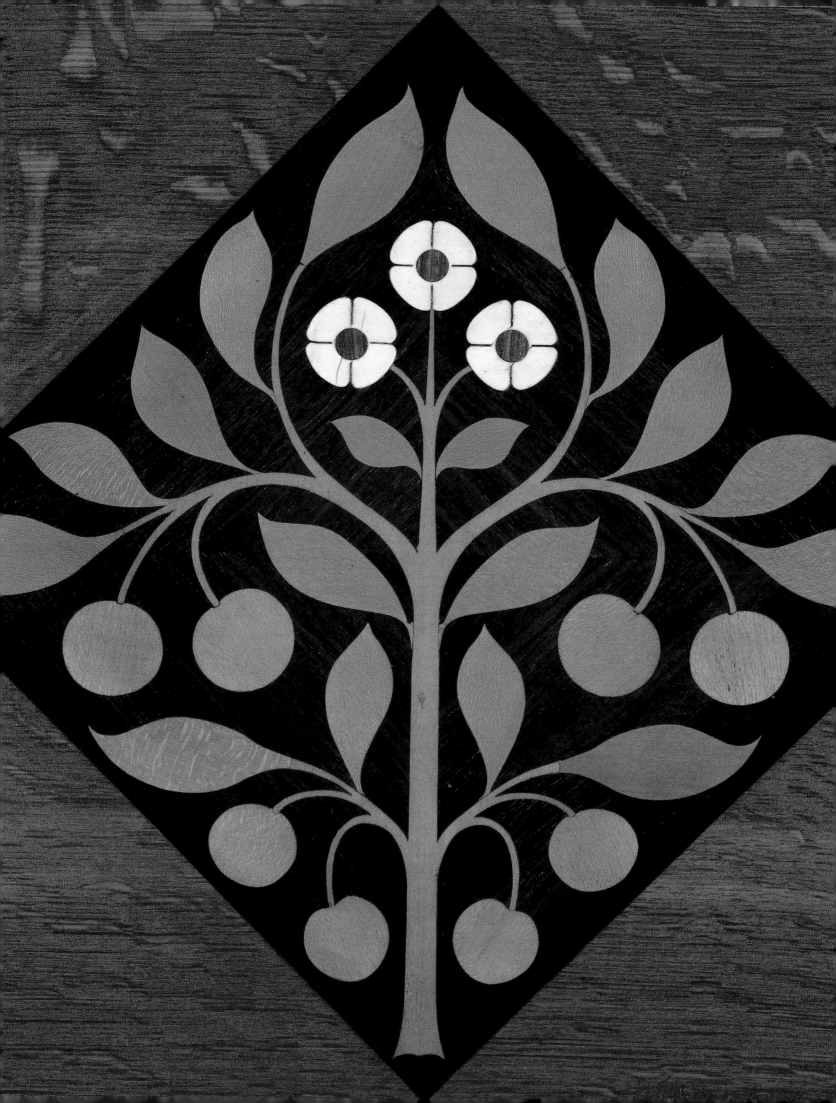

THE BRITISH ARTS AND CRAFTS MOVEMENT

Industrialization, in its potential to produce more and cheaper goods for an ever-increasing population of consumers, seemed in the early nineteenth century to be cause for celebration. But by mid-century the Industrial Revolution had already left in its wake a host of social problems: dirty environments, crowded cities, a growing underclass that was ill-housed, ill-fed, and uneducated, and, among the vast class of workers, disenchantment with the workplace due to the repetitive, joyless tasks and anonymity that characterized much industrial production.

As far as household goods were concerned, manufacturers often created a single vessel shape of glass, metal, or ceramic, or a single chair or table form, to which would be added an overlay of surface decoration in one of several popular revival styles, thereby creating greater possibilities for the marketplace. A dismayed critic of the manufactured goods shown in the 1851 Crystal Palace exhibition in London censoriously observed that ornament was "out of control," having become so excessive that it "substitutes the ornament itself for the things to be ornamented." Similar insights into the poverty of design standards for the goods of everyday life were increasingly coupled with an awareness of deteriorating social conditions.

The seeds of ideas sewn earlier by A. W. N. Pugin found fertile ground in the thought of Oxford aesthetician John Ruskin, who appreciated the significance of Pugin's belief in the moral value of Gothicism, a style in which materials were simple and decoration was drawn from structure. In his numerous publications, Ruskin went beyond Pugin's tenets, eschewing mechanization and demanding a return to handwork. Further, he insisted on an order in which the worker derives a sense of pleasure in that work. Ruskin hoped ultimately to join the activities of labor and art and, in the process, to reform social conditions. Ruskin's message was put into action by his student William Morris. A painter and architect, Morris devoted his energies to championing the decorative arts, organizing the collaborative firm of Morris, Marshall, Faulkner and Company in 1861 (succeeded by Morris and Company in 1875) to produce textiles, stained glass, glassware, wallpapers, and furniture. Morris strove to counter both the dehumanizing environment and low-quality products of the industrialized factory by reestablishing the traditions of craft guilds and workshops where laborers and craftsmen worked with equal pride. As art historian Nikolaus Pevsner first pointed out, it was Morris who sought to elevate the status of handcrafted objects to that of the fine arts, a notion that, as Pevsner said, "marks the beginning of a new era in Western art." Morris's speeches and writings, along with his life's work of implementing Ruskinian ideology in design and production, were seminal to the Arts and Crafts movement in Britain and America. They also encouraged numerous turn-of-the-century movements in France and Belgium (Art Nouveau), Germany and Austria (Jugendstil, Secession), Italy (Stile Liberty), and virtually every other western country.

William Frend De Morgan, the greatest English ceramist of his era and an avowed disciple of Morris, produced tiles, vases, plaques, panels, and a variety of other forms, all enriched with vivid colors and glazes, and usually decorated with the flat, stylized patterns similar to Morris's wallpaper and textile designs. A vase (p. 113) made between 1882 and 1888 at De Morgan's Merton Abbey pottery was hand-thrown and decorated in the so-called Persian style, inspired by, but not copying, Near Eastern forms

Manxman Pianoforte

Designed by Mackay Hugh Baillie Scott (Scottish)
Case and metalwork by Charles Robert Ashbee (attr.)
1897, English (London)
Oak, ebony, mother-of-pearl, ivory, copper fittings

and patterns. In the spirit of Ruskin's and Morris's ideals for decoration, the nature of the patterns aptly enhances the exotic shape of the vessel.

One of the most important workshops, in terms of its national and international influence, was that founded by Charles Robert Ashbee, an architect who was a generation younger than Morris and devoted to the principles of handcraftsmanship until late in his life, when he recognized the indispensible role of the machine in twentieth-century civilization. Ashbee formally established the Guild and School of Handicraft in 1888, following Ruskin's and Morris's dictates but fusing them with his own political and educational emphases. The craftsmen who worked in the various shops and taught in the school were accorded their individual approaches, the whole enterprise being an experiment in an idealized socialist democracy. From 1891 to 1902, the Guild was located in London at Essex House. It was there that a silver coffeepot designed by Ashbee (p. 112) was made by a silversmith who, having stamped it with only the touchmark of the Guild, is anonymous to us now. The hand of the craftsman is plain to see in the coffeepot's embossed and hammered surface. Its shapeliness and the richness of its materials — including the ivory of its handle and a chrysoprase finial — add the quality of elegance to the simplicity and strength of Ashbee's design.

The celebrated Scottish architect and designer Mackay Hugh Baillie Scott worked with Ashbee and the Guild of Handicraft to furnish rooms in the palace built in Darmstadt, Germany, by the Grand Duke of Hesse in 1898. Among the items that filled the grand duke's interiors was an upright pianoforte enclosed in a cabinet with strikingly decorated surfaces. It, as well as an example from 1897 (p. 110), were two of a small group of so-called Manxman pianos done in collaboration with John Broadwood and Sons of London, who made the musical movements. Baillie Scott had produced his first version of this design in 1896, to the acclaim of critics who found its solution to the somewhat awkward form of the upright piano — enclosing it as in a cabinet — clever and inspired. When opened, the cabinet reveals itself as a musical instrument, as well as displaying a profusion of metalwork: hand-hammered copper hinges, candle holders, pulls and escutcheons, and spectacular, plantlike strap-hinges that serve to support the weight of the lid. The design, like a keyboard, is a study in contrasts of light and dark, as well as in the relationships of rectilinear forms. The witty handling of the alternating pattern of its lower section makes an unmistakeable visual pun on the keyboard itself. From pairs of stylized, inlaid panels, replete with ivory and mother-of-pearl, a medievalizing spirit resonates. Appreciating that resonance within the complex milieu in which this work was created leads to a greater appreciation of the movement that created it. For in recognizing such objects as "works of art," worthy of inspection and discussion, we acknowledge one of the revolutionary Arts and Crafts ideas.

View of closed pianoforte

Coffeepot

Designed by Charles Robert Ashbee
1900/1901, English (London)
Silver with chrysoprase

Vase

Designed by William Frend De Morgan
1882/88, English (Merton Abbey, Surrey)
Tin-glazed earthenware with
polychrome decoration

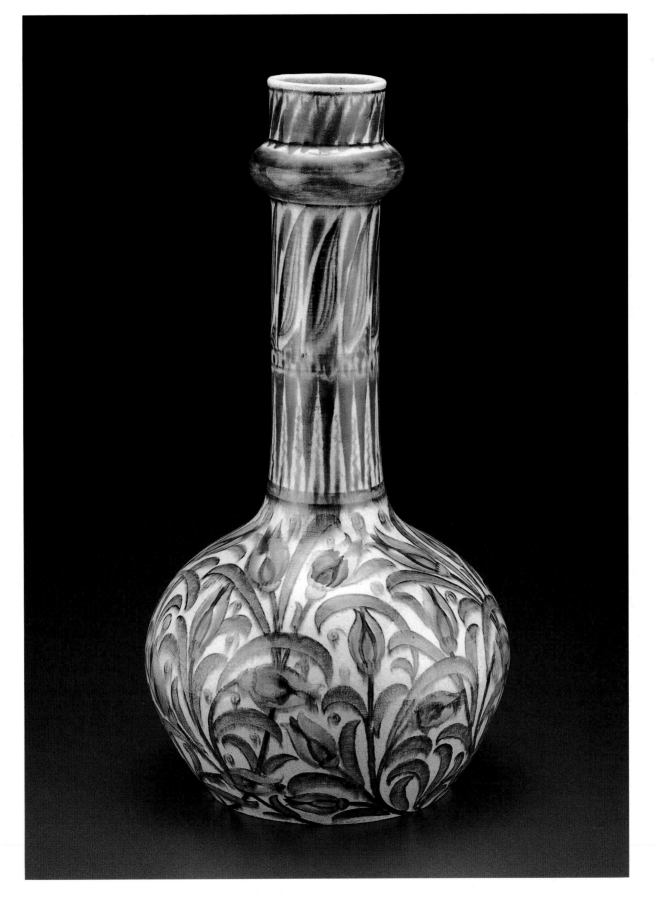

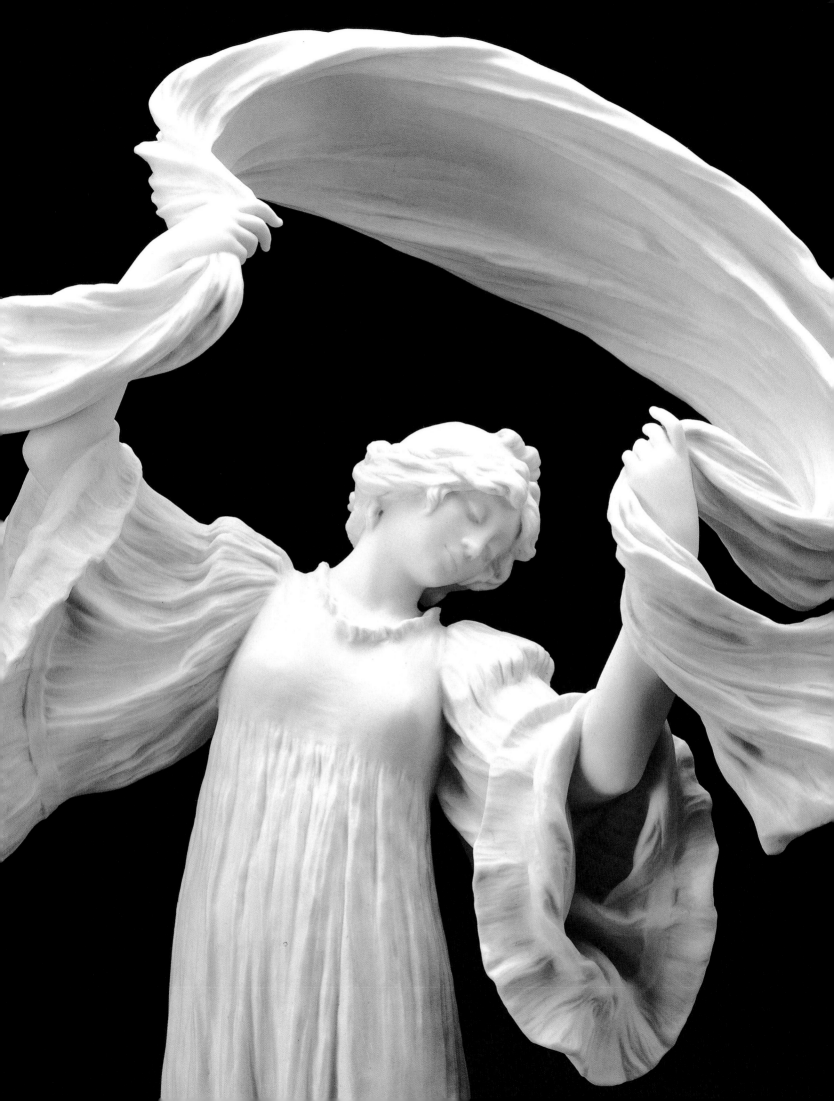

ART NOUVEAU

Art Nouveau was an international design movement informed by the British Arts and Crafts movement, that was born in the 1880s, flourished at the turn of the century, and expired during the First World War. It was a style characterized by sinuous lines abstracted from foliage and tendrils, which, at its best, merged form with structure to create wholly new designs. The term derived from the name of a shop, *L'Art Nouveau,* opened by Siegfried Bing in Paris in 1895. Bing commissioned designs from artists based as far away as America, England, and Germany for production in France, creating and satisfying a taste centered in Paris.

Hector Guimard, best known as an architect and sculptor, was one of the leading Parisian proponents of Art Nouveau. Rigorously rejecting straight lines, Guimard's architecture favored what, in another context, he described as "dominant lines which describe space, sometimes supple and sinuous as arabesques, sometimes flourishes as vivid as the firing of a thunderbolt." Guimard sought to harmonize the plans and elements of his interiors, matching the curving lines and wood tonalities of wall paneling and built-in cabinetry to the furniture. Crisply carved lines in the back and legs of a pearwood side chair by Guimard (p. 118) seem to bend the chair into its pliant shape. A heart-shaped, embossed leather back focuses the network of lines. While fine furniture like this was commissioned for wealthy and adventurous clients, Guimard's designs also stretched along the stairwell entrances of newly constructed Metro train lines, and the popular Art Nouveau style became closely identified with urban life in Paris in the 1900s.

One of the principal designers supporting Bing's enterprise was Edward Colonna. Born in Germany, Colonna emigrated to America as a youth, working first for Louis Comfort Tiffany in New York, and later designing railroad parlor cars and buildings in Ohio and Canada. Returning to Europe, this peripatetic artist designed jewelry, ceramics, and furniture for *L'Art Nouveau* until the shop closed in 1903. An example in the collections (p. 117) is representative of a series of porcelain vases designed by Colonna for production in the factory Gerard Dufraissex et Abbot, in Limoges. As with all the vases in the series, it features stylized botanical motifs in delicate shades of green, pink, and gray. The abstract flowers seem to flow naturally across the lustrous surface, yet are disciplined into patterns that emphasize base and rim. The vertical stems accentuate the height of the vase and divide its circumference into regular sections. Like many Art Nouveau adherents, Colonna and Bing were fascinated by oriental, particularly Japanese, art. In these vases, Japanese influence is evident in the soft colors, the incised decoration, and the stylized flowers at their bases.

Bing's success was promoted by his pavilion in the 1900 Exposition Universelle in Paris. Among the numerous designs launched at that great fair was a series of Sèvres porcelain figurines, *Le Jeu de l'Echarpe,* or, as they are called in English, "the Scarf Dance" (pp. 120–21). Modeled by Léonard Agathon van Weydeveld, the figures, numbering fifteen but designed to be displayed in any number, embody the spirits of Dance and Music. It is believed that Mrs. Potter Palmer, the great Chicago patroness of the arts, bought the Art Institute's six figures—three of Music, and three of Dance—following the Paris exposition. Yet another instance in which sculpture shaped the decorative arts, the designs apparently evolved from an earlier project for reliefs in the foyer of a dance hall, eventually becoming the set of three-dimensional figures, which were intended as a table centerpiece or as the primary exhibit in a porcelain cabinet.

Inspiration for the set came, in part, from the phenomenal success of the American dancer Loie

Fuller, the celebrated predecessor of the now better-known Isadora Duncan. Her filmy silk costumes and sensuous movement were a sensation in Paris, and dances she choreographed using billowing scarves excited great admiration. The flowing shapes of her dance were immortalized by such sculptors as Raoul Larche and Henri Rivière, and she herself employed the best Art Nouveau designers to build the theater in which she performed at the 1900 exposition. While the motif and dress of the figures owe much to Fuller, their composition exhibits the sober, measured grace of ancient Greek dancers. Indeed, the most popular of the dancers, the woman adjusting her slipper, was called *La Cothurne,* after the thick-soled boot worn by actors in Greek tragedy. The continuing popularity of the set led the famous foundry Susse Frères to produce later editions in bronze.

The striking interiors of Bing's shop were designed by the Belgian Henry van de Velde, one of the primary figures of the Art Nouveau movement. Although van de Velde shared the theoretical interests of Bing and others in handcrafted, functional objects and their organic relationship to their surroundings, he was concerned as well about making relatively inexpensive designs accessible to a broad public. A samovar designed by van de Velde (p. 119), for example, is made of silvered brass, though some ex-amples were made in silver for the luxury market. It was probably made by Theodore Müller's workshop in Weimar, the city where van de Velde moved from Brussels in 1900. A system of German *Werkstätten,* or small, craftsman-owned-and-operated workshops such as Müller's, produced a broad range of objects for wide distribution.

Dating from 1902 or 1903, the samovar, or tea kettle, beautifully illustrates the adroit mixture of taut lines and curvilinear motifs that characterize its designer's mature Art Nouveau style. From the central burner, lines snake and twist around upright brackets, which, in their architectural strength, look much like the columns in Bing's shop. The stand's braided bands are continued in the teak handle, but the kettle itself is simple in form, unornamented, and, with a prominent hinge on the spout cover, appears to be more engineered than crafted. This formal tension reflects the aesthetic debate even within the crafts movement on the role of the industrial machine in modern decorative arts. In 1904, van de Velde became director of a school in Weimar that would develop from being a center of the workshop tradition to become the Bauhaus, the bastion of the Modernist movement. Long outliving the Art Nouveau movement he helped to found, van de Velde witnessed its sensuous line transformed into the severe geometry of a more hard-edged society.

Vase

Designed by Edward Colonna (German)
1900/1902, French (Limoges)
Hard-paste porcelain with stenciled
and incised decoration

Side Chair

Designed by Hector Guimard
c. 1900 or c. 1913, French
Pearwood, tooled or stamped leather

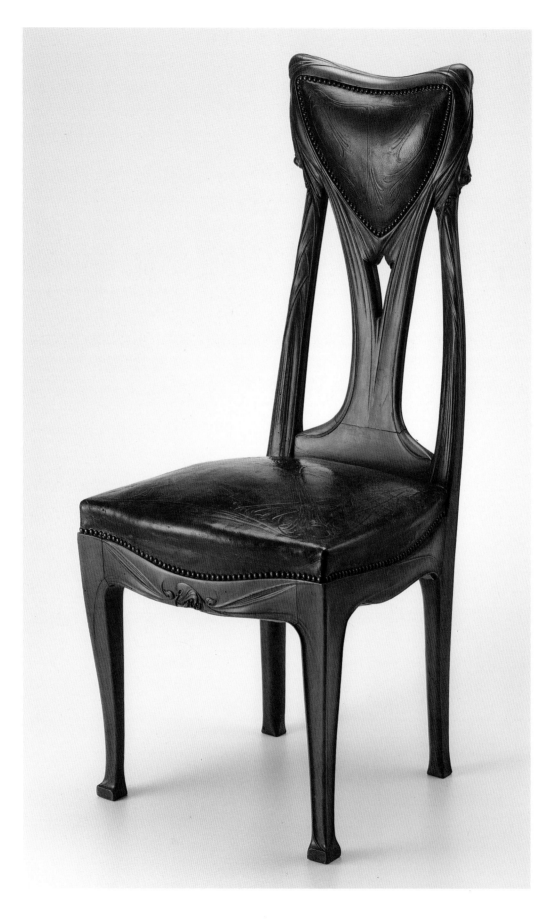

Samovar

Designed by Henry van de Velde (Belgian)
1902/1903, German (Weimar)
Silvered brass, teak

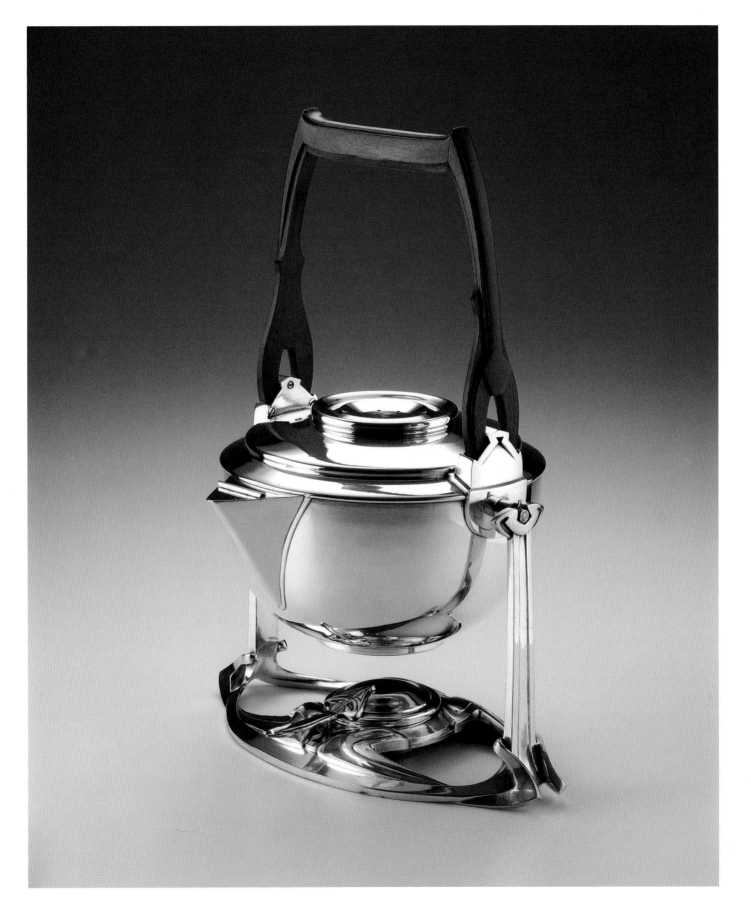

Centerpiece ("The Scarf Dance")

Modeled by Léonard Agathon van Weydeveld
c. 1900, French (Sèvres)
Hard-paste porcelain, biscuit porcelain, silver

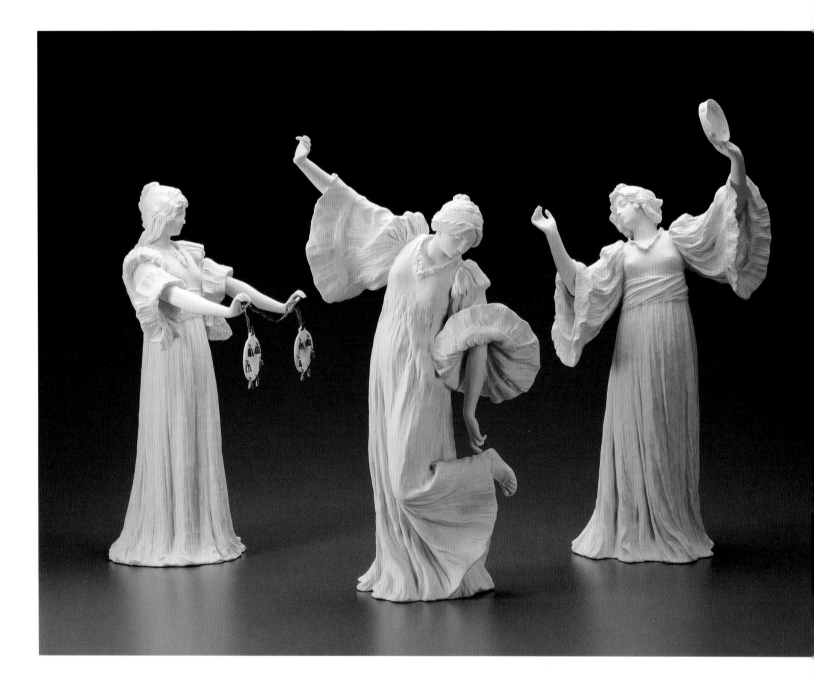

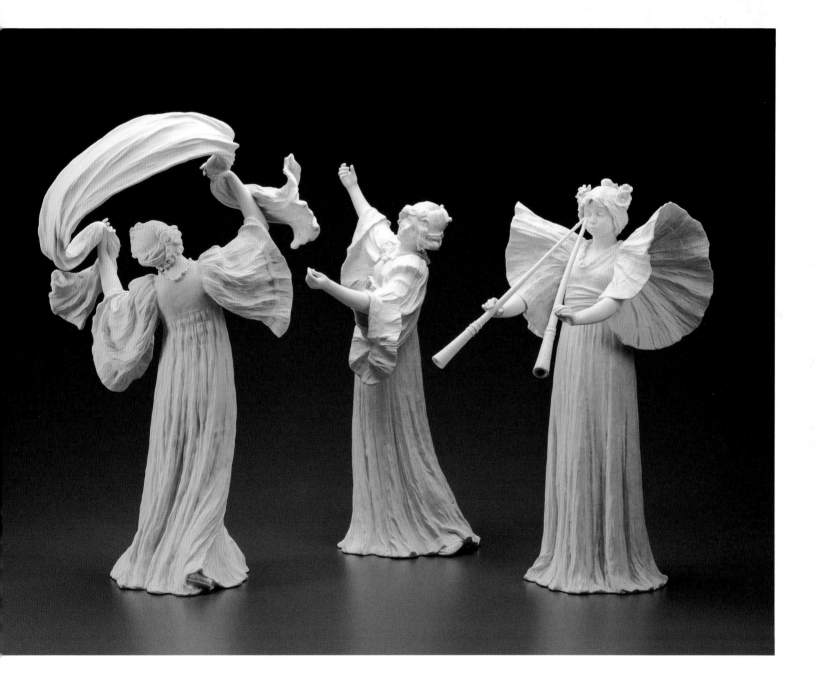

THE WIENER WERKSTÄTTE

At the end of the nineteenth century, Vienna was preparing its own response to the artistic reforms initiated in Great Britain by the Arts and Crafts movement. Throughout the 1890s, there had been increasing dissatisfaction on the part of architects, artists, and designers in the Austrian capital who felt the artistic climate of the city was backward-looking and unfulfilling. The approaching dawn of a new century helped inspire a reevaluation of cultural life among these progressive individuals, who sought new forms, methods, and materials with which to work. Progressive teachers, such as the architect Otto Wagner, called for the creation of a Viennese style that would make a conscious break from the past. In 1897, dissident artists and architects, led by the painter Gustav Klimt, severed their ties with the traditional artistic establishment of Vienna and formed a group that called itself "the Secession." Hoping to reinvigorate the arts of Vienna through an exhibition program in which the best foreign artists would be invited to show their work side-by-side with that of the Secessionists, the artists proposed the radical idea of including not only paintings and sculpture, but the whole range of decorative arts, along with posters and architectural drawings. Just as their British counterparts had, the Secessionists initially supported the credo that art is for everyone; they eschewed the production of luxury goods, opting to create objects that could be serviceable for daily life.

Josef Hoffmann was a principal founder of the Vienna Secession. In 1903, with the financial backing of Fritz Waerndorfer, a Viennese admirer of Arts and Crafts ideals, he and Koloman Moser organized a collaborative workshop patterned on Charles Robert Ashbee's Guild of Handicrafts. The Vienna Workshop, or Wiener Werkstätte, was created with the specific commercial goals to link "public, designer, and worker," and "to produce good and simple articles of everyday use." The 1905 manifesto of the Werkstätte was unambiguous regarding the relative roles of function and ornament: "Our guiding principle is function, utility our first condition, and our strength must lie in good proportions and the proper treatment of material. We shall seek to decorate when it seems required, but we do not feel obliged to adorn at any price."

This thinking is perhaps nowhere better expressed than in the modest and utilitarian *Gitterwerk* objects, which were mass-produced at the Werkstätte from die-punched metal in a gridlike pattern. Often executed in base metals such as tin and copper, *Gitterwerk*, which literally means basket- or trelliswork, was used to make a variety of containers, frames, and stands. These objects could be painted white or even silverplated. In the case of the cruets and stand (p. 124) designed by Moser for his friend and patron Waerndorfer, and fashioned in the Werkstätte shops by Alfred Mayer, the material used was silver. While avoiding applied decoration that relied on past historical styles, this diminutive set is nevertheless distinguished by its elegance and strength of character. The intersecting lines and negative spaces of *Gitterwerk*, together with the abstract, modern form of the simple glass cruets, become almost emblematic of the purified spirit sought by the Vienna reformers: the beauty of pure shapes, surfaces, and materials are, in themselves, worthy of admiration.

Soon, however, it was clear that the furnishings made by the Secessionists largely failed to appeal to the working and lower-middle classes, the very

Cruet Stand

Designed by Koloman Moser
c. 1904, Austrian (Vienna)
Silver, glass

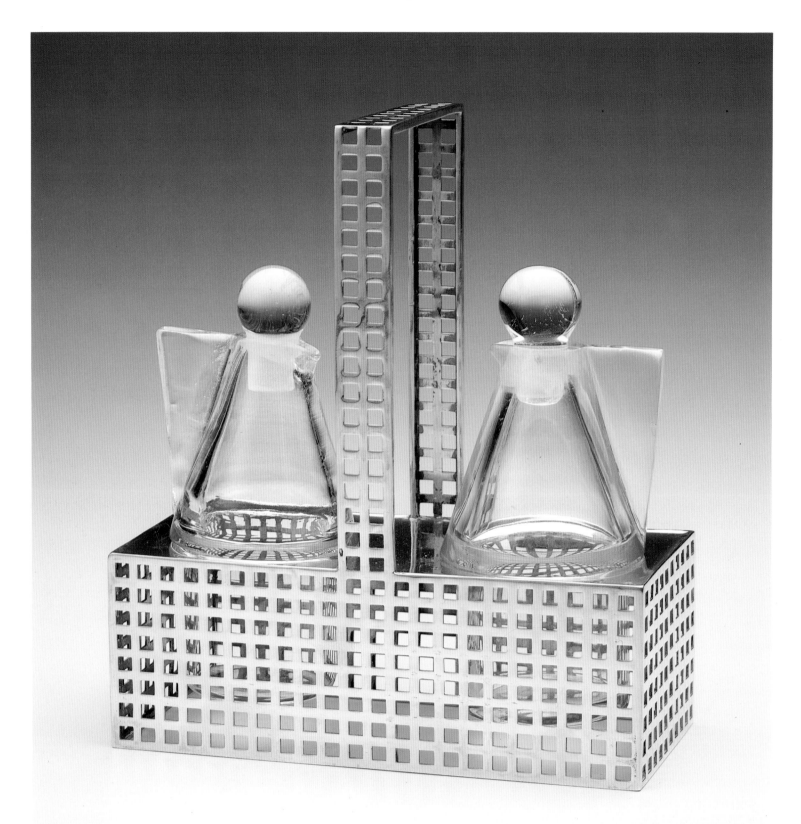

market at which they were aimed. Rather, it was the upper classes, intellectuals, and individuals with avant-garde leanings to whom the new aesthetic appealed. The Werkstätte expanded rapidly within a short time to accommodate ambitious commissions for complete architectural schemes, including all the elements for furnished interiors. Its clientele increasingly required unique and luxurious goods.

A tall case clock of around 1906 (p. 126), a design collaboration of Hoffmann and workshop member Carl Otto Czeschka, embodies the unexpected dichotomy within the Werkstätte between its early, reformist ideals and the demands of its commercial success. In Hoffmann's architectonic design of the case, with its simple white-painted pine, one clearly sees the influence of the Scottish Arts and Crafts designer Charles Rennie Mackintosh, whose work had been dramatically introduced in Vienna through the 1900 Secessionist exhibition. The cabinetmakers' equivalent to *Gitterwerk* is seen in the clock case's inlays of dark-and-light-wood squares. A striking contrast to the austerity and rectilinearity of Hoffmann's portion of the clock is its dial and door, designed by Czeschka. The door is fashioned from hand-embossed gilt brass, inset with cut-glass prisms; the hands that grace the dial are of silver-plated copper. The door seems to present a golden world punctuated by glints of light from gemlike prisms, where birds perch in pairs on scrolling vines. The effect is magical.

Shortly after the creation of the clock, Hoffmann himself was persuaded to satisfy the luxury market, as is evident in the rich, undulating surfaces of a tea and coffee service (p. 127) designed by him in 1916 and fashioned in the silver shop of the Werkstätte in 1922. Made of sterling silver and ivory, and embellished with finely wrought finials, its preciousness is at some distance from the products and markets envisioned by the writers of the 1905 manifesto. Until it terminated in 1932, the Wiener Werkstätte continued to produce richly ornamental objects such as the tea and coffee service, in which one delights not only in the intrinsic qualities of the medium, but in the pleasurable, evocative possibilities of its decoration.

Tall-case Clock

Designed by Josef Hoffmann and Carl Otto Czeschka
c. 1906, Austrian (Vienna)
Painted maple, ebony, mahogany, gilt brass, glass,
silver-plated copper, clockworks

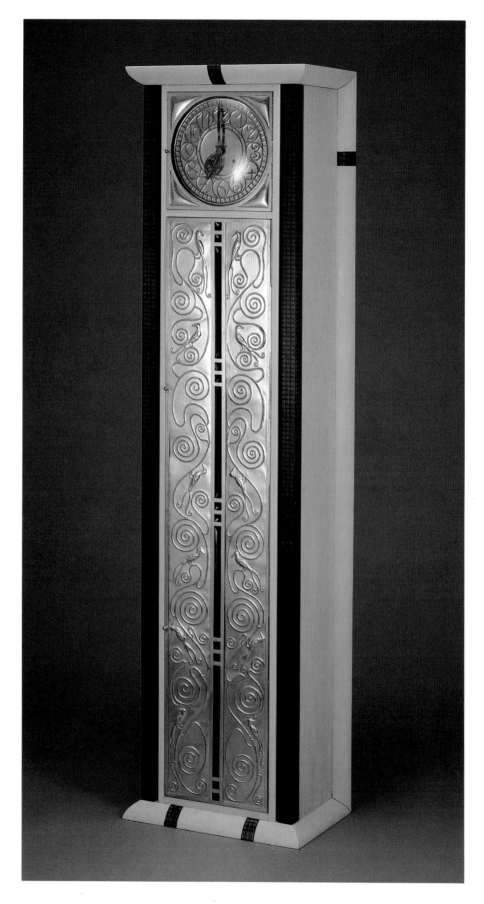

Tea and Coffee Service

Designed by Josef Hoffmann
1922 (designed 1916), Austrian (Vienna)
Silver and ivory

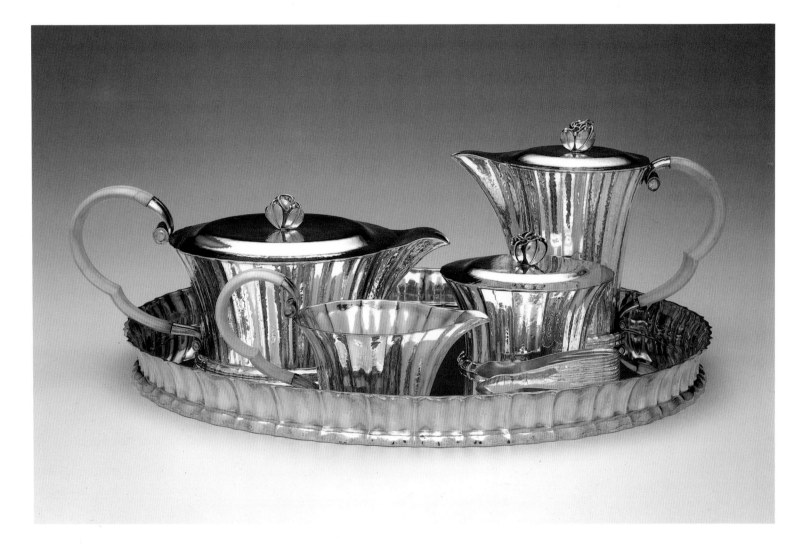

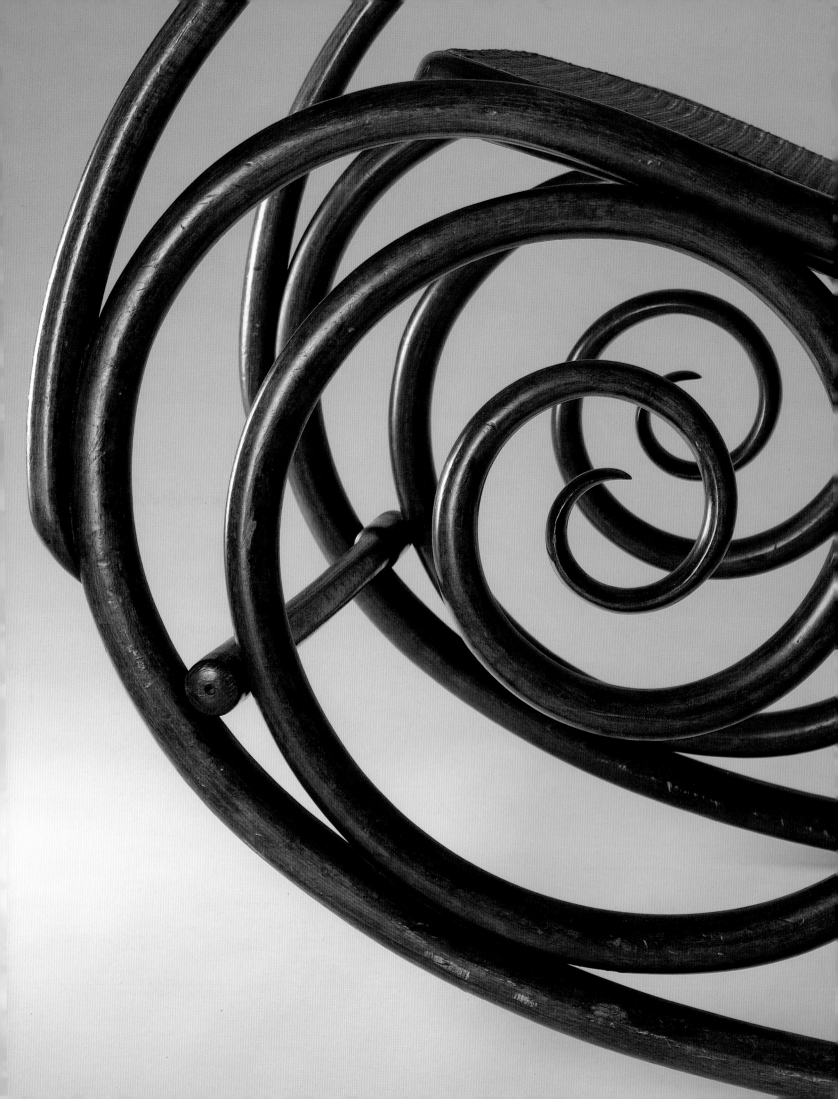

IDEALS OF MODERNISM

The transition of furniture production from the era of relatively small-scale workshops of specialized craftsmen to the age of mechanized mass-production was as revolutionary as the corresponding developments in modern art and architecture. The sleek and abstract products that have come to represent early twentieth-century design have roots embedded in the functional and simply ornamented works of reform-movement architects and designers. The generation that produced them, a diverse group of visionaries whose similar concerns defined Modernism, sought through the use of standardized elements and current technologies to produce affordable objects that were useful, aesthetically pleasing, and simple to maintain.

Many of these issues were presaged in the furniture of Michael Thonet, a Prussian-born inventor and designer who, around 1849, perfected at his Austrian factory a process for bending solid lengths of wood into an endless variety of previously unimagined curvilinear shapes. Assembled from standardized elements that could be combined in a multiplicity of inventive designs, Thonet's furniture eliminated the traditional methods of joinery and carving and the need for specialized trades within the factory system. As a result of his revolutionary process, little wood was wasted; and the amount of wood in any one of the furniture forms was so minimal, in comparison with traditional chair-and-cabinetmaking methods, that the pieces were extremely lightweight. The technique of producing standard elements also meant that the furniture could be shipped unassembled, to be easily joined with screws upon arrival. The manufacturing process had a formative influence on design and allowed such economies that the objects produced were affordable to a broad range of consumers. The attractiveness of Thonet's furniture, such as a rocking chair of around 1860 (p. 131), made it appealing to

aristocratic clients as well as to middle-class consumers in Austria, and eventually, throughout much of the world. The sinuous curves and countercurves of the rocking chair, one of many variations of an Anglo-American form that Thonet first introduced to Continental Europe in the 1860s, illustrate the extraordinary pliability of bentwood and clearly reveal how decoration can be united with its structural form.

Aesthetic experiments with the forms of chairs proliferated in the seventy years following Thonet's innovations. Gerrit Rietveld, designer and maker of the "Red-Blue" chair (p. 132), explicitly used the word "experiment" to describe his work. The Dutch artist explained the guiding principle behind his series of chairs, saying: "The construction is attuned to the parts to insure that no part dominates or is subordinate to the others. In this way, the whole stands freely and clearly in space and the form stands out from the material." Like his fellow members of the avant-garde group De Stijl, Rietveld pledged himself to abstraction, restricting expression to the horizontal and vertical planes, and using a palette limited to the three primary chromatics (red, yellow, and blue) and three primary non-chromatics (black, gray, and white). Rietveld utilized inexpensive materials such as lath and plywood and anticipated the production of his pieces by repetitive mechanical processes, although it is recorded that he personally made this example. Like his Arts and Crafts and Wiener Werkstätte precursors, he wished to make his designs available to a broad clientele at a moderate cost. And yet, Rietveld radically challenged the ideals of the Arts and Crafts movement of the previous half century, for his furniture is complex and illogical, and its natural material is enveloped in paint.

The significance of Rietveld's contribution was not lost on the principal architects and designers of

the Bauhaus, the German arts and crafts school established in Weimar by architect Walter Gropius. The aim of the Bauhaus was the creation of prototypes in the service of the mass-production of domestic goods. "The ultimate, if distant, goal of the Bauhaus," its manifesto stated, "is the collective work of art—the building—in which no barriers exist between the structural and decorative arts." Students and teachers were trained to work in all media as well as in all aspects of design. Marcel Breuer was a notable Bauhaus designer who responded to the challenge of Rietveld's bold work. Breuer rethought the very form and function of the chair—examining its essence in terms of structural articulation, abstraction of spatial volume, and cantilevering. When Breuer completed his variations, culminating in his now ubiquitous chrome-plated, tubular-steel chair, he had created one of the great functionalist icons among twentieth-century designs. The profound influence of Rietveld's chair on Breuer, however, can best be seen in one of Breuer's earlier, wooden armchairs (p. 133), in which one can also trace Breuer's working out of the design problems of the cantilever system that were resolved in his later masterpiece.

The *MR-90* armchair (p. 134), the aesthetically refined, highly functional creation of Ludwig Mies van der Rohe, is a classic example of Modernist design, and has continued in production over the decades at four successive firms. Mies, who ultimately headed the Bauhaus in Dessau, its second location before it was driven from Germany by Nazi persecution in 1938, presented this chair in the 1927 Weissenhofsiedlung exhibition in Stuttgart. The design caused a sensation, and even today strikes new viewers as a very contemporary and modern work.

The Swiss-born architect Charles Edouard Jeanneret, called Le Corbusier, frequently specified that Thonet chairs were to be used in his interiors. Le Corbusier sought solutions to Modernist problems through an industrialized aesthetic. In the chaise longue he designed in 1928 (p. 135) as a collaboration with his cousin Pierre Jeanneret and Charlotte Perriand, he reworked an eighteenth-century French form that had also been brilliantly interpreted in the nineteenth century by the Thonet firm. About his industrialized designs, suitable for the modern apartment, Le Corbusier wrote, "Decorative art is equipment, beautiful equipment." Where Rietveld's aesthetic did not permit considerations of comfort, Le Corbusier, in his chaise and other pieces, took into consideration the comfort of the human body, making his furniture eminently desirable in modern interiors even to this day.

Rocking Chair

Designed by Michael Thonet (German)
c. 1860, Austrian (Vienna)
Bentwood and caning

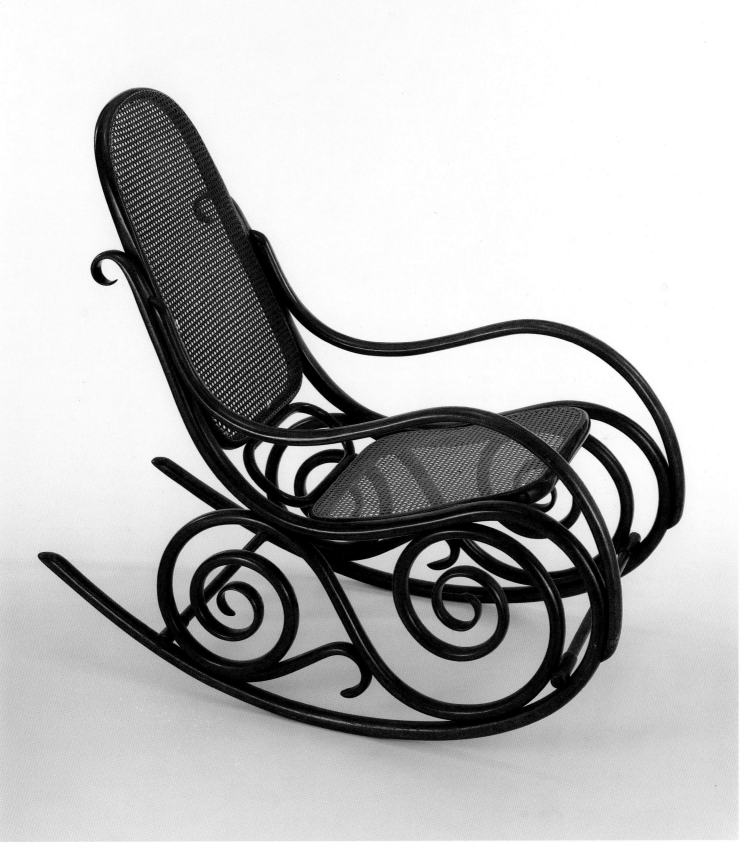

"Red-Blue" Chair

Gerrit Rietveld
1920/21 (designed 1918), Dutch
Painted plywood

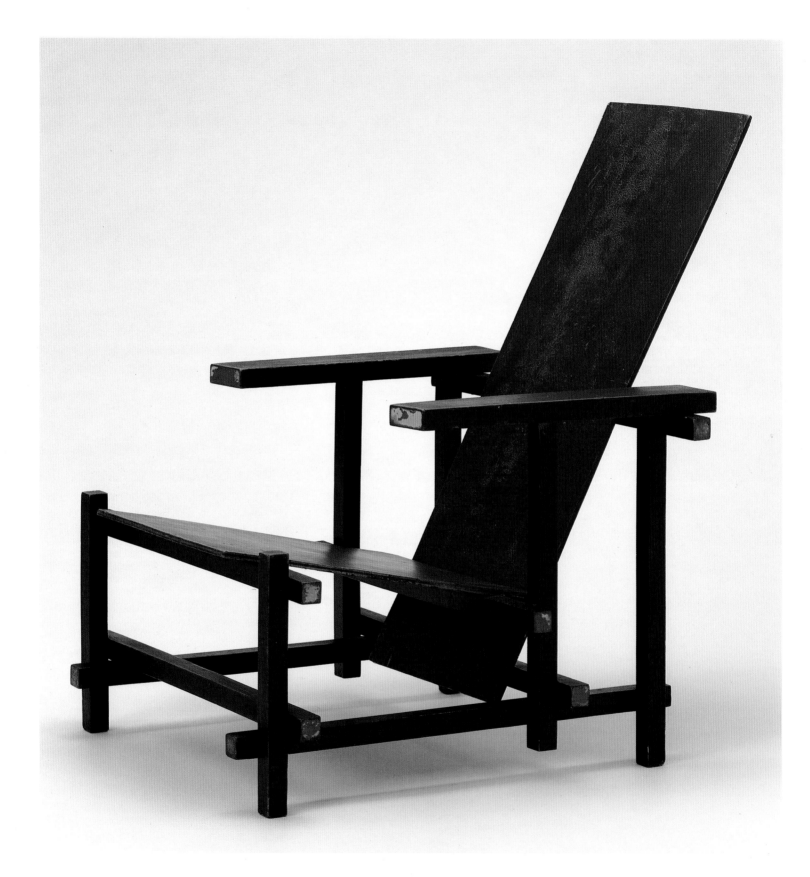

Armchair

Designed by Marcel Breuer (Hungarian)
1923/24 (designed 1922), German (Weimar)
Stained oak, canvas

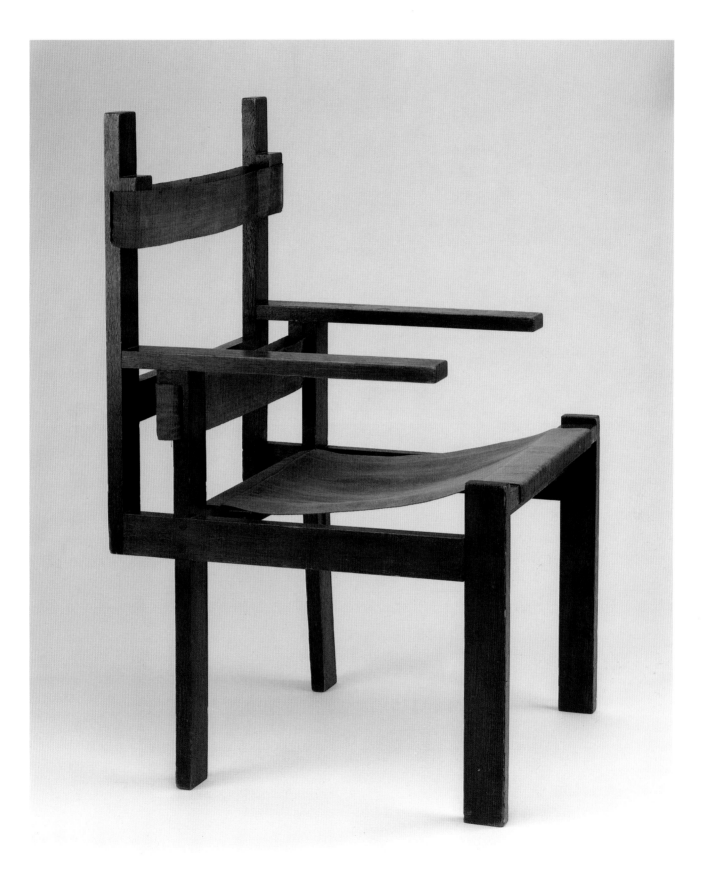

MR-90 Armchair

Designed by Ludwig Mies van der Rohe
1926/27, German (Berlin)
Chrome-plated steel tubing, leather

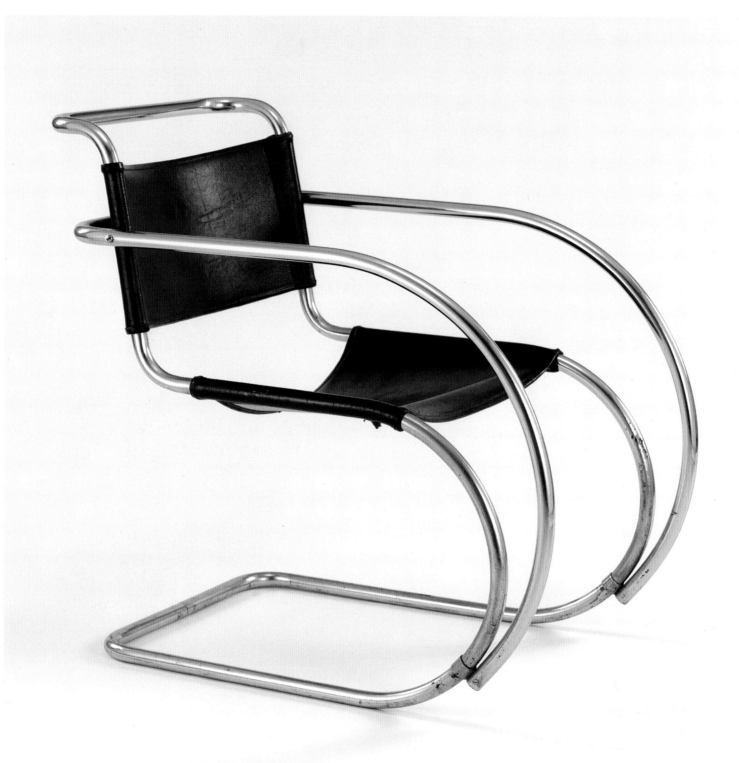

Chaise Longue

Designed by Le Corbusier
with Pierre Jeanneret and Charlotte Perriand
c. 1933 (designed 1928), Swiss (Ruti)
Chrome-plated steel and iron

CHECKLIST OF OBJECTS

Listed chronologically by medium or type.
Page numbers of illustrations given in italics.

Ceramics

Wine Cistern
Painted by Francesco Durantino (active
1543–53, Monte Bagnolo, Castel Durante)
Italian (Castel Durante)
1553
Tin-glazed earthenware (maiolica);
26.0 × 51.4 × 41.3 cm
Anonymous Fund, 1966.395
Pp.*18* (detail), 20, *24*

Dish
Probably made by Ralph Simpson
(1651–1724)
English (Staffordshire)
c. 1690
Lead-glazed earthenware with slip
decoration; diam. 46.4 cm
Richard T. Crane, Jr., Memorial Fund,
1959.55
Pp.*36* (detail), 39, *41*

Centerpiece and Stand
Modeled by Johann Joachim Kändler
(active 1731–75, Meissen)
German
Meissen porcelain factory
1737
Hard-paste porcelain with enameling and
gilding, chased and engraved gilt-bronze
mounts. Bowl: 28 × 44.4 × 25.4 cm; stand:
15.2 × 66 × 50.8 cm
Atlan Ceramic Club, Buckingham Luster,
Decorative Arts Purchase funds, 1958.405
Pp.*70* (detail), 71–72, *72* (sugar caster), *73*

Ewer and Basin
Modeling attributed to Giuseppe Gricci
(active 1743–59, Capodimonte)
Italian
Capodimonte porcelain factory, Naples
c. 1745
Soft-paste porcelain with enameling
and gilding. Ewer: h. 30.5 cm; basin:
16.5 × 38.7 × 34.3 cm
Gift of Mr. and Mrs. Robert Norman
Chatain in memory of Professor Alfred
Chatain, 1957.490
Pp.*76* (detail), 77–78, *81*

Tureen with Cover and Stand
French

Pont-aux-Choux factory, Paris
c. 1750
Lead-glazed earthenware (faience fine);
33.0 × 58.4 × 42.6 cm
Gift of R. Thornton Wilson in memory of
his wife, Florence Ellsworth Wilson,
1951.277
Pp.78, *80*

Punch Pot
English (Staffordshire, Stoke-on-Trent)
1755/65
Salt-glazed stoneware with enameling;
20.3 × 31.8 cm
Charles Netcher II Memorial Collection,
gift of Mrs. Charles Netcher II, 1935.179
Pp.65–67, *66, 67* (detail)

Mourning Madonna
Modeled by Franz Anton Bustelli
(Swiss, active 1753–63, Nymphenburg)
German
Nymphenburg porcelain factory
1756/58
Hard-paste porcelain; 30.6 × 17.2 × 12.2 cm
Gift of the Antiquarian Society through the
Mrs. Harold T. Martin Fund, 1986.1009
Pp.49, *52*

"Elephant Candelabrum" Vase
(*vase à tête d'éléphant*)
Design attributed to Jean Claude Duplessis
the elder (active 1745/8–74, Sèvres)
Painting attributed to Vincent Taillandier
(active 1753–90, Sèvres)
French
Sèvres porcelain factory
1757
Soft-paste porcelain with enameling and
gilding; h. 39.2 cm
The Theresa and Joseph Maier Memorial,
gift of Kenneth J. Maier, M.D., 1986.3446
Pp.77, *79*

"Monkey Band"
Modeled by Johann Joachim Kändler (active
1731–75, Meissen) and Peter Reinicke
(active 1743–68, Meissen)
German
Meissen porcelain factory
1765/66
Hard-paste porcelain with enameling and
gilding; fifteen figures, ranging in height
from 12.7 to 15.2 cm
Gift of Robert Allerton, 1946.479–94
Pp.72, *74–75*

"The Portland Vase"
Modeling attributed to Henry Webber
(active 1782–95, Wedgwood) and William
Hackwood (active 1769–1832, Wedgwood)
English
Wedgwood Pottery, Burslem, Staffordshire
c. 1790
Black jasper ware with white jasper cameo-
relief decoration; 25.4 × 18.7 cm
Gift of Mrs. Rosalyn M. Rose, 1979.738
Pp.*88, 89*

The Londonderry Vase
(*Vase étrusque à rouleaux*)
Designed by Charles Percier (1764–1838);
decoration designed by Alexandre Théodore
Brongniart (1739–1813)
Decorators: flowers and ornament by
Gilbert Drouet (active 1785–1825, Sèvres);
birds by Christophe Ferdinand Caron
(active 1792–1815, Sèvres)
French
Sèvres porcelain factory
1813
Hard-paste porcelain with polychrome
enamel decoration, gilding, gilt-bronze
mounts; h. 137.2 cm
Harry and Maribel G. Blum Foundation,
Harold L. Stuart funds, 1987.1
Pp.*90* (detail), 91–92, *95*

Vase
Designed by William Frend De Morgan
(1839–1917)
English
William Frend De Morgan Pottery, Merton
Abbey, Surrey
1882/88
Tin-glazed earthenware with polychrome
decoration; h. 53.3, diam. 28.6 cm
Gift of Margaret Fisher in memory of her
mother, 1981.638
Pp.109, *113*

Centerpiece: The Scarf Dance
(*Le Jeu de l'echarpe*)
Modeled by Léonard Agathon van
Weydeveld (b. 1841)
French
Sèvres porcelain factory
c. 1900
Hard-paste porcelain (*porcelaine nouvelle*),
biscuit, silver; six figures, ranging in height
from 42.9 to 53.2 cm

Bequest of Mrs. Gordon Palmer, 1985.106
Pp.*114* (detail), 115–16, *120–21*

Vase
Designed by Edward Colonna
(German, 1862–1948)
French
Gerard Dufraissex et Abbot, Limoges
1900/1902
Hard-paste porcelain with stenciled and
incised decoration; h. 15.2, diam. 10.2 cm
Mrs. Harold T. Martin Fund, 1988.40
Pp.115, *117*

Clocks

Wall Clock
(*pendule en cartel*)
Jean Pierre Latz (c. 1691–1754)
French (Paris)
1735/40
Movement by Francis Bayley (n.d.), Belgian
(Ghent)
Oak veneered with tortoiseshell and
kingwood, brass inlay, gilt bronze, glass;
musical movement; 147.3 × 52.3 × 36.4 cm;
clock: h. 94.0 cm
Ada Turnbull Hertle Fund, 1975.172
Pp.*54* (detail), 55–56, *57*

Tall-case Clock
Case designed by Josef Hoffmann
(1870–1956)
Metalwork designed by Carl Otto Czeschka
(1878–1960)
Austrian
Wiener Werkstätte, Vienna
c. 1906
Painted maple, ebony, mahogany, gilt brass,
glass, silver-plated copper, clockworks;
179.4 × 46.4 × 30.5 cm
Laura Matthews, and Mary Waller
Langhorne funds, 1983.37
Pp.*122* (detail), 125, *126*

Enameled Metalwork

Plaque of a Bishop
German (Mosan region, probably Cologne)
1175/1225
Gilt copper and champlevé enamel;
15.2 × 5.7 cm
Buckingham Fund, 1943.88
Pp.11, *13*

Tazza
Painted by Jean de Court (active 1509–83,
Limoges)
French (Limoges)
1553/75
Enamel on copper; h. 11.4, diam. 23.5 cm
Mr. and Mrs. Martin A. Ryerson Collection,
1937.819
Pp.19–20, 22, *23* (profile)

Furniture

Augsburg Cabinet
German (Augsburg)
c. 1640
Ebony, carved and inlaid ivory, stained and
carved wood relief, gilt bronze, iron
implements; 160.0 × 110.5 × 64.8 cm
Anonymous Purchase Fund, 1970.404
Pp.*32* (detail), 33, *34, 35, 35* (closed)

Pair of Side Chairs
English (London)
1690/1700
Painted and gilded beechwood; modern
upholstery; 134.9 × 56.2 × 63.2 cm
Gift of Mr. and Mrs. I. W. Colburn through
the Antiquarian Society, 1972.1169–70
Pp.43, *44*

Settee
Possibly designed by William Kent
(1684–1748)
English
1725/35
Gessoed and gilded beechwood; modern
upholstery; 111.1 × 142.2 × 72.4 cm
Richard T. Crane, Jr., Memorial Fund,
1949.357
Pp.43, *45, 47*

Side Chair
Firm of Giles Grendey (1693–1780),
London
English
c. 1740
Walnut and walnut veneer; contemporary
needlepoint; 97.0 × 52.0 × 45.7 cm
Restricted gift of Eloise W. Martin; Harold
T. Martin Charitable Trust, 1983.918
Pp.*42* (detail), *46*, 47

Door from the Ca'Rezzonico
Italian (Venice)

c. 1750
Lacquered and gilded wood;
279.4 × 139.7 cm
Bessie Bennett Fund, 1953.461
Pp.65, *69*

Chest of Drawers
(*Commode*)
Jean Henri Riesener (German, 1734–1806)
French (Paris)
1770/80
Oak (secondary), mahogany, kingwood,
purple heart, unidentified exotic woods, gilt
bronze, marble; 95.8 × 165.7 × 56.5 cm
Major Acquisitions, Wirt D. Walker funds,
1972.412
Pp.*82* (detail), *87,* 89

Secretary Desk
David Roentgen (1743–1807)
German (Neuwied)
c. 1775
Walnut and other woods, gilt mounts;
272.4 × 139.6 cm
Gift of Count Pecci-Blunt, 1954.21
Pp.*64* (detail), 67, *68*

Pedestal Table
Designed by Thomas Hope (1769–1831)
English
c. 1810
Mahogany with ebony and metal inlays,
gilt-bronze mounts, gilding; 72.4 × 106.7
× 105.4 cm
Restricted gift of Mr. and Mrs. Henry C.
Woods, 1964.346
Pp.92, *94*

Secretary Desk
Austrian (Vienna)
1810/12
Unidentified woods, limewood, carved,
gilded, and painted in patinated bronze
color, with gilt-bronze mounts; interior:
copper, brass, and maple wood marquetry,
with mahogany and yew; 146.5 × 91.2 ×
39.2 cm
The Antiquarian Society Centennial Fund,
1976.39
Pp.92, *92* (closed), *93*

Side Chair
Factory of Joseph Danhauser (1780–1829)
Austrian (Vienna)
1815/20

Walnut and walnut veneer; modern
upholstery; 237.5 × 123.2 × 121.9 cm
Gift of the Antiquarian Society through the
Capital Campaign Fund, 1987.215.4
Pp.96 (detail), 97, 98

Armchair
Austrian (Vienna)
1820/25
Walnut and walnut veneer, poplar; modern
upholstery; 94.5 × 69 × 74 cm
Gift of the Antiquarian Society through the
Capital Campaign Fund, 1987.215.3
Pp.97, 99

Revolving Library Table
Design attributed to Richard Bridgens
(active 1810–39, London)
Probably made for or retailed by Edward
Holmes Baldock (1777–1845), London
English
c. 1840
Mahogany and pine (secondary), ebony
veneer, kingwood, boxwood, mahogany,
satinwood, brass, ivory, mother-of-pearl,
leather (replacement); h. 76, diam.
148.6 cm
Gift of the Antiquarian Society through the
Capital Campaign Fund, 1987.215.1
Pp.103, 104 (detail), 105

Rocking Chair
Designed by Michael Thonet (German,
1796–1871)
Austrian
Gebrüder Thonet, Vienna and Moravia
c. 1860
Bentwood and caning;
108.9 × 48.3 × 48.3 cm
Restricted gift of Mrs. Samuel G. Rautbord,
1970.30
Pp.128 (detail), 129, 131

Armchair
Luigi Frullini (1839–1897)
Italian (Florence)
1876
Walnut, cut-silk velvet upholstery;
88.9 × 93.9 × 93.9 cm
Through prior gifts of Emily Crane
Chadbourne, Edna Olive Johnson, Mr. and
Mrs. Joseph Regenstein, Sr., Mrs. Gustavus
Swift, Jr.; restricted gift of Kenilworth
Garden Club, Mr. and Mrs. Bruce
Southworth; Richard T. Crane, Jr.,

Endowment; European Decorative Arts
Purchase Fund, 1986.1002
Pp.102 (detail), 104, 106

Side Chair
Hector Guimard (1867–1942)
French
c. 1900 or c. 1913
Pearwood, tooled or stamped leather;
108 × 45.7 × 47 cm
Through prior gifts of Mr. Walter Brewster,
Mrs. James Cook, Mr. Joseph Nash Field,
Mrs. T. Clifford Rodman, Mrs. Clive
Runnells, Mr. and Mrs. Martin Ryerson,
Mrs. Norman Schloss, Mrs. Sidney
Schwartz, Mrs. Diego Suarez, 1985.764
Pp.115, 118

"Red-Blue" Chair
Gerrit Rietveld (1888–1964)
Dutch
1920/21 (designed 1918)
Painted plywood; 85.7 × 66 × 81.3 cm
Through prior gifts of Mrs. Albert J.
Beveridge, Florene May Schoenborn and
Samuel A. Marx; through prior acquisitions
of the Richard T. Crane, Jr., Memorial and
the Mary Waller Langhorne funds; Richard
T. Crane, Jr., Endowment, 1988.274
Pp.129–30, 132

Armchair
Designed by Marcel Breuer (American,
b. Hungary, 1902–1981)
German
Bauhaus Carpentry Workshop, Weimar
1923/24 (designed 1922)
Stained oak, canvas, 94.6 × 56.5 × 57.1 cm
Richard T. Crane, Jr., Endowment, 1988.39
Pp.130, 133

MR-90 Armchair
Designed by Ludwig Mies van der Rohe
(American, b. Germany, 1886–1969)
German
Gebrüder Thonet A.G., Berlin
1926/27
Chrome-plated steel tubing, leather;
80 × 54.3 × 85.1 cm
Restricted gift of the Graham Foundation,
1970.403
Pp.130, 134

Chaise Longue
Designed by Le Corbusier (Charles Edouard

Jeanneret-Gris, 1887–1965) with Pierre
Jeanneret (1896–1965) and Charlotte
Perriand (b. France, 1903)
Swiss
Embru-Werke, A.G., Ruti
c. 1933 (designed 1928)
Chrome-plated steel and iron; 54.6 × 157.5
× 59.1 cm
Bequest of Hedwig B. Schniewind,
1963.1128
Pp.130, 135

Glass

Tumbler
Probably Netherlandish
Sixteenth century
Blown glass with applied decoration, metal
rings; h. 13.3, diam. 8.3 cm
Gift of Julius and Augusta N. Rosenwald,
1927.1282
Pp.27, 28

Tall Beaker
(Humpen)
Czech (Bohemian)
c. 1600
Blown glass with polychrome enamel;
h. 31.0, diam. 13.3 cm
Gift of Julius and Augusta N. Rosenwald,
1927.1012
Pp.27, 30, 31 (detail)

Goblet
Attributed to Georg Schwanhardt the elder
(1601–1667)
German (Nuremburg)
c. 1660
Blown glass with diamond-point engraving;
h. 36.7, diam. 14.6 cm
Gift of Julius and Augusta N. Rosenwald,
1927. 1255
Pp.26 (detail), 29, 31

Tumbler
Factory of Friedrich Egermann
(1777–1864)
Czech (Bohemian)
1830/40
Lithyalian glass and gilding; h. 11.4, diam.
9.7 cm
Gift of Julius and Augusta N. Rosenwald,
1927.1120
Pp.100, 101

Ivory

Triptych with Scenes from the Life of Christ
French (Paris)
Fourteenth century
Ivory; 25.4 × 17.8 cm (open), 8.9 cm (closed)
Mr. and Mrs. Martin A. Ryerson Collection, 1937.827
Pp.11, *15*, 16

Saint John of Nepomuk
Peter Hencke (d. 1777)
German
c. 1750
Ivory, gilt-wood socle. Statuette: h. 28 cm; socle: h.21.5 cm
Richard T. Crane, Jr., Memorial Fund, 1959.496
Pp.49, 50, *53*

Marble

Vase
Clodion (Claude Michel, 1738–1814)
French
1766
Marble; 36.4 × 19.8 × 18.4 cm
Through prior acquisition of the George F. Harding Collection; Harold L. Stuart Fund, 1987.55
Pp.83, *84*

Metalwork

The Chasse of Saint Adrian
Spanish
1100/1135
Repoussé silver on oak core; 16.2 × 25.4 × 14.5 cm
Buckingham Fund, 1943.65
Pp.*10* (detail), 11, *12*

The Veltheim Cross
German
c. 1300
From the Guelph Treasure of the Cathedral of Saint Blaise, Brunswick
Gilt silver, enamel, gems; 20.5 × 12.8 × 3 cm
Gift of Mrs. Chauncey McCormick, 1962.92
Pp.*14*, 16

Covered Goblet
German (Augsburg or Nuremburg)
c. 1500
Parcel silver gilt with repoussé, cast, and applied decoration; h. 41.6 cm
Gift of Rudolph Gutmann, 1956.777
Pp.16, *17*

Tazza
Italian or Netherlandish
1550/1600
Silver gilt; h. 13.3; diam. 14.3
Buckingham Fund, 1947.476
Pp.19, *20* (top), *21*

Rosewater Ewer and Basin
Franz Dotte (active c. 1575–1600, Nuremburg)
German (Nuremburg)
c. 1596
Silver gilt; diam. 48.3 cm
Buckingham Fund, 1947.477
Pp.20, 23, *25*

Standing Cup
Marked "A.B." (probably Anthony Bates, 1550–1607)
English (London)
1607/1608
Silver gilt with repoussé, cast, applied, and chased decoration; h. 31.1 cm, diam. 13.3 cm at lip, 12.1 cm at foot
Kate S. Buckingham Jacobean Room Fund, 1972.321
Pp.37, *40*

Ewer
Silver mounts: English, c. 1610; marked "EI" (unidentified)
Vessel: Chinese, Ming Dynasty, Wanli period (1573–1620)
Hard-paste porcelain with underglaze decoration, silver; 26.2 × 25.1 × 16.2 cm
Gift of Mr. and Mrs. Medard W. Welch, 1966.133
Pp.37, *38, 39*

The Tredegar Cup
Paul de Lamerie (1688–1751)
English (London)
1739/40
Silver with repoussé, cast, applied, chased, and engraved decoration; 35.6 × 33.3 cm, diam. 16.4 cm
Restricted gift of Eloise W. Martin; Harold T. Martin Charitable Trust, 1974.530
Pp.59, *60*

The Lockhart Cup
Richard Gurney and Thomas Cooke II
(in partnership 1721–61)
English (London)
1757/58
Gold; h. 20.3 cm
Buckingham Fund, 1957.455
Pp.59, *61*, 63

Monstrance
Joseph Moser (n.d.)
Austrian (Vienna)
1762
Silver gilt with semiprecious stones, seed pearls; h. 70.5 cm
Emily Crane Chadbourne Fund, 1970.114
Pp.*48* (detail), 50, *51*

Pair of Andirons
Modeled by Etienne Maurice Falconet (1716–1791)
Casting attributed to Quentin Claude Pitoin (active 1742–77, Paris)
French (Paris)
c. 1769
Double-gilt bronze. Venus: 51.0 × 49.5 × 21.5 cm; Vulcan: 50.5 × 51.5 × 24.0 cm
Restricted gift of the Harry and Maribel G. Blum Foundation, 1987.221.1–2
Pp.83, *86*

Candelabrum
Firm of Matthew Boulton (1728–1809) and John Fothergill (d. 1782), in partnership 1768–82, Birmingham and Soho
English
1771/72
Gilt bronze, Derbyshire fluorspar (blue john), wood with tortoiseshell veneer; 49.5 × 66.9 cm
Restricted gift of Mrs. Medard W. Welch, 1969.233
Pp.*85*, 89

Tureen
John Bridge (1755–1834)
English (London)
1823/24
Silver with repoussé, cast, applied, and chased decoration; h. 38.1 cm
Restricted gift of Emily Crane Chadbourne, 1967.486
Pp.*58* (detail), *62*, 63

Model Chalice
Designed by Augustus Welby Northmore Pugin (1812–1852)
English

John Hardman and Company, Birmingham
1846/49
Gilt base metal, enamels, semiprecious
stones; h. 26.0 cm
Bessie Bennett Fund, 1981.640
Pp.104, *107*

Coffeepot
Designed by Charles Robert Ashbee
(1862–1942)
English
Guild of Handicraft Ltd., London
1900/1901
Silver with chrysoprase; 15.7 × 17.9 × 12.7
cm
Gift of the Antiquarian Society through the
Eloise W. Martin Fund in honor of Edith
Bruce, 1987.354
Pp.111, *112*

Samovar
Designed by Henry van de Velde (Belgian,
1863–1957)
German
Theodore Müller, Weimar
1902/1903
Silvered brass, teak; 37.9 × 28.5 × 23.5 cm
Gift of the Historical Design Collection and
an anonymous donor; Mr. and Mrs. F. Lee
Wendell and European Decorative Arts
Purchase funds; Edward E. Ayer
Endowment in memory of Charles L.
Hutchinson, Bessie Bennett Endowment;
through prior gifts of Walter C. Clark, Mrs.
Oscar Klein, Mrs. R. W. Morris, Mrs. I.
Newton Perry; through prior acquisition of
European Decorative Arts Purchase funds,
1989.154
Pp.116, *119*

Cruet Stand
Designed by Koloman Moser (1868–1918)
Made by Alfred Mayer
Austrian
Wiener Werkstätte, Vienna
c. 1904
Silver, glass. Stand: 17 × 14.8 × 6.8 cm;
cruets: h. 10, diam. 5.6 cm
Richard T. Crane Endowment; restricted gift
of Mrs. Julian Armstrong, Jr., Mrs. George
B. Young, 1987.219.1–3
Pp.123, *124*

Tea and Coffee Service
Designed by Josef Hoffmann (1870–1956)

Austrian
Wiener Werkstätte, Vienna
1922 (designed 1916)
Silver and ivory. Tray: 3.2 × 39 × 34.3 cm;
coffeepot: 15.6 × 20.3 × 9.9 cm; teapot: 11.2
x 26 × 14.7 cm; creamer: 5.6 × 17.1 × 9.6
cm; sugar: 9.2 × 11.4 × 10.8 cm; sugar
tongs: 2.2 × 13.2 × 3.2 cm
Gift of the Antiquarian Society through the
Eloise W. Martin Fund in memory of Mrs.
Alfred Collins, 1987.213.1–6
Pp.125, *127*

Musical Instruments

Manxman Pianoforte
English
Designed by Mackay Hugh Baillie Scott
(Scottish, 1865–1945)
Case and metalwork attributed to Charles
Robert Ashbee (1863–1942)
Guild of Handicraft Ltd., London
Movement by John Broadwood and Sons,
London
1897
Oak, ebony, mother-of-pearl, ivory, copper
fittings; 129.5 × 69.9 cm
Through prior restricted gifts of Robert
Allerton, Margaret Day Blake, Mr. and Mrs.
Leopold Blumka, Walter S. Brewster, Emily
Crane Chadbourne, Richard T. Crane, Jr.,
Jack Linsky, Harry Manaster, Mrs. Joseph
Regenstein, Sr., Mr. and Mrs. John Wilson,
Mrs. Henry C. Woods; through prior
acquisition of the Florene May Schoenborn
and Samuel A. Marx Fund; European
Decorative Arts Purchase Fund, 1985.99
Pp.*108* (detail) *110*, 111, *111* (closed)